There is no institute of photography that fully comprehends the commercial application of photography. This knowledge is the preserve of the world's highest paid photographers.

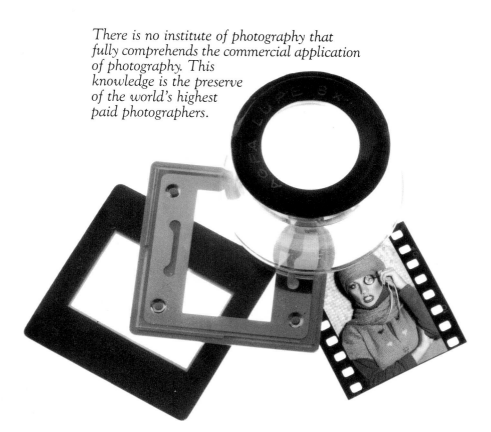

About the book.

This is a Chatsworth Book, published
in Canada by Methuen Publications,
2330 Midland Ave., Agincourt, Ontario
Canada M1S 1P7.

Printed in Canada.
First printing June 1981.
Second printing October 1981.
ISBN 0-458-95240-0

Ⓝ
Methuen.
Toronto, London, Sidney.

*Image from a cosmetic poster for the Hudson's Bay
department stores. A carton of feathers was obtained
from a dressmaker's supply shop and over 20
different variations were photographed before settling
on this final version. Shot on 35mm with a 300mm
lens to compress the facial features and give
maximum graphic impact to the feather.
Model: Denise McCloud.*

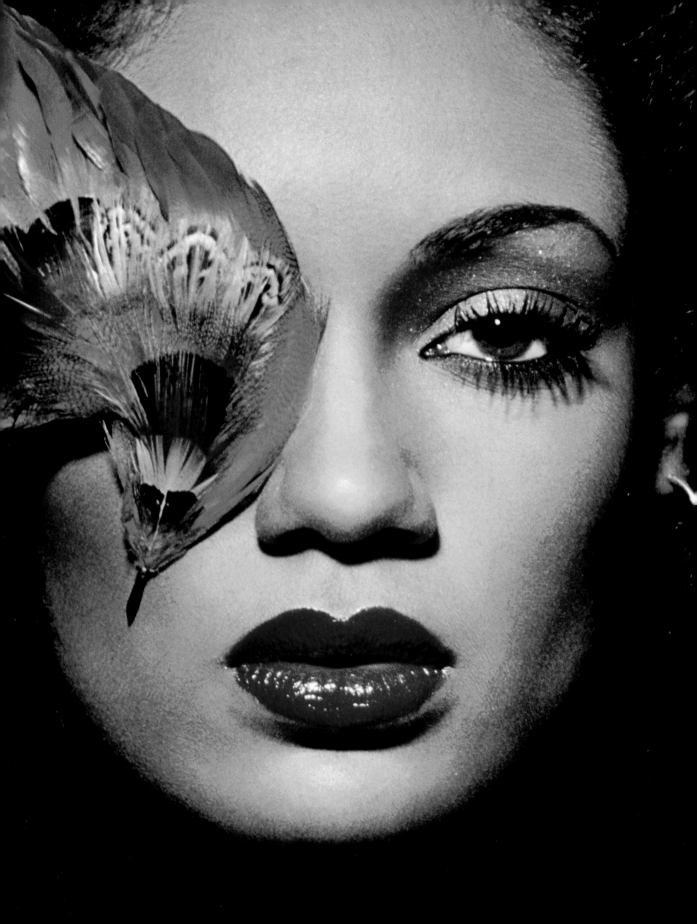

SHOOTING YOUR WAY TO A $-MILLION.

A photographer's strategy for success by Richard Sharabura.

The contents.

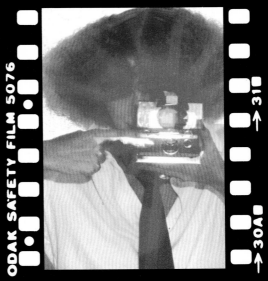

*Transparency from an actual fashion shoot.
The burst of red rays was created by Scotch taping a
deep red gelatin filter over the flash cube on the
Polaroid camera in the model's hand. Exposure was
made by placing the studio in complete darkness and
leaving the shutter open while the model fired the
Polaroid camera.*

First words.

No other profession spawns more eager hopefuls. No other profession calls so many and chooses so few.

Year after year students graduate in droves from institutes of photography. Photographers everywhere roam the streets practicing their art. In fact, practically everyone with a camera secretly envisions themselves as a potential 'pro'. In spite of all this, the ranks of successful, professional photographers remain notoriously thin. And each year, scores of photographers try to break into the specialized field of commercial photography, yet most meet with little success. The doors of the fortress remain forever closed. And inside, the assignments flow on to the 'superstars', to the 'favorites', to the people who, however else they may be judged, know the rules of the game, and of the business. The business of commercial photography.

This book was conceived to explain that business: its nature, its demands, and its rewards.

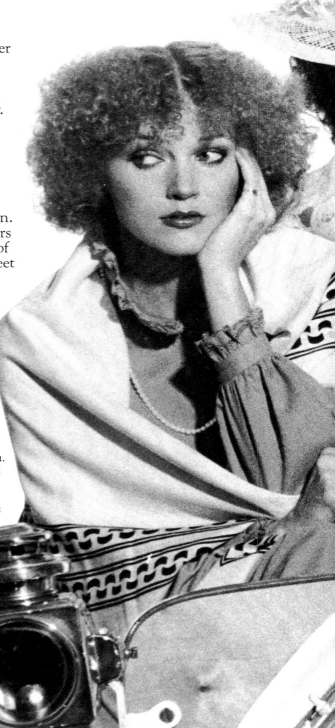

Antique cars provided a theme for country fashion. To duplicate the effect of outdoor sunlight inside a car museum, a strobe head with a wide angle reflector fitting was elevated to 12 feet, and two strobe heads were aimed into white reflector cards behind the car. The reflected backlight on the background was set on the power pack at a ratio of 2:1 over the front mainlight. A 300mm lens on a 35mm camera compressed the car and models sufficiently to help give the appearance of a distant shot of a car rambling down a country road. Shot on Kodak Tri-X Pan pushed to 800 ASA.

8

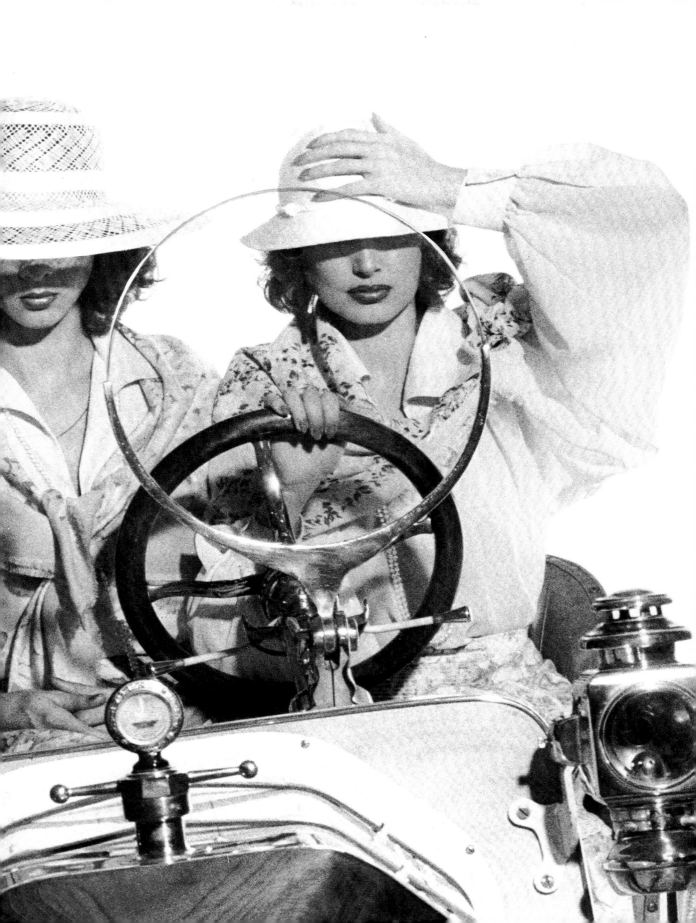

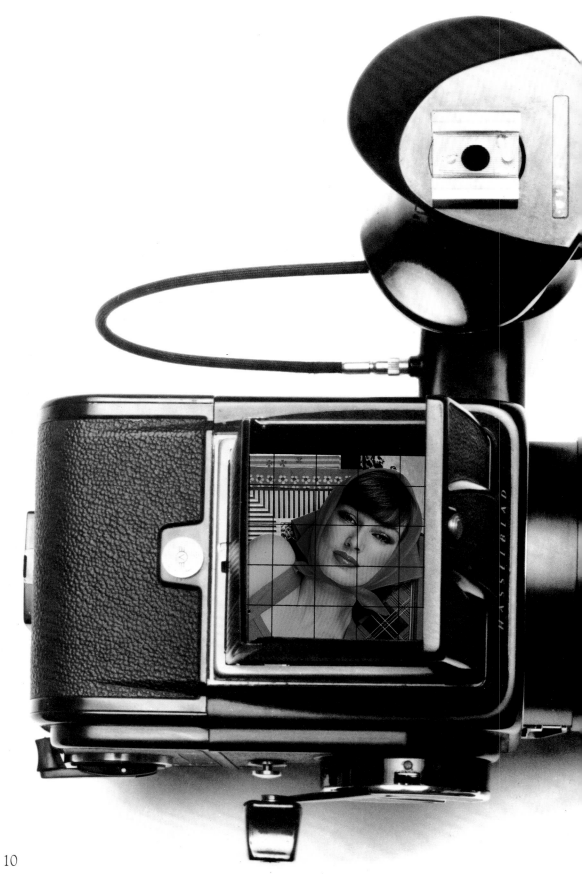

Turning professional.
An introduction.

GREAT COOKING, GREAT LOOKING
EVESHAM

Ever popular Evesham oven-to-tableware and dinnerware
by Royal Worcester.
Now is the perfect time to add to your Evesham collection,
or give Evesham as a much-appreciated gift.
Elegant Evesham oven-to-tableware by Royal Worcester.
It's a compliment to your good taste.

ROYAL WORCESTER
Oven-to-Tableware

One of a series of eight photographs taken for an advertising campaign for Royal Worcester. Total photographic fee for the campaign, which was completed in four days: $8,000.

Practically every photographer has a preconceived notion about what he will shoot and what he won't shoot. This is probably one of the most common stumbling blocks to financial success.

Photographers who pursue only fashion and glamour and deliberately neglect to develop their skills in shooting appliances, packaged goods, and catalogue merchandise, will rarely garner riches. If you too adopt a purist point of view, you must also expect to take your place in the ranks of struggling artists.

As the great painters of yesterday were supported by the church and patrons of the aristocracy, so today's commercial artists and photographers are supported by the purveyors of persuasion: the creators of advertising.

It is true that being versatile can be looked upon with a suspicious eye by the artistic fraternity. I recall having an unfortunate encounter with one particular photographer who visited my studio. I had been assigned to shoot a number of pages of a catalogue in an impossibly short period of time and my only hope was to bring in a freelance photographer who would work under my direction. When I asked him if he would undertake to shoot part of the fashion section, he was delighted, but when I suggested he help with some of the product photography, he bolted from his chair and commenced to attack

What it takes to earn $100,000 a year as a commercial photographer. A frank discussion.

my sanity. "How can you do this?" he demanded, pointing to my samples of fashion and product photography pinned on my wall, "You are prostituting yourself!"

Forgive my madness. But I have maintained a gross income in excess of $250,000 a year by shooting everything from Muppet toys to refrigerators, from lingerie to toasters. If I had specialized in fashion, food, or any one of the other popular categories, I doubt whether I would have generated more than $50,000 a year in fees.

Deciding whether or not to specialize may depend, then, upon what you consider adequate income, how much competition you are up against, and where you establish your business.

In New York, for example, where there are dozens of specialists in every category of photography, even the practice of specializing is not sufficient. Here, the photographer who succeeds does so by virtue of creating a unique visual style within his speciality – and then promoting himself with relentless fervor. But New York is always the exception.

Another point should be mentioned. In commercial photography, a decision to specialize carries a heavy price. It not only excludes you from the large volume work of retail advertisers with their continuous flow of advertisements and catalogues, but also from manufacturers who produce an endless quantity of flyers, folders and booklets.

In this business, when a photographer develops a reputation for doing outstanding work, many national advertisers will not hesitate to pay what may appear to be astronomical sums for his particular style. In one case, for example, I was commissioned to shoot six final transparencies for new package designs for the Warner Bra Company. For this assignment, which took one day of planning and two days of shooting, I received $7,200.

Probably the single reason most photographers never receive a chance at high-paying commercial assignments is because their portfolio is ill-conceived and provides only client entertainment. Many photographers attempt to impress a prospective client with their knowledge of special effects and technical tricks, hoping it will demonstrate their creative and artistic ability. But this only results in a portfolio which is completely disconnected from the kind of work they are actually seeking. Such an intriguing portfolio inevitably draws great admiration from the artistic members of any advertising agency, but it seldom leads to commercial assignments. A photograph of a blue butterfly in a goldfish bowl, or a glowing lightbulb lit without any apparent wires, provide for visual entertainment, but will rarely persuade a client to entrust you with his merchandise. Fashion clients want to

see fashion, food clients want to see food, and catalogue clients are relieved when they see imaginative photographs of stereos, watches and calculators. My portfolio is intentionally devoid of photographs of exotic models in alluring fashion, even though one-quarter of my income is derived from fashion photography. Fashion photographers are in far too great a supply for one photographer to stand alone, unless, of course, he has won acclaim for a unique style.

To prepare an impressive portfolio, the best strategy is to develop new ideas for advertisers. This is what opens doors to assignments. Such interest in developing ideas encourages advertisers and art directors to take you into their confidence. It brings them to view you as a problem-solver and this is where you win the most votes.

Another stumbling block which prevents a photographer from succeeding financially is not knowing what his services are worth in the commercial market. Many photographers, especially beginners, undercharge to an extent that is damaging to both themselves and to their profession. I even know of many photographers who will accept less than what the models earn, simply for a chance to do the job. Beginners, also through unfamiliarity with the market and what a job will actually pay, usually quote far less than the fee normally paid for the assignment. Once the realization is upon them, it is often too late. It is difficult to explain later why you are suddenly worth twice as much.

A number of times I have quoted against other photographers and won the job because they actually quoted too low. In one instance, the Hudson's Bay Company invited a number of photographers, myself included, to quote on a 32-page fashion promotion. I quoted $26,900, an amount which was well within competitive rates charged by major studios for a project of this size. As it happened, I got the job. But later, another photographer disclosed to me that he had submitted a quote for $7,000. This was almost $20,000 less than mine! I could not contain my disbelief and when I later pressed the advertising manager for an explanation, I received the abrupt reply, "Obviously, he completely underestimated the amount of work involved. How could he possibly have done it for that amount?"

Ironically, it wasn't that the photographer did not appreciate how much work had to be produced; he simply hadn't realized what the job was worth.

With major department stores, it is not uncommon for the advertising manager or art director to request quotes from up to five different suppliers, especially on large projects. In these cases, studios pit themselves against each other with brutal determination, each trying to outguess the other's quote and each trying to shave their costs to

reach the winning figure. A frenzy of lunching and dining takes place as each representative attempts to build up influence. And freelancers rush to make tie-in connections with large studios so that they too can compete. The competition is ferocious.

How to maneuver through this system requires careful study, and this book is designed to give a photographer an insight into how the business works, how creative people think, and what will be required if one is to emerge a winner.

For example, in dealing with major clients, all large studios know by experience what the acceptable charges are for assignments. Understandably, this knowledge is closely guarded, and the independent photographer has little likelihood of competing for the same business without some idea of the competitor's quote.

Through years of being in the creative business and the photography business, I have come to know what the going rates are for almost every type of assignment, and in chapter III, I have set out the figures which guide all competitive quoting.

But to succeed requires more than an inside knowledge of what the market will bear. It requires a highly developed sense of visual aesthetics. Many photographers never achieve this because they fail to apply the principles of good design. As the world's first instant art form, the lure to photography is understandably overwhelming. An artistic inclination can be immediately satisfied with a snap of the shutter, but this does not automatically raise a photograph to professional status.

If you have any talent for visual communication, it will be seen by the artistic merit in your photographs. And it is this element which separates the amateur snap shots from the professional photographs.

To develop this artistic merit requires an understanding of art, design and graphic communication. The greater your training in the visual arts, the greater your perception becomes. Few photographers realize this.

In commercial photography, regardless of what you are photographing, your success will depend on how well you demonstrate the principles of good design. And you can only learn these principles through study and repeated practice. There is no magic or short cut.

Shooting in the big league.
A professional's curriculum of study.

A summer theme of strawberries and champagne for a cook book. Photographed on 4 x 5 with a Schneider Super-Angulon 75mm lens. Perspective was further increased by tilting the lens plane away from the table. A bank of soft diffused lighting was placed directly above the set and angled towards the camera to allow the light to flood over the table and through the champagne. A double layer of frosted acetate was used as a scrim for the light to create liquid reflections on the violin and clean white reflections on the silver. White reflector cards were strategically placed in front of the set to bounce light back onto the strawberries and onto the gold foil wrapping of the champagne bottle.

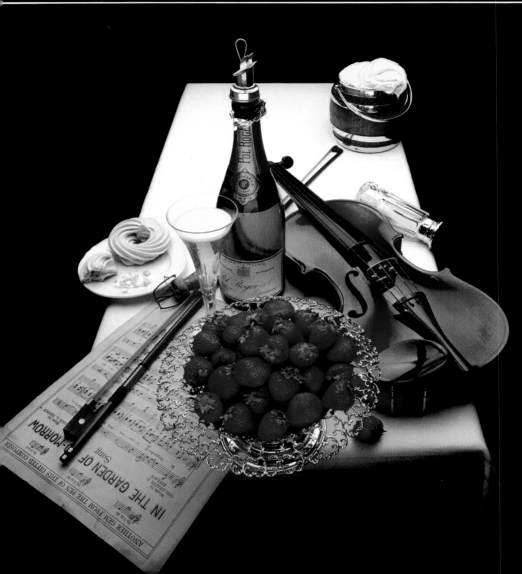

How to create the illusion of depth.
A primer in human vision.

Human vision has one extraordinary ability that a photographer cannot take for granted. It can perfectly focus on two separate images as seen by two eyes, each from a slightly different angle, and marry them into one single picture. Such binocular vision is the key to how we perceive shape, form, and depth, and it cannot be duplicated in photography.

Even a camera with two lenses cannot form one single image. The invention of stereoscopic or 3-D vision was the closest attempt. The twin-lens camera took two photographs, each from a slightly different position, but they still had to be viewed through a close-up magnifying lens corresponding to the spatial difference between the eyes.

With binocular vision it becomes easy to locate objects, to judge distance, and to perceive depth. Try to thread a needle with one eye closed, and you will realize how this loss of dimension handicaps your vision.

The camera lens is also handicapped; it sees with only monocular vision. You cannot fully duplicate this loss of dimension just by closing one eye. The mind helps to compensate for this loss as a result of years of visual experience seeing with both eyes, a process which develops naturally, from the moment of birth.

In addition to the limitation of monocular vision, photography reduces an image to a two dimensional form – the flat surface of the paper, combined with only the appearance of depth within the image. As one critic remarked upon observing the invention of photography, "A camera has the unique ability to turn good wine into vinegar."

Replacing lost dimension.

Photographers soon discovered how to overcome this lack of a third dimension. It was necessary to dramatically manipulate light and shade to convey the illusion of depth. By applying the same principles of light and shade mastered by the great painters, their photographic images began to acquire the appearance of a third dimension.

As all art is a composition of light and shade, so a photographer will find the greatest success by approaching his subject with the assumption that nothing exists until it is created by light.

The classically sculptured shape of the ordinary egg makes a perfect study to demonstrate the basic principles of lighting.

Begin by placing an egg on a white background and with a single light source from above make it appear out of the darkness. Observe how the shadow cast beneath it leaves no doubt that the egg is sitting on the paper. Then direct the light to the front so that the shadow is removed; suddenly the egg appears detached from the surface as if it were floating.

Lower the light to a 45-degree angle and direct it so that it shines like a flashlight on the object; under this hard,

direct lighting, a coarse pebbly texture reveals itself and the egg appears heavy with weight.

Add a second light and the shape becomes confused among the shadows and difficult to define.

Now place a large sheet of tracing tissue or frosted acetate above the egg and flood the set with light from above. With the egg now engulfed in soft, diffused light it appears clean, pure and fragile and its full oval shape emerges from the soft, delicate shadows.

When you have photographic control over the simple, sculptured shape of an egg, when you can render its form with all the various subtle tones of lighting, and when you can do all this with visual clarity, you will have demonstrated an awareness of how to create with light. In such training lies the development of visual perception.

Separating with tone.

To make an object appear detached from the background is one of the technical skills that marks an accomplished photographer.

An object placed against a bright and illuminated background stands out distinctly. Yet if you place the same object against a dark background, the side of the object which is in shadow will cause the object to appear fused to the background. Thus the image will appear to lack depth.

With a white card as a reflector, bounce light to the dark side of the object. This lightens the shadows and makes the object emerge from the background. To achieve depth, it is important to see details in the shadow itself.

Only if the reflected light is insufficient should you introduce a second light source. This second source is often necessary when photographing dark objects against dark backgrounds. In this case, the fill-in light should be used with extreme care so that it does not produce shadows of its own. Its purpose is to relieve the heavy shadows from the main light.

It is wise to keep the tones of an object lighter than the tones of the background, for the eye may interpret dark tones as part of the background rather than perceiving the object.

As the painter Leonardo da Vinci observed on his study of separating and detaching figures from their backgrounds: "You must place your dark figure against a light background, and if your figure is light, place it against a dark background, and if it is both light and dark, put the dark side against a light background and the light side against a dark background."

Applying perspective.

Each eye sees through a viewing angle of approximately 150-degrees. Only the bridge of your nose prevents you from scanning 180-degrees with one eye.

With both eyes, the angle of view overlaps and you have binocular sight along with a 180-degree angle of view.

There is no single camera lens that can duplicate both the angle of view and the perspective of the human eye. With a 35mm camera, for instance, to duplicate the angle of view alone requires a 16mm fisheye lens. But such a wide-angle lens causes tremendous distortion in scale.

On the other hand, in order to duplicate the same perspective and scale that your eye sees would require a 43mm lens. But this reduces the field of view to less than one-third of normal vision.

To create the illusion of depth by using perspective, remember the following:

1. Since distance affects perspective, use a short lens which brings you closer to your subject, and creates more roundness and shape.

2. For more extreme perspective, choose a wide-angle lens which increases depth by increasing distortion.

This allows you to exaggerate shape and dimension. To minimize distortion, place the subject in the center of the lens where the change in perspective is at its minimum.

3. Design your photographs using the artist's technique of vanishing lines.

A wide-angle view at the end of an old, tumble-down gate carries your eye to a rustic farmhouse in the distance. The lines recede into infinity, like railroad tracks, and lead your eye deep into the scene.

4. Contrast size to create depth. In classic still life photographs, small foreground details are often added to attract and fascinate the eye, guiding the viewer through the increasingly larger elements in the composition, and finally into the background.

5. To restore lost space and dimension, re-arrange the components of your photograph specifically for the camera, creating greater space and distance among them. Even wide-angle lenses tend to compress distance and objects and such an adjustment may be necessary. Viewed by the eye, the composition may appear open and loose, but a glance through the camera will usually reveal the objects to be close and tight.

When constructing a photograph, choose a perspective that gives you a clean, strong flow of lines. Design every photograph so that these lines lead to the subject, and travel without interruption. Give the eye the least visual resistance, and it will travel easily through your photograph.

With this knowledge, not only will you be able to create the illusion of depth and dimension, but you will enjoy the artist's satisfaction of creating beauty from even the simplest of subjects.

Cover photograph of model Sam Turkis for *Chatterley* magazine. Shot on 35mm GAF 500 daylight transparency film pushed to 1000 ASA. A strobe head was placed directly behind the model's hair and a soft white semi-translucent umbrella was used in front on the main light. The backlight was set at a ratio of 4:1 over the main light so that it would stream through the hair. During exposure, the shutter was left open for three seconds to allow the tungsten light from the modeling bulbs to shift the color of the image to a warm, golden tone. At the same time, the camera was deliberately moved in a swirling motion to blur the tungsten light and give the effect of painting with light.

Technical testing. A portfolio of knowledge "For Your Eyes Only".

The professional photographer makes one assumption that the amateur does not: in photography, there is no problem that does not have a solution. There is no impossible shot. The only question is how to arrive at the solution in the swiftest manner.

In my studio, I have a number of binders which I keep confidential, and in them are documented the results of all my technical testings, complete with samples of film, prints and negatives. Lighting and exposure mistakes are recorded, as well as visual embarrassments and bizarre effects. For me, the information yielded from these trial-and-error tests is priceless.

Similarly, by documenting your errors, no mistake is ever repeated twice. And you'll find that the results of each new test add immeasurably to your private bank of technical knowledge. To attempt to commit the results of such testing to memory is folly, for the permutations are endless. Thus, only with continuous and systematic trial-and-error testing can you ever achieve technical excellence.

Also, a private reference file is valuable for recording all the technical and creative details of every assignment. In this way, when future and similar projects occur, the technical solutions will be instantly available.

The technique of pushing film.

In pushing film, you actually underexpose the film and then overprocess it to compensate. With high-speed films, this greatly increases the amount of visible grain and produces the grainy images which you see so often on the fashion pages of European magazines.

To push film one stop, you double the ASA of the film. Set your camera's ASA to this number and then expose your film as if it were at that speed. For each stop you push your film, you must double your ASA. For example, to push 400 ASA to 800 ASA is one stop, 1600 ASA is two stops, and 3200 ASA is three stops.

There is no set formula for push-processing. The amount of extra time to increase processing depends on the characteristics of the film and the developer. But as a guide, most professionals begin by adding 50% to the normal processing time for each extra stop. If the normal processing time is eight minutes, for example, and you wish to push your film one stop, you will need to process for twelve minutes. For two stops, you will need to process for an additional four minutes – or sixteen minutes total.

If you find the density too great, for your preference, and therefore the contrast too high, cut back the development time. (Some labs add only two minutes extra for each additional stop.)

During push-processing of any film the extra chemical activity forces the exposed silver crystals to swell and clump together. This makes the grain pattern considerably more pronounced. Even if you extend push-processing further, you will not achieve significantly greater grain, for every film has its own characteristics – and limits. Extreme development will only chemically force the unexposed silver crystals to become processed – which in turn will eventually fog the image and make it unprintable.

With color film, according to Kodak you cannot push Ektachrome more than two f-stops, or color negative film more than two-thirds of an f-stop, before the image quality suffers irreparably.

Kodachromes are not suitable for push-processing because of their unique emulsion characteristics and if the processing time is altered even slightly, the color will collapse. For this reason, Kodak usually refuses any request to push-process Kodachromes.

Also, with all slow-speed films, whether color or black-and-white, the grain structure is so fine and tight that push-processing produces only a barely discernible difference. But on the other hand, the higher the film's speed, the coarser its grain structure and therefore the greater the potential grain obtained by overprocessing.

Pushing film also greatly increases contrast. With black-and-white film this can be very effective. But with color film, overprocessing not only increases contrast, but affects the color balance of the film. Even a one-stop push can cause a noticeable color shift, depending on the emulsion. By experimenting with Kodak Color Compensating filters, known as 'CC' filters, you can usually restore color balance satisfactorily. If test results lead you to anticipate a slightly greenish cast, expose with a CC05-or CC10-magenta filter in front of the lens to absorb the cast. Pushing film successfully is largely a matter of testing, documenting your results, and producing your own formula for the effect you want.

Pushing film, either color or black-and-white has other advantages: it allows you to work in low level light and it gives you a higher shutter speed than the film would normally allow. This is especially useful when shooting fashion or any sports action where there is insufficient light.

However, you should observe one caution. Because you are intentionally underexposing, a certain amount of shadow detail is lost and cannot be replaced by an increase in development. Push-processing cannot produce an image where none exists.

To obtain the maximum amount of grain with any film, concentrate on flat lighting, and low contrast scenes. With black-and-white film, bear the following in mind:

If the scene is low in contrast, mostly grays with few blacks, you may be able to push the film up to three stops. But if the scene is high in contrast, ranging from bright highlights to deep black shadows, push-processing by one f-stop produces negatives of such high contrast that they become extremely difficult to print. Selecting subjects of low contrast is therefore the key.

High speed developers such as Acufine are available to help reduce the rapid increase in contrast by raising the fog level in the film during processing. In this way, a wider tonal range is retained in the final image. These high-speed developers also have the additional benefit of reducing the inconveniently long processing times involved.

With color film, each color lab has their own formula for the amount of time to be added for push-processing. For consistent results, process with the same lab where you had your test roll developed. If you are on location, and this is not possible, ask the lab for a clip test. This is a matter of having them process only the first few inches of a roll of film for you to approve. If the test indicates that the film is too rich and has too much contrast, speak to the lab technician about increasing the processing time on the final run. Or, if

the film appears thin and overexposed, direct the lab to 'drop back' the processing time.

Of all the technical tests that I have conducted, the following yielded the most valuable information. These tests not only reveal how to produce the maximum amount of grain in an image, when it is desired for artistic effect; but also how to virtually eliminate grain from a print when a client requires a completely grain-free image. Also included are tests that will reveal how to control contrast and how to obtain maximum color saturation – all skills that no high-paid professional should be without.

Test no. 1
To achieve maximum grain in black-and-white film.

1. Expose and process three rolls of 35 mm *Kodak Tri-X Pan Film*: one roll at 400 ASA (normal), one at 800 ASA (push one stop), and one at 1200 ASA (push one and a half stops). Expose each roll under a variety of lighting conditions, ranging from soft, flat lighting, to hard, high-contrast lighting. Include a model in these tests as it allows you to determine the effect of grain on skin tone. Process the film in Kodak D-76 film developer, adding 50% more processing time for each additional stop.

A little girl kissing dad was the theme behind this photograph for a Father's Day promotion. To place the visual emphasis on the little girl, colored ribbons were added to her hair, and the male model was allowed to graphically merge into the background by wearing a black turtleneck.

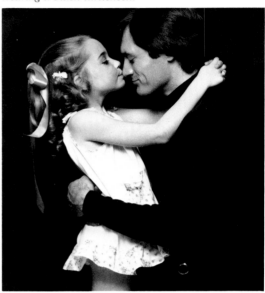

You may wish to experiment with pushing Tri-X to 1600 ASA or higher, but from my tests I have found no significant increase in grain above a two stop push, and only extreme difficulty in printing due to the excessive density of the film.

Print a set of contacts and pull a range of test prints on 8 x 10 paper. Blow up a small section of a negative from each roll to determine the maximum size of grain you can produce through enlargement.

2. Expose and process two rolls of 35 mm *Kodak Royal-X Pan Film:* one roll at 1250 ASA (normal) and one roll at 2500 ASA (push one stop). At this high film speed, you may find that you need a neutral density filter on your lens to cut down the light. On this point, note that a 4x neutral density filter reduces the light by two stops.

Follow the lighting approach suggested with Tri-X, and compare the results. On all tests, record your lighting and exposure details on a technical test sheet which can then be stored in a 3-ring binder, complete with negatives and sample prints.

Test no. 2
To achieve maximum grain in color transparency film.

Expose three rolls of 35 mm *Kodak Ektachrome EL Film:* one roll at 400 ASA (normal), one at 800 ASA (push 1 stop), and one at 1200 ASA (push 1-1/2 stops).

When pushing color film, bracket your exposures by overexposing. This will help prevent the darker tones and deeper colors from plugging-in due to the increase in contrast. Shoot the first frame according to your meter reading. Over-expose the second frame by half a stop and the third frame by one full stop.

For processing, mark the film cartridge "Push 1" or "Push 1-1/2". This is all the lab needs to know.

Pushing film represents a departure from standard processing, and you will probably be charged double; it depends on the lab. Locate the labs used by professional photographers. They will be used to custom service and push-processing film will be a matter of course for them.

I recommend against having test film mounted. With the roll of film intact, you can view the entire strip at a glance and easily coordinate the sequence of pictures with your technical test sheet notes. You can also pull the entire strip through your enlarger so that you can study, in rapid sequence, the effect of grain over the entire range of images.

Test no. 3
To achieve the least grain and the finest detail in black-and-white film.

1. Expose and process one roll of 35 mm *Kodak Panatomic-X Film* at 32 ASA (normal) and one roll of 35mm *Kodak Plus-X Pan Film* at 125 ASA (normal). Choose a variety of subjects that contain detail and texture and photograph these objects on a light to medium gray background.

When working with natural light, use a tripod to obtain the highest degree of sharpness and select f-stops in the mid-range where lens resolution is at its peak. Include a few head shots on each roll. Nothing reveals differences in film quicker than photographs of a face.

2. For 2-1/4 format, repeat this study using *Kodak Panatomic-X Professional Film, ASA 32*, and then compare the results with *Kodak Plus-X Pan Professional Film, ASA 125*. These are the finest grain, black-and-white films available for 2-1/4 format.

3. On 4x5, the preferred film is *Kodak Plus-X Pan Professional Film, 4147*. This film has very fine grain and an exceptionally high degree of sharpness.

In this test, photograph an object on white no-seam and arrange the lighting so that the background receives as much light as the object. This can be achieved by placing the object as close to the background as possible and lighting with a broad source of light, such as from an umbrella or through a large scrim.

Pull a print of your exposure. If the background comes up slightly gray, increase the paper contrast to knock out the tone, bringing it back to pure white. With a correctly exposed negative, usually a no. 2 grade will be sufficient to achieve this.

Test no. 4
To achieve maximum color saturation and detail in color transparency film.

Achieving maximum color saturation is primarily a matter of critical exposure. With color reversal film, saturation increases with underexposure. Over-exposure washes out color. When transparencies are required for reproduction, it is not surprising that most art directors request that you provide them with bracketed exposures. In the photo-mechanical process of making color-separations, a darker transparency can always be 'cut back' to reveal cleaner colors. (This is usually done by reducing the density in the black layer.) But to add color is a difficult and costly process

which few clients will entertain. Such transparencies not only reproduce poorly, but if models are in the photograph, skin tone appears unpleasingly pale.

To discover how to achieve maximum color saturation and the finest detail in color transparency film, undertake the following tests:

1. Expose one roll of 35 mm *Kodachrome II Film, ASA 25*, which is the slowest of the Kodachromes, and one roll of *Ektachrome EPR 64*, the slowest of the Ektachromes. The differences will often be remarkable. Expose each roll under a variety of lighting conditions. Shoot half the roll with flash, and half outdoors with available light. The more variations you experiment with, the more knowledge you will draw from the results.

In the studio, include test frames with umbrella lighting and hard, direct lighting. This will help reveal subtle but important differences in the qualities of each emulsion.

As a suggested studio set when shooting with a model, use a light to medium gray no-seam background with a large white box as a prop. Color differences between the emulsions, and color balance of the film, will clearly show up in the gray, and the white area will help you assess exposure more critically. If the model is wearing a colorful outfit, this will help you determine the color differences, as well as a degree of color saturation.

With outdoor lighting, a good test with a model would include facing the model directly into bright sunlight and into late afternoon sunlight. Include an exposure with the sunlight behind, exposing for the front of the model. Also, place the model half in sunlight and half in shadow; then expose one frame by averaging the reading, expose a second frame by reading for the shadow, and expose a third frame by reading for the highlight. A valuable test on its own.

2. With a 2-1/4 camera, expose a roll of *Kodak Ektachrome EPR 64*. Again, use a model in order that you can critically assess skin-tone color. Here is a suggested shooting sequence:

Frame	Lighting	Exposure	Filter
1	Single umbrella	–1/2 f	—
2	Single umbrella	normal	—
3	Single umbrella	+1/2 f	—
4	Twin umbrella	–1/2 f	—
5	Twin umbrella	normal	—
6	Twin umbrella	+1/2 f	—
7	Direct strobe	–1/2 f	—
8	Direct strobe	normal	—
9	Direct strobe	+1/2 f	—
10	Direct strobe	normal	+10R
11	Direct strobe	normal	+10M
12	Direct strobe	+1/2 f	10M + 10R

3. With a 4x5 camera, expose six sheets of *Kodak Ektachrome Daylight Film 6117, ASA 64*. Use soft lighting, bounced through a large scrim as described in the lighting section on pages 46–59.

Select an object that is colorful and three-dimensional, such as a pot of flowers, and shoot it on a table top with white no-seam as a background. Place Kodak Color Control Patches in the foreground, positioned so that they receive the same amount of light, and angled to avoid any reflective glare. Place an information card beside the object, describing the technical details: film, normal meter reading, actual f-stop exposure – and change the notation for each exposure.

Expose critically to within 1/2 an f-stop. Do this by adjusting the light so that the meter reads an exact number. Shoot three sheets with bracketed exposures. Then change the background to black. Re-measure the light as there will be less light reflecting back from the subject. Shoot another three sheets also with bracketed exposures. You will find that by shooting on black, a tremendous amount of light is absorbed, and therefore you will have to compensate by opening the lens an extra 1/2 to 1 f-stop, or by adding a generous amount of fill light. These are important results to document.

Before an assignment.

Once you decide on the film for an assignment, purchase a sufficient quantity of the same batch number, as the emulsions may vary slightly from one batch to another.

Always inspect the description sheet that comes with the film. Never assume that because a film is commonly rated at ASA 64 that every batch will maintain this speed rating; it could be re-rated to 50 ASA.

A few times, I have had color film shift slightly towards green or yellow. This was the result of the film being exposed to excessive heat or moisture at some point. A slight magenta cast is also possible as a result of such neglect.

To maintain the delicate color balance of film, you need to store it below 13°C (55°F). Unless you purchase your film directly from the store's refrigerator, you have no way of knowing if it has been properly stored. Professionals always pick up their film from a color lab or camera store that takes these precautions. Always buy "right out of the fridge".

Before using color film, remove it from your refrigerator and allow it between one and three hours to warm up. Do not break open the moisture-proof wrap until it has reached room temperature, otherwise moisture will condense on the cold film surface. This can affect the contrast as well as the color balance. Cold film is also slightly slower in speed, and this will affect your exposure. A glance at the processing times given with Polaroid color film will reveal how sensitive a color emulsion layer is to temperature.

*Fabulous model Kerry Jewitt photographed for a
double page spread of cosmetics. A strobe flash head
was placed directly above the camera lens and a
300mm telephoto lens was used to give the image
graphic compression. The background was actually a
fabric with a foil sparkle weave. Shot on 35mm
GAF 500 transparency film and pushed one stop to
further increase the film's grain structure.*

Developing your trademark.
Key to commanding $2,500 a day.

What is it that makes one photographer's work so outstanding and different from the rest? Is it merely technical ability?

If you study the work of the great photographers – Avedon, Penn and Turner, for example – it becomes apparent that it is not what they shoot, but how they shoot it that makes their work so memorable.

All photographers who have risen to such acclaim demonstrate a unique style in their work, a way of seeing which belongs only to them. It is this strikingly personal viewpoint that immediately identifies their work and becomes their signature.

David Hamilton's soft, romantic images of young girls are in a class by themselves. His books *Dreams of Young Girls*, *Sisters* and *La Danse*, for example, are instantly recognizable as the work of one photographer. Sarah Moon's timeless, turn-of-the-century period scenes in her fashion photographs are her trademark. And Pete Turner's powerful graphics are his calling card.

With commercial photography, one's style will usually vary depending on the category. For example, with food photography, I concentrate on classic still life compositions based on the

Developing your trademark.
Key to commanding $2,500 a day.

Quietly simple and carefully composed photographs are always my first inclination when shooting fashion. For me, it has almost become a trademark in my work. For a shoot on children's fashions, camera and portable strobe were taken into a children's school with permission of the headmaster who was delighted to see some of the children not only earn a little extra pocket money, but have the benefit of the experience.

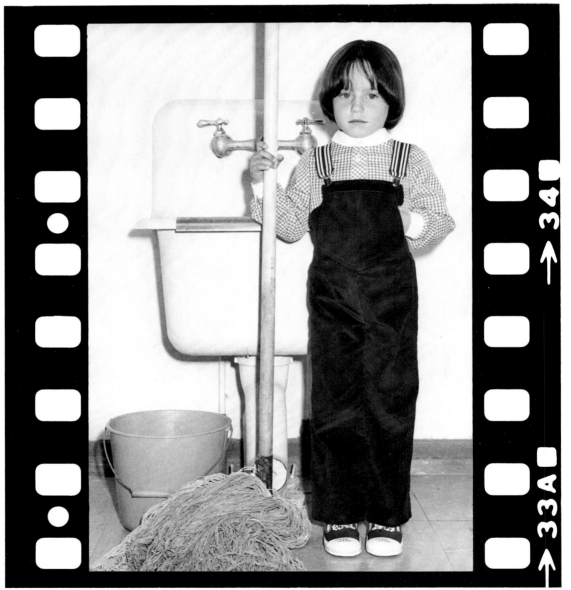

influence of the 18th century Dutch painters. For product photography, I place more emphasis on a graphic style where I can use strong lines and perspective to give greater dimension than you would normally see. Or for fashion photography, I often include birds, animals or musical instruments to add story atmosphere. In all, this is what I am known for.

With advertising agencies, I have consistently been paid $2,500 as a 'day rate' to work on such projects, an amount which may often be for only a single photograph.

Naturally, you cannot always execute your own individual style. It is a matter of what the layout dictates, or what the client permits. But your style is what gains you recognition. And most art directors will select photographers whose style and visual preferences match the projects they have in mind.

Even though a layout and a specific set of instructions may be provided, a client will expect you to interpret these ideas, and to add the creative touch or inspiration which marks your style. After all, when a client is paying $1,000 and more for a single photograph, he is expecting more than just technical skill.

In the end, success in our profession goes to the few who take the pains to cultivate a style and then polish it to perfection.

The most important decision you make as a photographer lies in the execution of the photograph. How will you shoot it? Which way will have the greatest impact? How will you create a visual story.

As you strive to find a solution, your mind may wander through different schools of photography – graphic, classic, surreal, editorial. From this process of creative evaluation, you will discover that you come to prefer one approach over the other, the one which inspires you most. And as you find your own individual creative expression you will come to perceive and to interpret things in a very personal way. This is the beginning of the development of style.

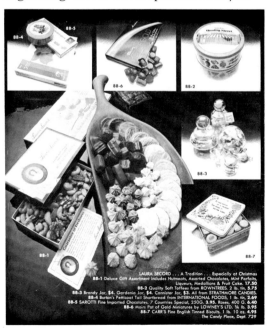

No two photographers will handle the same project the same way. What differentiates them is their own particular approach, or their own individual style. My own particular style is for strong lines and perspective and geometric composition, which this advertisement demonstrates.

In this editorial photograph of ingredients for spaghetti sauces, an almost Oriental style graphic was created. A red rim was painted around the bowl and green noodles were added to the presentation. A spattering of green pepper seeds, with each seed placed in position with tweezers, gave the image visual motion. Shot on 8 x 10 format to obtain maximum detail and color saturation.

1. Graphic.

In creating graphic images, place your visual emphasis on one-dimensional design. Strive to make your photographs communicate with the visual power of a stop sign. Regardless of your subject, determine how to distill it to graphic simplicity.

Graphic photographs draw their strength from: (1) arresting symbols, (2) vibrant color, (3) forceful lines. To emphasize graphic design, place visual importance on shape. To keep the image on a one-dimensional plane, eliminate depth by using direct or shadowless lighting. And to give it graphic impact, compress your subject with a telephoto effect. The final *coup d'etat* is a courageous crop.

Choose the purest colors and create vibrant contrast: hot red on vivid green, bright yellow on deep blue. In the absence of a complimentary color scheme, black can be the most effective background to contrast color against.

For visual symbols, use the human component. A woman's luscious red lips, glossy red nails, or stark futuristic face; these are particularly effective elements in photographing jewelry, cosmetics and beauty products.

Developing your trademark.
Key to commanding $2,500 a day.

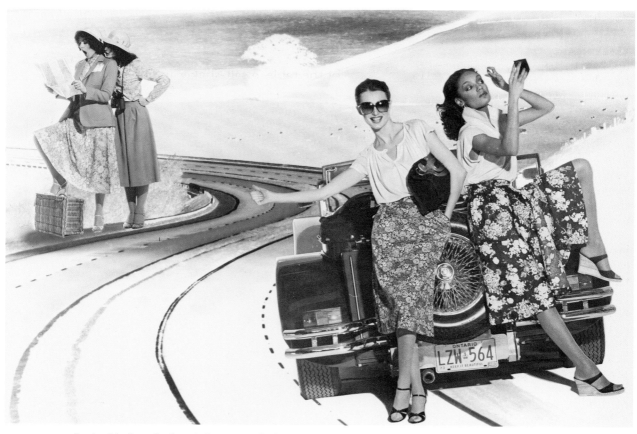

In this black-and-white fashion spread, the
background was shot separately and printed directly
from a color transparency to produce a black-and-
white negative image. The models and car were
stripped in on top and the result was a surreal effect.
Final printed image was reproduced in sepia tone.

2. Classic.

If you have an interest in classic art, you will gravitate naturally toward this approach. You may find that you tend to solve every photographic problem with a classic still life solution in mind, and as a visual romanticist, art books will then become a limitless source of inspiration.

In fashion photography, you may find yourself continually abandoning the stark reality of your studio in favor of the romantic images you can create among tumbling country-sides, quaint cottages, farms, and winding country lanes. You may also find you come to prefer the soft natural light diffusing through a window, or the warm glow of late afternoon sun rather than the cold, artificial light of the studio strobe.

To heighten this romantic theme, select an extremely high-speed film, not only for its speed in low level light, but for the grainy appearance it gives the image, imitating the pointillist technique of the French Impressionists.

Muted, neutral backgrounds add to the painterly effect, and by directing models to relate to the environment and not to the camera, you will increase their naturalness in the photograph; this is the essential ingredient if the viewer is to have the feeling of peering into a private world.

With product and food photography, another technique of the classic painters may be borrowed: visual tension. Here, objects balance precariously at the end of the table, a salt-shaker in a food shot is discovered to have accidentally tipped over, spilling grains of salt, an egg has rolled out of its basket, and cherries have tumbled from their bowl. In still life photographs, the secret often lies in creating organized chaos.

Antiques and mementos are added to mark the passage of time, and personal objects – a pair of spectacles, a pocket-watch, Victorian photographs – each reveals a tiny portion of the lives and events of people in these story-like settings.

3. Surreal.

Surrealism, on the other hand, is futuristic. It questions all reality and reassembles it into a new world. It is visually jarring. A window in the sky, tubes of lipstick orbiting the earth, a package of cigarettes sitting mysteriously in a gold bird cage. These photographs challenge the imagination and are frequently used in commercial photography.

To create these kinds of images, you will need to experiment with rear screen projection and with sandwiching different images together.

You can obtain astronomical transparencies from a planetarium or museum, and further add to your working material by photographing natural phenomena in the night sky, including sunsets, cloud formations and the moon in its different phases. Transparencies of faces or products can be stripped in or superimposed over these spectacular images. A good working relationship

For a cover on cough syrups for Drug Merchandising, a pharmaceutical magazine, four white disposable plastic spoons were used with a different cough syrup on each. The lighting was adjusted until it gave a well-shaped highlight on each spoon which was necessary to convey the appearance of liquid.

with a technician in a color lab is a must for achieving many of these striking effects.

Collect unusual small things: a mouse-trap on which to photograph an expensive ring or watch; a sardine tin that opens to reveal deep stellar space, all made possible simply by stripping one transparency into another.

Experiment with size relationships. Create a room in miniature, six to twelve inches in height. Increase perspective by angling the floor, ceiling and walls 45-degrees towards the camera. This will cause the room to appear visually larger, deceiving the eye of the room's true size. In this miniature set any number of things may be placed and photographed – a silver evening shoe, a cocktail glass, a strand of pearls – all become exotically appealing when the mind sees them in a scale which causes them to appear larger than life.

To increase your visual story even further, add a miniature window frame to the back wall and strip in a picture of clouds drifting by, or a lunar landscape, or a person's eyes surveying the interior. In surreal, anything is possible.

4. Editorial.

In creating advertisements, most art directors will rely on real-life situations to add credibility. In television commercials such situations are known as 'slice-of-life', and creating believable scenes around a client's product is a proven method in the art of persuasive advertising.

With photography, humor is often the basis to make the story more believable. A pot-bellied beer drinker pointing to his stomach in a Bromo Seltzer advertisement is not without endearing qualities. And this approach will undoubtedly give the ad higher recall than simply showing the package on its own.

In adding samples to your portfolio, invent playlets or scenes that could be used in advertising. Concentrate on visually demonstrating the proposition in the advertisement.

No photographer who wishes to succeed photographing people and real-life situations should be without a volume on Norman Rockwell's paintings. His settings are remarkably believable and every detail reveals a glimpse into the life of the character. The simplest human emotion sparkles with life as if he had snapped a shutter at the perfect instant.

In Rockwell's compositions, study how the lines of the one body flow into the lines of the other. Appreciate how all human movements and expressions are intentionally exaggerated. Notice the tightness and compactness of his compositions. Not only does Rockwell's work represent a good source for inspiration, but it will heighten your sense of composition immeasurably, and greatly influence your ability to tell a story in a single picture.

Poster for the Toronto-Dominion Bank. The photograph was designed in the tradition of a Rockwell painting with numerous little visual stories contained within the composition. The shot took two days to prop and three hours to photograph. Total charge for photography: $2,500.

With retail advertisements for the Hudson's Bay, a wide angle approach was used to give a distinctly different appearance to their advertising. By having established this single visual style at the outset of the campaign, more time could be spent on the creative design of each photograph without repeated concern for technical execution. Practically every advertisement was photographed on 4 x 5 for maximum perspective control and with a 75mm Super Angulon Lens.

How to shoot with style.
A study in design and perspective.

When I was first commissioned to undertake the photography for the Hudson's Bay Company, I was faced with an awesome task: how to create an entirely new look for their advertisements. The art director encouraged me to break with the traditional catalogue approach of retail advertising and to show merchandise with more imagination and style. I set myself the task of creating a stylized form of perspective, and laid out the following notes to myself:

1. Construct every photograph so that it flows from a point at the top, and reaches out to the viewer at the bottom.

When you embark on this wide-angle approach to product photography, your greatest concern is to maximize the three-dimensional perspective, but at the same time minimize distortion. This can be achieved by (1) keeping the product or subject in the center of the lens where distortion is least, (2) allowing unimportant details to recede into the background, and (3) using the edge of the lens to exaggerate both the foreground and the visual lines of the subject, in order to give the photograph its graphic style.

Some art directors will overlap the peak of the photograph onto the heading, giving the photograph even greater dimension on the page. This design has the advantage of drawing your eye naturally up through the photograph and into the heading.

This geometric style of photography, when linked with type, is extremely effective. It established a unique look for the Bay's national advertising, one that made their photography distinct from that of other department stores.

Although layout and page design are the art director's domain, an understanding of these techniques will serve you well.

2. Allow for type areas. And make the type itself an integral part of your composition.

To make certain you leave a sufficient amount of space for the type indicated on the layout, scale down the layout on a piece of tracing paper and place this over the focusing screen on your camera. Or alternatively, have a stat house duplicate the layout onto a piece of clear acetate film sized to the proportion you need and use this over the focusing screen instead. This is a standard procedure when shooting with a 4 x 5 or 8 x 10 camera and is equally worth the trouble with a 2-1/4 format.

With the layout now superimposed over your image area, you can compose your shot to fit the proportions of the ad perfectly, and adjustments can easily be made to accommodate type.

3. Shoot from a high angle which duplicates the reader's natural viewpoint.

The objective is to make the product appear to be sitting right on the news-

In soliciting any retail account, it is profitable practice never to quote your day rate, which would probably be considered unaffordable, but rather to quote on a volume basis. Six ads may be considered minimum volume. These photographs were invoiced at $400 each, a volume discount on a minimum of 12 advertisements. Retail is strictly bread and butter income.

paper, as though you could lift it right off the page.

To achieve this, the natural viewpoint of the reader must be taken into account. For example, when thumbing through a newspaper or magazine, your natural viewpoint is an angle of view of approximately 45-degrees; this is the angle to duplicate with your camera, especially when applying the perspective of a wide angle. Presented in this manner, such photographs are visually startling to the viewer because they appear almost three-dimensional.

4. Dress every product shot with atmosphere and real-life details.

If you are photographing an electronic calculator, one way to convey its range of mathematical and scientific functions is to place it on a set of scientific draftsman's plans, as a background.

When photographing cookware, hold the viewer's attention by showing a red lobster plopped into an open pot. Fill kitchen containers and cookware to the brim with fruit, pasta or vegetables, for they lack appeal when left empty. With cups of coffee or tea, add flakes of dry ice at the moment of shooting, to create bubbles and steam for a freshly poured look, or just add bubbles with a syringe.

Luggage photographed on its own often lacks visual appeal. A puppy snoozing in the foreground, with its leash coiled around one of the bags, may be one solution. Sleeping bags can be shown with children warmly nestled

inside. When touches like these are added, photographs spring to life.

5. Light for maximum shape and form. And print for contrast.

The position of the light is always a trial-and-error procedure. To give maximum shape and form, pay careful attention to where the shadows fall. To enhance the three-dimensional form, a strong tight shadow should embrace the bottom of the object. Without this shadow, an object appears to be floating, and all dimension which gives it reality, is removed. Some art directors actually remove these shadows, opaquing them out, not realizing that shadows are the most important element in conveying dimension on the page, and consequently, the image lacks depth.

When the subject is photographed on white no-seam, the half-tone screen should be applied only to the subject and to the foreground shadows, causing the background to drop out completely. This gives the photograph even more impact. Some inexperienced art directors make the mistake of screening a white background. This produces a gray background, reduces the contrast, and makes the image appear flat.

Most newspapers have such abysmally poor reproduction that every shot must be lit for maximum contrast. Often, with small table-top shots, the light has to be placed within inches of the set to increase contrast and to create a tight shadow at the base of the object. Exposure is taken from the highlight area, so that in the print the shadows

show up rich and dark. During processing, the film may be given a slight push by adding five to ten seconds to every minute of development time, increasing the contrast still further.

The essence of good advertising is a persuasive message stated with credibility. Your task is to create stopping power and to demonstrate visual salesmanship. When studying advertising, concentrate on how these objectives are obtained. By so doing, your judgment will quickly sharpen.

II
On the mastery of technique.
The pursuit of excellence.

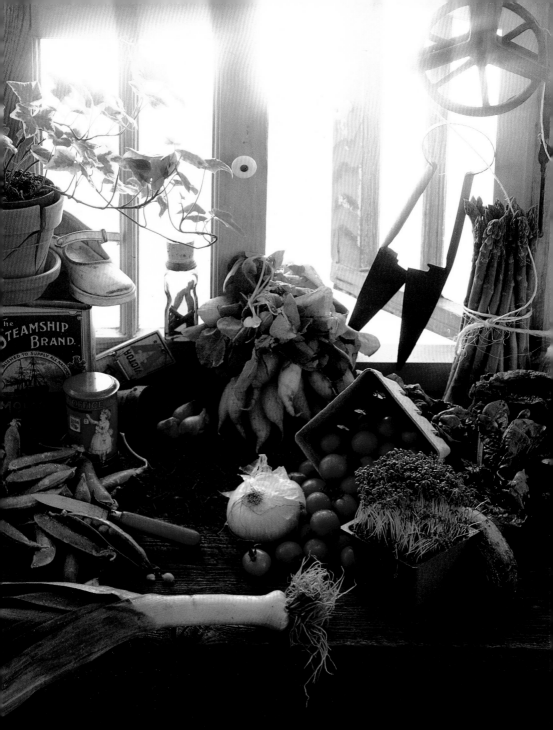

A crash course in lighting.
The finer points explained.

As a beginner, the business of lighting struck me as being awesomely complex. In search of inside knowledge, I managed a tour of a large photo studio. From an inside balcony, I viewed a space the size of an arena where dozens of photographers and assistants quietly went about their work, each within their own cubicle of space.

Watching each photographer silently and skillfully arrange his lighting was an almost mystical experience. Hundreds of pieces of lighting equipment lay at their command, and no two pieces seemed identical. How to choose the right light, let alone how to use it, was a matter which only caused me confusion, and my curious eyes gleaned few secrets. I left the studio under the delusion that years of apprenticeship would have to be served to acquire such coveted knowledge.

But I chose not to take the path of a dutiful assistant. Instead, I clung to magazine articles and books which demonstrated the principles of lighting.

For a photograph of fresh-picked vegetables, a gardener's shed theme was used. The set was constructed in the studio using miniature pine windows found in an antique shop and a plank of old gray barnwood made up the ledge. The rust colored earth was a type of peat obtained from a gardening center. To duplicate bright sunlight streaming through the window, a large scrim was placed behind the window and bounced lighting was directed through it. A slight smear of Vaseline on the camera lens gave more visual intensity to the light. A large white reflector card was used in the foreground to reduce the lighting contrast.

I sought judgment of my work from photographers whose work I admired. I elicited technical information from lighting technicians wherever I could find them, and I conducted endless tests until my book of technical testing grew thick with experimenting. Gradually, the mystery unfolded.

Lighting, on a scale.

All lighting fits into a scale, ranging from the beautifully soft, diffused light streaming through a window, to the harsh, glaring light of a bare bulb. By understanding the differences and effect of each form of light, you will come to know instinctively which light to choose.

In commercial photography, transparencies need the maximum degree of color saturation if the ultimate in color reproduction is to be attained. The most effective way to achieve this is with soft, diffused lighting.

1. Diffused lighting.

The softest light is created from bouncing light into a reflector and then diffusing it through a sheet of frosted acetate or mylar. Layers of tracing tissue may also be used to diffuse light, as well as gauze, window sheers or even a white bed sheet. In this manner, you can create the same kind of soft, delicate north window light which has inspired painters for centuries.

One lighting unit which perfectly duplicates this form of light is known as a Broncolor Hazy, developed by Braun

47

A crash course in lighting.
The finer points explained.

For a series of advertisements for Stuart Crystal, the crystalware was photographed on a matt black arborite surface and diffused lighting from above was angled to place highlights and reflections along the edges. Photographed on 4x5 with Kodak Plus-X Pan Professional film, 4147 and tray processed to retain delicate glass appearance in negative.

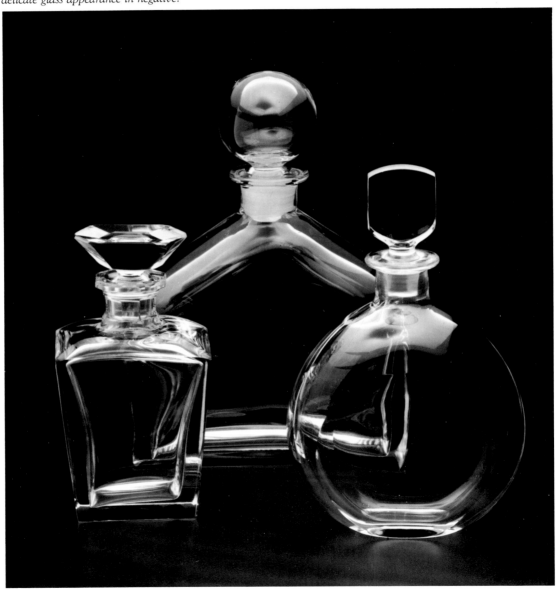

of Switzerland. This type of lighting equipment is also known as a 'box light' and has become extremely popular for studio lighting among commercial photographers.

Inside the reflector shell of the Hazy, four flash tubes bounce the light into a separate, small reflector in the center, which in turn, bounces the light back into the silvered interior. The final bounced light then passes through a diffusing screen made up of two sheets of frosted mylar. This is the softest light you can produce.

Understanding how simple the principle is, it is not difficult to make one of these box lights yourself, as many photographers have done, although there are claimed to be mathematical formulas involved in designing the most efficient reflector shell.

This form of diffused light produces deep, rich shadows which can be most effective in establishing atmosphere in a photograph. Even the square or rectangular reflection of the light itself adds dimension to the photograph. It gives luster to jewelry, shape to bottles, and a clean white highlight to silver, chrome and other reflective surfaces. There is no limit to the versatility of diffused lighting and it is usually the first choice of lighting for commercial product photography.

2. Umbrella lighting.

Bounced umbrella lighting is next down the scale. A strobe head aimed directly into an umbrella produces soft, practically shadow-free lighting. This lack of shadows is also due to the wide dispersion of light. For shooting fashion, the umbrella's soft, wide-angled source of light makes it overwhelmingly popular.

Strobe lighting may also be bounced off ceilings and walls, simulating the effect of light from a giant umbrella. When a room or large set needs to be flooded with light, this is a particularly effective way to achieve it.

Fundamentally, there are four different kinds of umbrellas. The softest lighting is achieved with the simple white umbrella, usually made of translucent white material. Because the umbrella is translucent, you may also turn it around, facing the back of the umbrella towards the subject and fire the flash through it. This produces a delicate, soft fill light.

Another style of umbrella has stripes or wedges of reflective silver fabric stitched to the inside, and this produces crisp lighting. Such an umbrella is aptly named a Zebra by its manufacturer Balcar.

For greater sharpness and contrast, a completely silvered umbrella is recommended. However, the increased contrast of this lighting makes it more effective in black-and-white photography than in color.

There is also a gold surface umbrella, designed to add warmth to the cold, bluish-white light of the strobe, giving a more pleasing color to skin tone.

The size of umbrella is another important consideration. When the scale of your shot is the complete human figure, the jumbo umbrella is recommended. These average two meters in diameter. With such a broad light source, the light is more evenly distributed over a wide area.

When an umbrella is being used for close-up portrait work, the reflection of both the umbrella mounts and ribs can be seen in the subject's eyes. This distraction can be removed by attaching a translucent diffuser over the front of the umbrella. This also has the advantage of further increasing the softness of the light.

3. Direct lighting.

With the umbrella removed, and the strobe light aimed directly towards the subject, the quality of light becomes harsh. But this can be its very advantage.

Placed at a distance, for example, and at an angle of 45-degrees to the subject, this source of direct light duplicates the effect of bright sunlight with its long, hard, crisp shadows. Yellow and orange filters may be placed in front of the light to convey the atmosphere of late afternoon sun.

Reflector heads are chosen to control the angle of light. Depending on the shape of the reflector head, every conceivable form of direct lighting may be created, ranging from the broad beam created by the pie-shaped reflector to the narrow shaft of light created by the snoot attachment.

Direct light can be manipulated even further. With a Balcar grid spot clipped to the front of the reflector head, you can create dramatic light fall-off. The grid spot is shaped like a disc and its screen resembles a honeycomb pattern in design. The light is brightest from the center, gradually fading towards edges as it changes its optical axis through the grid. These grids are particularly effective in fashion photography for they allow you to create visual emphasis by the use of light alone.

Spot lighting approaches the end of the scale for harshness. As a spotlight, it throws a concentrated beam, much like a flashlight. It produces smaller, sharper highlights, and darker, harder-edged shadows. As the effect is more dramatic, spot lighting is normally used as an accent light or to project colors onto a background.

To soften the shadows from a spotlight, screens, grids, or heat-resistant fiber cloth may be used.

With Balcar's Opalite lighting system, the mylar diffuser not only softens the light but warms it up by approximately 150° Kelvin.

In working with any form of direct light, it is always good practice to clip barn-doors onto the reflector to prevent light spill or lens flare.

All front lighting was eliminated to achieve the effect of the model being engulfed in sunlight. One strobe head was aimed directly into a background of medium brown no-seam, which was placed about six feet behind the model, and the meter reading was taken directly in front of the model. A six foot foam core reflector board was set up two feet in front of the model to eliminate any shadow cast. With this technique, the strobe flash burned out the brown background through overexposure leaving only the lighter tones of yellow and orange to be cast into the light. This reflected light duplicated the effect of sunlight and enhanced the color of the model's skin tone. Shot on 35mm with a 200mm Nikkor Zoom lens. Film used is GAF 500 pushed one stop but similar grain structure can be achieved using Kodak Ektachrome 400 pushed 1-1/2 stops.

How to warm-up electronic flash.

Electronic flash has two peculiar problems which the professional must attend to.

The first problem is the excessively high degree of ultraviolet light produced by the intense electrical discharge of the flash. Unless your flash is color corrected, this may cause the white area in your transparency to appear slightly bluish-gray. A white shirt, for example, may appear dirty.

Although the cast may seem slight on the transparency, the problem becomes magnified when the image is blown up or converted into color separations.

A UV or skylight filter on the lens helps to correct this problem by absorbing a percentage of the UV. In addition, you may wish to use a Kodak Color Compensating filter in front of the lens. A CC05 or a CC10-yellow should filter out any remaining blue cast, and this can easily be determined by a test roll of film. But as CC filters are made of gel and not optical glass, there may be a slight loss in image sharpness. But I have always found the difference to be indiscernible.

The more preferable method is to

When a classic stylized photograph of a glass or liquid is required, bottom lighting can always provide a beautiful solution. White plexiglass, 1/4-inch thick makes a perfect table, and at the back edge of the table where the light falls off into darkness, a colored gel can be added to the backlight so that the transition of lighting is from white to color to black, an extremely effective lighting technique.

filter at the light source and for this purpose Kodak provide a UV absorbing filter under the code name CP2B. This is placed directly in front of the flash head, and is usually held in position by a clamp.

The second peculiarity of electronic flash is that it is not always perfectly balanced for daylight color film. It is usually easy to discern whether or not the flash head or flash tube is color corrected by examining the glass to see if it has been coated with a color. Properly color corrected, it should have a warm, yellowish tint.

Daylight color film is rated at 5500° on the Kelvin color temperature scale. But electronic flash, unless it is properly color corrected, emits light which is colder than this daylight rating. Electronic flash usually ranges from 5900°K to 6200°K. To correct for this, Kodak recommends an 81 or 81A Kodak Conversion and Light Balancing filter.

But even when corrected to 5500°K this temperature of light is still too cold and unflattering for a model's skin tone. To impart additional warmth, you need to lower the Kelvin rating by at least another 150°K before you will become aware of any perceptible difference.

This subtle color difference is often a matter of personal taste. With Kodak Color Compensating filters you can sandwich more than one color together, such as a CC05-yellow with a CC05-magenta, allowing you to critically blend the color of your light.

A crash course in lighting.
The finer points explained.

A gold rimmed plate photographed for Royal Worcester. Over a dozen test shots were made varying the lighting each time in order to determine the best reflections and to create the most effective appearance of luster on the gold. Bracketed exposures were taken 1/3 f/stop apart in order to choose the transparency with the minimum burn-out in the white area while still retaining maximum color saturation in the blue. Photographed on 4x5 using a 300mm lens normally designed for 8x10 use. With the longer focal length, perfect round symmetry on the plate could be more easily maintained.

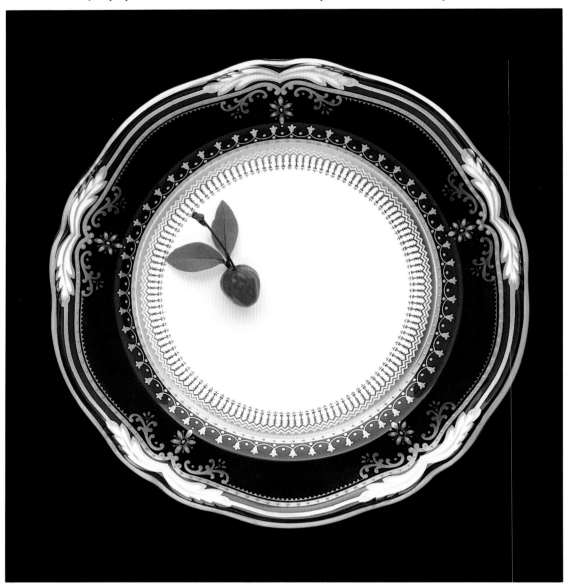

Shooting flash with tungsten.

When you are shooting with electronic flash, but wish to record the existing tungsten light as well, you need to balance the two forms of light to one color temperature.

The easiest way of doing this is by lowering the color temperature of your strobe light with filters. A Balcar X filter attached directly to the strobe head will drop the color temperature of your flash to 3400°K, and a Balcar X + Y filter will combine to drop the color temperature to 3200°K. This will allow you to use Kodachrome 40 KPA, Ektachrome 50 EPY or Ektachrome 160 ET, all of which are tungsten films.

The color temperature of lights in hotels, restaurants and other commercial interiors vary enormously, and cannot be color corrected or brought into balance with flash. But when these locations are used, it is always more effective to leave the shutter open following the flash exposure and then allow the background lights to record their various shades of yellow and orange which add natural atmosphere and mood to the shot. Fluorescent lighting, however, will cause a greenish cast on daylight film. Separately, it can be corrected with a special filter, but it is technically difficult to combine flash with fluorescent light when a filter change is required during the exposure. If there are no models or motion in the shot, two separate exposures can be made on the same sheet of film; the first

exposure with the flash, and the second exposure after the filter has been put in place.

If you are shooting in a residence, the existing light is usually incandescent and therefore considerably warmer than tungsten. The color temperature of a 100-watt house light bulb is approximately 2850°K which produces a deep orange cast on daylight film.

To shoot with strobe and include this existing light, one solution is to place Balcar X + Y + Z filters together over the flash head. This will effectively reduce your flash to the same lighting temperature, or the required 2850°K. Then a blue color correcting filter such as type 82 is added to the front of the lens to raise the general overall color temperature to 3200°K or 3400°K depending on which type of film is used. This now allows you to shoot with a tungsten type film.

But often it may be more convenient to exchange the light bulb in a lamp with a 500-watt blue bulb and leave the shutter open during the exposure.

The process for determining this exposure is as follows: test fire your strobe to calculate your f-stop. Next, place your daylight meter within six inches of the lamp shade, and take a reflected light reading. Note the time required to give a correct exposure at the predetermined f-stop. For example, you may shoot at f/22 for the flash exposure, but need to leave the shutter open for one-half a second or more to

A crash course in lighting.
The finer points explained.

In this backlit photograph of model Yanka, the power output on the strobe was adjusted until it gave a reading of 4:1 over the umbrella mainlight. To scatter the light, a cross-screen diffusion filter was used. Shot on 35mm with a 105mm lens using Kodak Tri-X Pan film pushed one stop.

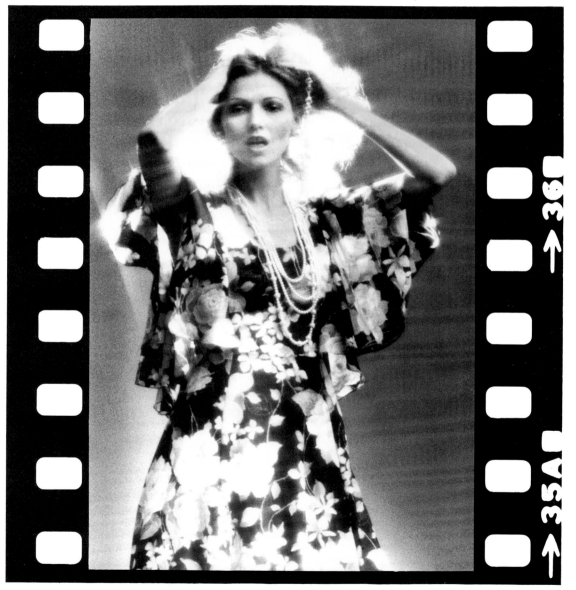

register the light from the lamp. With these time exposures, remember to turn off your modeling lights as well as any other unwanted light.

When using 500-watt blue bulbs, a word of caution. These bulbs have a life span of only three hours, and you will find it prudent to carry more than one spare.

You may also wish to acquire a Kelvin meter which measures the color temperature of tungsten light. One model available is the Gossen Sixticolor, and if you are shooting interiors, it is a valuable little aid.

Strobe power.

Photographers who have never photographed a room set are often under the impression that with strobe lighting you need a great deal of strobe power. But in actuality, because the camera distance is so much greater, you can often place the entire shot in focus at only f/5.6 on the lens, especially if it is one of the wide-angle lenses that I have recommended, and therefore you may actually need less strobe output than for small product photography where close-ups can require f/32, f/45 or even f/64.

As you close down the aperture and proceed to each f/stop along the scale, the light requirement doubles. Therefore, to limit the lighting power you need, limit yourself to the first two or three f/stops on the lens. Choose the minimum f/stop which will give you the depth-of-field you need.

In terms of actual strobe power, I have never required more than 3500 watt-seconds of power to light a full room set.

Pumping strobe light.

If you do not have sufficient light output from your strobe to give you the minimum f/stop you need, there is one technique by which you can seemingly increase your strobe's power.

It is possible to expose the same sheet of film a number of times, firing the strobe until the light builds up to give the correct exposure.

For every extra f/stop you need, you have to increase the amount of light by doubling it, as shown in the table below.

Example: Meter	You need	Extra f/stop	Total flashes*
f/5.6	f/11	+1	2
f/5.6	f/16	+2	4
f/5.6	f/22	+3	8
f/5.6	f/32	+4	16
f/5.6	f/45	+5	32

*Includes first exposure.

If you are fortunate enough to own the Minolta Flash Meter III, you will find it is programmed to make this computation for you automatically.

For the additional flashes, do not use your shutter release cable to fire the strobe. View cameras are extremely flexible by design and each cocking of the shutter and firing of the mechanism causes a minute vibration within the camera. If the lens does not settle in

Model Suzanne Cyr photographed for the cover of Applause magazine. Direct flash was used to eliminate virtually all shadows on the skin, leaving only a thin pencil line shadow around one side of the model. Shot on 35mm with a 200mm Nikkor Zoom lens and filtered with a combination of CC05M and CC05R gel filters to increase the warmth of the skin tone. Shot on Kodak Ektachrome ASA 64.

precisely the same position each successive image will be out of register.

Instead, turn off your studio lights and set your camera on 'T' for time exposure. Fire the first exposure from the camera – this will automatically leave the shutter open – and then manually fire the strobe the required number of times by triggering the flash release button on the power pack.

Pumping strobe light is a technique that can be used not only for room sets but for any product photography as long as you do not have a model or any movement on the set.

To make your own scrims.

The standard scrim is a simple wooden framework with a sheet of frosted acetate, mylar or other diffusion material taped securely into position. Scrims are an important lighting accessory in shooting glass or bottles.

By running a strip of black tape down the center of the scrim, in the form of a cross, the reflection on the glass or bottle looks like the reflection from a window. Or by boxing in the back of the scrim with reflector cards, and bouncing light into the cards before it passes through the diffusion sheet, you have created the same kind of soft, diffused light associated with window light. The large professional light banks which contain a number of strobe heads or flash tubes are simply sophisticated versions of a scrim. For sharper lighting with more contrast,one has only to aim the flash head directly into the scrim.

To make your own scrims, you will need the following:

1. Lumber to construct the frames, approximately 2 cm x 7 cm (3/4"x 2-3/4").
2. Metal "L" clamps for corner joins. Do not place blocks or wedges into the corners for they will prevent a clean, rectangular shape of light when you use it.
3. Frosted mylar .005 cm (.002") thick, available from most art supply shops. I have ordered mylar under the name 'Translar' which comes in a 105 cm (42") width with a frosted finish.
4. Black masking tape 2.5 cm (1") or wider to hold the mylar tightly in position and to conceal the edge of the frame so that it will merge into darkness and not show up in the reflection.

For the mylar to fit tightly on the frame, use Scotch tape to hold the edges in position and then keep tightening each side until you have it under maximum tension. Do not use a staple gun as the puncture from the staple gives the mylar a place for it to begin tearing when you pull it taut.

Support the scrim on stands, held in position with two, twist grip clamps.

Prior to using your scrim, conduct a light test with it by taking a series of exposures of the Kodak Gray Scale placed together with the Kodak Color Control Patches. Regardless how pure or white the acetate or mylar, I have found through my own testing that they add a certain amount of yellow to the light. This may be corrected by adding a blue color compensating filter in the range CC05B – CC20B.

How to master the 'big gun'. Taking the fear out of large format photography.

The first time I peered through the back of a 4x5 camera, and saw the richness of color, texture and detail in a large image, I was hooked. And when I looked through the back of an 8x10, I became positively addicted to what is known as the 'big gun'. The only problem was to figure out how this awesome piece of equipment actually worked.

The big camera is the professional photographer's mystique. To operate one is to have almost divine knowledge. It is a skill shrouded in professional secrecy and it is not difficult to understand why. The old view cameras functioned largely on the principle of trial-and-error. A great deal of experience and technical knowledge were required on behalf of the photographer. Not surprisingly, the view camera eventually became regarded as a device which dulled inspiration.

The reputation of these difficult cameras still lives on. And a good number of professional photographers do everything possible to avoid having to use one, even concocting marvellous tales as to how they can achieve the same results on their 2-1/4 camera.

By comparison to the old view camera, there is now one camera which is so brilliantly engineered that practically every other large format camera is obsolete by comparison. This is the Sinar camera made in Switzerland. No other view camera holds the same unique patents which make this camera so particularly outstanding.

62

The Sinar probably represents the first systematic approach to view camera photography. There is no fumbling or guesswork; instead, there is a systematic procedure that governs how you compose and focus your shot. And the camera is designed so that this can be done quickly and without hesitation.

The Sinar is also a modular component system with hundreds of creative possibilities, and simply by changing the camera back and bellows, it ingeniously converts from a 4x5 to an 8x10.

You can also obtain from Sinar *"Photo Know-How – A self-study course of sophisticated camera technique by Carl Koch"*. From this course material, one is able to master the view camera without special instruction. In my instance, this was my sole source of knowledge.

First of all, you will find it comforting to know that the principles of the view camera are remarkably simple. A few hours of study with the Sinar will reveal the basic principles of operation and a few weeks of diligent practice may be all that is necessary for you to become reasonably proficient. With any other view camera a far longer apprenticeship would have to be served.

Here is how the system operates: by leaving the lens plane at the front of the camera parallel to the image plane at the back of the camera, the large view camera is no different from an ordinary camera. To focus, instead of twisting the lens barrel, you turn a knob which causes the bellows to open and close.

In product photography, the most common problem you will encounter is that part of the subject is out of focus due to insufficient depth-of-field. You then have the choice of either selecting a very high f-stop or backing up the camera and focusing to infinity. However, neither may be practical.

But with a view camera, you can alter the depth-of-field without affecting the image. For example, imagine the problem you have when your camera is aimed downwards at a 45-degree angle to a bottle of wine sitting on a table, and the top half of the bottle is completely out of focus. With a view camera, you can tilt the lens plane so that it is parallel to the bottle. In this way, the depth-of-field passes through the bottle, from front to back instead of top to bottom – a significantly shorter distance. With this greatly reduced depth-of-field, a lower f-stop can be used and the image can now easily be put into focus. What you have actually done is to relocate the plane of sharpness.

Besides tilting the lens plane upwards and downwards, you can swing it sideways. You can also do the same with the image plane at the rear of the camera. For this reason, these view camera movements are known as the 'swings and tilts'. They allow a photographer an unlimited degree of control over

How to master the 'big gun'.
Taking the fear out of large
format photography.

perspective and depth-of-field and there is practically no problem that cannot be solved creatively or technically.

To find out the f-stop you need to place your entire subject in focus, use the depth-of-field scale on the focusing knob. Without doubt, this device is the crowning achievement of the Sinar. By focusing on the closest and farthest point of the subject, the scale measures the distance covered and tells you exactly the f-stop you need. With this precise a measurement of depth-of-field, you will also know how far you can tilt or swing the movements of the camera to fit within the distance range.

Your lighting determines the maximum f-stop you can use. If the f-stop indicated on the focusing knob is too high, f/64 for example, and you have only sufficient light for f/32, you can reduce the depth-of-field by angling the lens plane and not the camera.

This may sound complicated but it becomes a quick reflex action when you see the image in front of you on the focusing screen.

The most remarkable feature of a view camera is its control over perspective and distortion. With any lens, especially a wide-angle, distortion increases rapidly as you approach the subject. On the view camera, you can almost completely eliminate this natural distortion simply

by tilting the lens plane downward and then re-focusing. This will compress the image back to its proper shape. On the other hand, if you wish to increase distortion, you tilt the lens plane away from the subject.

With only a single standard lens on the view camera, you can instantly duplicate the effect of a wide-angle lens.

By tilting the lens plane away from the subject, you stretch the image, which in turn, causes the foreground to become exaggerated and the background to recede. The creative possibilities are endless, and the wider the angle of lens you begin with, the more extreme the creative effect becomes.

Because of this enormous control over perspective, only the fewest number of lenses are needed. With the 4x5 camera format, for example, I have photographed every conceivable piece of merchandise, ranging from room sets to perfume bottles, with only the standard 150mm lens or a wide-angle 75mm lens.

In controlling perspective, the view camera has the ability to keep lines straight when they are viewed at an angle. If you wish the image to remain perfectly vertical, whether it is a bottle of wine or a city skyscraper, keep both the lens plane and image plane parallel to the subject, even though the camera is at an angle. If the image is not fully in view, for example, the top of the building cannot be seen, the lens plane may be moved up or down to bring it into sight. This camera movement is known as the 'rise and falls' and it adds another element of control.

For extreme close-ups, a view camera does not need special lens attachments such as extension tubes or close-up lenses. Magnification increases by extending the bellows and if one bellows is not sufficient, you add a second bellows. Even the shallow depth-of-field resulting from extreme close-ups can be handled more easily by controlling the swings and tilts.

A question of sharpness.

A common misconception among newcomers to commercial photography is that the reason large format cameras are used is for greater sharpness. In actuality, this is rarely the prime reason.

Lenses are now manufactured to such high technical standards that the actual size of the lens does not automatically mean greater sharpness. Surprisingly, lenses designed for 35-mm cameras may have twice the resolving power of lenses designed for larger cameras. Manufacturers design them this way for the reason that small transparencies and negatives must be able to stand a higher degree of magnification. In fact, the resolution of a good 35-mm lens is now so high that it exceeds the resolution of the human eye by a factor of almost 2:1. This means that the image will appear sharper than what you actually see.

How to master the 'big gun'.
Taking the fear out of large
format photography.

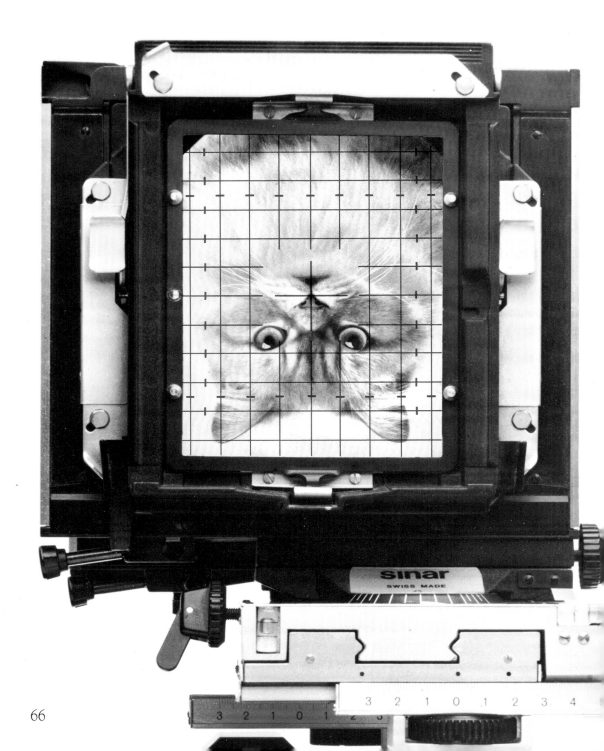

The extraordinary sharpness of an image on a large negative or transparency is due as much to the resolution of the film, and its sheer size, as it is to the sharpness of the lens.

Seeing upside down?

There is great visual discomfort in dealing with an image that appears not only upside down but with left and right sides reversed. However, any concern that this may prevent you from taking a good photograph should be dismissed. Any visual discomfort, or nuisance, is only temporary; like a camera lens, the human eye receives its images in the same upside down state. The brain does not mysteriously turn the image upright but interprets the signals in the way it has learned to do by experience. You actually see upside down but your brain says you do not.

Experiments have been conducted with people wearing specially designed eyeglasses that caused them to see upside down. At first, they were completely disorientated, reaching upwards to tie their shoelaces, and stepping downwards to climb up stairs.

So uncoordinated were their movements that some even had to crawl to get safely across a room. Yet within a short period of time they were able to ride bicycles and even ski.

Actually, the brain has very little difficulty coping with an image which is upside down. Oftentimes, when I am concentrating on a shot through the focusing screen I find I become totally unaware of the image being reversed. This faculty seems to develop naturally with experience.

For those without patience, Sinar makes a device for the back of the camera which turns the image right-side up. To use such a device, however, robs you of a unique visual opportunity. By viewing an image in reverse, your mind becomes infinitely more sensitive to shape and form. It sees objectively, with complete emotional detachment. Your sense of composition becomes intensely heightened.

Artists are familiar with this peculiarity of sight and they will often turn their illustrations upside down and hold them to the light in reverse, to check their composition and design. Only then if the illustration appears well-balanced is the artist satisfied.

With photography, it is impossible to reproduce the brightness range as seen by the human eye. The difference between what your eye sees and what is actually recorded on film can often be disappointing. So sensitive is the retina that the total range of tones which you perceive is in the order of 1:1,000,000.

Film does not have the capacity to record this brightness range. It is far beyond any film's latitude. Black-and-white films will only record a brightness range of up to 1:1,000. And color film is limited to a brightness range of only 1:200 – a far cry from the range of tones you are accustomed to seeing.

To take a correct exposure, you must first convert this brightness range into an exposure range. To do this, measure with your light meter the difference between the lightest and darkest areas of your subject. This will give you the exposure range of your subject, in terms of f-stops, and from this information you will have control not only over exposure, but over the entire tonal range of your final image.

For example, to successfully reproduce a good black-and-white print in any magazine or printed media, it should have an exposure range no greater than five f-stops. With color negative film, the exposure range should not exceed four f-stops. And with color transparency film, which has even less latitude, the exposure range should not exceed three f-stops.

Remember, too, that the reproduction range of enlarging paper is also limited. It has a maximum exposure range of six f-stops. Although you may distinguish a wider range of tones on your negative, these will be compressed to a more narrow range on your final print.

By referring to the exposure range table, you can determine how the exposure range affects contrast. By increasing the exposure range by only one f-stop, you double the contrast, and as you increase the contrast, you compress the tonal range of your subject. The higher the contrast, the fewer the tones which can be reproduced.

This measurement of contrast is known as the contrast ratio – a number which describes the amount of contrast in an image.

In photomechanical reproduction, when prints or transparencies are screened and converted to final film for magazine printing, the tones are compressed to within four f-stops, or a contrast ratio of 1:16.

This is why a brilliant transparency, with an exposure range of seven f-stops, or a contrast ratio of 1:128 can be so

A specially prepared gray scale has been included in the photograph on the right to show the compressed tonal range of the image. Note how the blacks and dark grays plug together, and how little separation there is between the lighter tones. This is the result of an intentionally overexposed negative printed on high contrast paper specially for effect. Reading the gray scale is essential to determining the limits of exposure – and reproduction.

How to take a perfect exposure.
Understanding the gray scale.

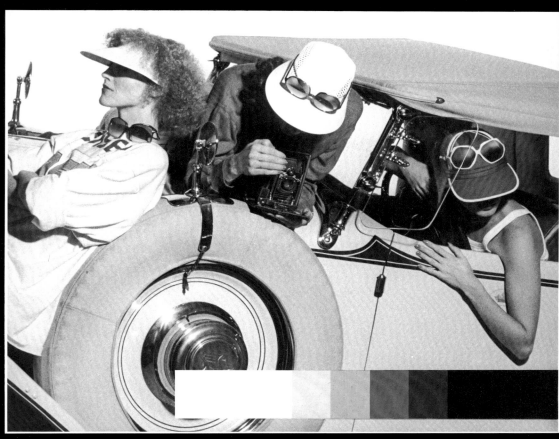

Fundamentally, the correct exposure depends on the correct selection of the reading point. The top row shows over-exposure with too high a reading point selected. The middle row shows correct exposure. And the bottom row shows underexposure with the reading point too far removed from the mid-tone.

.70

.70

.70

disappointing when it is seen reproduced. It has far exceeded the reproduction range of the printed media. The range of tones are compressed and the subtlety of color is lost.

A color transparency viewed on a light box has its brightness range boosted to over 1:100,000 by the sheer illumination of light passing through it. As a result, practically any transparency looks good on a light box. But only if its exposure range is within three f-stops will it reproduce satisfactorily. This is the reason for soft, diffused lighting in color photography. The secret is to create contrast through the use of color.

For maximum color saturation, lighting should be kept to within a contrast ratio of 1:4. This represents a two stop difference between light and shadow.

The perfect exposure has a contrast ratio that does not exceed the maximum range of reproduction. A correctly exposed color transparency, when viewed on a light box rated at 5500°K, should not require any lightening or darkening. This is the standard in commercial photography for achieving successful reproduction.

Exposure range table.

Density Difference	Exposure Range	Contrast Ratio	Maximum Range for Reproduction
0.00	0 f-stop =	1:1	
0.30	1 f-stop =	1:2	
0.60	2 f-stops =	1:4	
0.90	3 f-stops =	1:8	— Color transparencies
1.20	4 f-stops =	1:16	— Color negative film
1.50	5 f-stops =	1:32	— Black-and-white
1.80	6 f-stops =	1:64	prints
2.10	7 f-stops =	1:128	

This table gives you the relationship of exposure to lighting contrast. The f-stop range is the difference in exposure measured from highlight to shadow area.

In photomechanical reproduction, technicians measure the difference in density to determine the limits of reproduction. A density difference of 0.10 equals 1/3 of a stop, or .30 equals one full stop.

The gray scale.

There are two methods for taking an exposure. One is with an incident light reading with the meter held in front of the subject and pointed towards the camera. The only problem with this method of exposure is that the meter reads the average amount of light falling onto the subject and without allowing for brightness range or reflectance from the subject itself. For example, it does not take into account that yellow reflects more light than blue or that a shiny surface is twice as reflective as a matt surface. Or when a subject is made up entirely of light tones or dark tones, the incident light reading cannot compensate for this imbalance of tones, and therefore causes you either to over-expose or underexpose.

The other method of taking an exposure reading is by pointing your meter towards the subject and measuring the reflected light. This allows you to take into account all the previous problems associated with an incident light reading.

Whether you use a hand-held meter or one built into your camera, the success of your exposure is based on selecting the right tone from which to take your reading. This requires a precise spot reading of the mid-tone value of your subject.

This tone is the .70 density in the center of the Kodak Gray Scale. If you take a spot reading from an area in your picture which is equivalent to this mid-tone value, and use this to base your exposure on, you will produce the same range of tones shown on the gray scale. This provides the fullest tonal range for reproduction and it is the only way to assure a technically perfect exposure.

When selecting the mid-tone, half close your eyes for a better idea of tonal differences. A squint compresses the tones so that they can be more easily judged. To increase your accuracy of choosing the right mid-tone value, measure two subject areas which appear to be medium tones, and take an average of the two.

An equally effective alternative is to use a Kodak Gray card. This card is a duplicate of the .70 density on the Kodak Gray Scale and you can take a spot reading directly from it.

In extremely dark or light scenes place the gray card in an area which receives the same amount of light as that falling onto the overall subject.

Until your eye is trained to recognize the .70 density tone in scenes, the Kodak Gray card can be immensely helpful. If the scene you are photographing covers a large area, hold the card up in front of you and visually compare the mid-tone you have selected with the tone of the gray card.

With this system of taking an exposure, you can also manipulate how the tones will appear. This probably represents the most sophisticated technique you can master as a professional photographer.

By selecting a reading from a higher, lighter tone on the gray scale, you are intentionally forcing the mid-tone value up the scale and replacing the lighter tone with it. By pushing the .70 density upwards, you have pushed the lighter tones off the scale. This will result in a low key photograph made up mostly of dark tones, with rich, heavy shadows and very little tone separation.

In duplicating the commercial artists' technique of drawing elongated lines in fashion artwork, this photograph was given a similar visual stretch in the darkroom under the enlarger. The easel board was tilted upwards at an angle and the image focused at a midway point with the lens set to its maximum f/stop to retain depth-of-field. For exposure time, a card was held in front of the light path and gradually pulled across the print to allow less exposure towards the end of the print closest to the lens.

By selecting a meter reading from a darker tone, you then cause the mid-tone value to fall lower on the scale and to take the position of the tone from which you are basing your exposure on. This forces all the darker tones off the scale, replacing it with lighter tones. This has the effect of deliberate over-exposure and results in a high key photograph made up predominantly of delicate, light tones with very little tonal separation.

As this procedure of taking an exposure is unaffected by the brightness of other portions of the picture it is infinitely more precise than an overall average reading. By taking a critical, reflected spot reading of the .70 density mid-tone, your exposure should be technically perfect, everytime.

How to 'tune' your meter.

Never assume your meter is correct unless you have subjected it to a critical exposure test. I have never found two meters which gave the identical reading even when they were from the same manufacturer.

With electronic flash meters, the differences are often more extreme. Only when you know the precise amount by which your meter varies can you hope to attain perfect exposure.

To determine the accuracy of your meter, take a series of exposures of the Kodak Gray Scale mounted on a black card. Exposures should be 1/2-stop apart and noted on a piece of white card placed into the photograph. Use color transparency film, preferably 120-size, for easier viewing afterwards on a light box.

The perfect exposure will be the one which most accurately duplicates the complete range of gray tones. Study the tones at each end of the scale: if the lighter tones are merging together, you are overexposing; if the darker tones are merging together, you are under-exposing. With the correct exposure, you should be able to clearly distinguish between each tone. Once you have determined your exposure adjustment, mark it on your meter as a reminder.

This test should be conducted with soft, diffused lighting and then repeated with hard, direct lighting. The exposure adjustment may vary from one extreme of lighting to the other, depending on the sensitivity of the meter. When the meter has a 'hi' and a 'low' scale, compare the exposure readings when they overlap. Although the meter should give an identical reading regardless of which scale is chosen, it may have a bias towards one end of the scale and not the other. If the meter is off by much more than half a stop, it should be sent to a service technician to be re-calibrated.

73

By the practice of recording technical notes onto a Polaroid, an idea can be creatively and technically evolved in a systematic manner. For this Polaroid test for a carpet ad, the following describes my own shorthand notes: Remove scrim on Hazy mainlight to increase contrast. Overexpose by one-half f/stop to compensate for soft lighting. Add 10% to the final processing time to drop out background tone. Burn in tone on dove during printing. Add shadow in foreground and retouch edges around swatches. Bleach carpet area during darkroom printing to bring up texture. Strip in tail feathers on dove on final print. The following serve as reminder notes: With camera and angle set at 30° to the subject, set lens plane to +6° and set image plane to +2°. Advertisement, as it appeared, is shown on page 42.

Polaroid. Why you should never shoot without it.

Photography is a technically risky business and it is difficult to survive a career without an occasional disaster.

My first disaster occured on location in the middle of winter, shooting three models at night in evening gowns while they were attempting to ride a motor-cycle. It was bitterly cold and the lens barrel seemed stiff and hard to focus. I prayed the cold would not affect any other piece of equipment. I finished the shoot just as snow began to fall. The shoot seemed to be a success, and afterwards, in the warmth of the studio, everyone embraced each other with congratulations.

The following day when the film returned from the color lab, every frame of every roll was completely black! My first reaction was that the cold somehow caused a malfunction in the camera.

With camera gear in hand I returned to the freezing cold, and began a system-atic check of every piece of equipment I had used during the shoot.

I opened the back of the camera and peered through the lens while the shutter was pressed: the aperture opened and closed without hesitation, and the shutter leaf fled back and forth as it should. I checked the flash setting on the shutter dial and it was still taped into position on the red setting of 1/125, a precaution I always take when I am shooting with flash. I also checked the recycle time of the flash in case the cold caused a delayed action and I tested the flash output with the flash meter.

Everything worked. Meanwhile, the client was still waiting for the film.

My next reaction was to accuse the lab. Could it be that by accident the film had not been processed? But as the lab technician reminded me, "On color transparency film, a black image always indicates that processing has taken place but that no exposure has occured". For the moment, I was out of business.

Finally, staring at the camera on my lap, I noticed something that one never checks: the tiny 'XM' setting on the lens barrel was set on 'M' not 'X'. ('X' for electronic flash and 'M' for flash bulbs.) My assistant later confessed he had been tinkering with the lens out of curiosity and he must have inadvertently moved the setting. But, I wondered, as both settings are for flash, could the difference really matter?

I raced to my technical manuals and there I discovered that flash bulbs discharge later than electronic flash, and that the 'M' setting is designed to retard the timing on the shutter so that the instant of exposure follows fractionally later. By making the error of shooting electronic flash on the 'M' setting, the aperture was opening and closing a split second too late – just sufficient to prevent exposure.

That day, I resolved never again to shoot without Polaroid. With Polaroid, I would have detected the problem immediately. Although at the time I could not afford to buy a Polaroid back for my camera, one thing was certain – I could less afford the expense of a re-shoot.

When Polaroid is employed for such critical use, it must also be processed critically. According to Polaroid, although the film may be exposed successfully at any temperature, the temperature of both the film and the film holder at the time of processing has an important effect on development. Therefore, to choose the right processing time specified in the film data sheet, you must know the precise temperature of the film itself. This is best achieved by removing the film from the refrigerator at least three hours before shooting time, allowing the film to acclimatize. In this way, the room temperature determines the precise development time.

The negative which comes with the Polaroid positive-negative film is another blessing. By placing it in the enlarger and focusing it onto the layout, it gives you an opportunity to check your composition and camera cropping. If you discover that you have scaled or proportioned the shot incorrectly, you can immediately go back to the camera and make the necessary adjustments. When working to layouts, the practice of sizing before taking the final shot is extremely important.

If you are tempted to make your final black-and-white prints from Polaroid negatives, you will probably find that these negatives will not carry the density to produce the range of contrast you need for reproduction. However, by pushing the film one stop, you can increase the contrast of the film sufficiently to produce an excellent print up to twice the size of the negative itself. In my experience, as the print size is increased, the tones begin to flatten out, and printing becomes exceedingly difficult. But if great care is taken during exposure and printing, prints up to 8 x 10 in size can adequately be printed from 4 x 5 Polaroid negatives. For prints larger than this, I advise you to work from standard film.

Note: To push Polaroid film one stop, expose the film at double the ASA and then double the processing time. This may give you an underexposed Polaroid print, but will always result in a higher contrast negative.

With Polaroid positive-negative film, after you make the exposure, immerse the negative in a full-strength solution of Kodak Rapid Fixer at approximately 70°F (21°C). This should be done within three minutes after separation from the print.

If you cannot fix the negative immediately, you can temporarily store it in a tray of water in the studio. I have done this for three hours without affecting the negative. The fix period normally takes no longer than one

minute. To wash the negative, immerse it in running water for about five minutes at 70°F (21°C). After washing, dip the negative in a wetting agent, such as Kodak Photo-Flo. To dry the film quickly, hang it in front of a fan. The entire darkroom process can be done in daylight, and within less than fifteen minutes after taking the photograph, you can have a negative in your enlarger ready for viewing.

Creative insurance.

The number of things that can go wrong in the process of taking one technically perfect photograph is horrendous. Your meter, your sync cord, your flash equipment – all can let you down. And with a dozen calculations and settings to remember, it is easy for one detail to slip your mind, especially during the anxious moments of a shoot.

Only by taking a Polaroid can you know if a state of mechanical perfection exists. In professional photography, Polaroid is your insurance. You shoot without it at your own risk.

Of course, with Polaroid, you can check your composition as well as your lighting, and this is where it has become creatively invaluable. In the process of 'working up a shot', you can sketch changes on the Polaroid print and evolve your photograph in an orderly manner. Lighting and technical information can be recorded on the final Polaroid for future reference. Or, if you are shooting spreads of merchandise for a catalogue project, Polaroids can be attached to the layout giving a visual record of progress as well as indicating perspective, lighting and backgrounds that will have to be identically repeated. A few other helpful points follow.

Always choose Polaroid film which has the closest ASA to the film you are using. If you are shooting with ASA 64 film and you use Polaroid 3000 ASA, you will have to cut your light down so drastically that it may not represent the actual lighting, and therefore will give you a false impression. Also, with such a high-speed film, you may have to stop down your lens to such an extent that you create a false impression of your depth-of-field.

For 4 x 5 photography, where exposure precision is required to within 1/3 of a stop, Polaroid film can be used with remarkable accuracy to check your exposure. I never shoot without Polaroid Land Film Type 55/Positive-Negative. Many professional photographers whom I know actually take their final reading from their Polaroid print instead of from their meter, for it takes into account any exposure adjustment due to filters, bellows length or lighting contrast, and shows any reflected light that the meter may not have picked up from its reading.

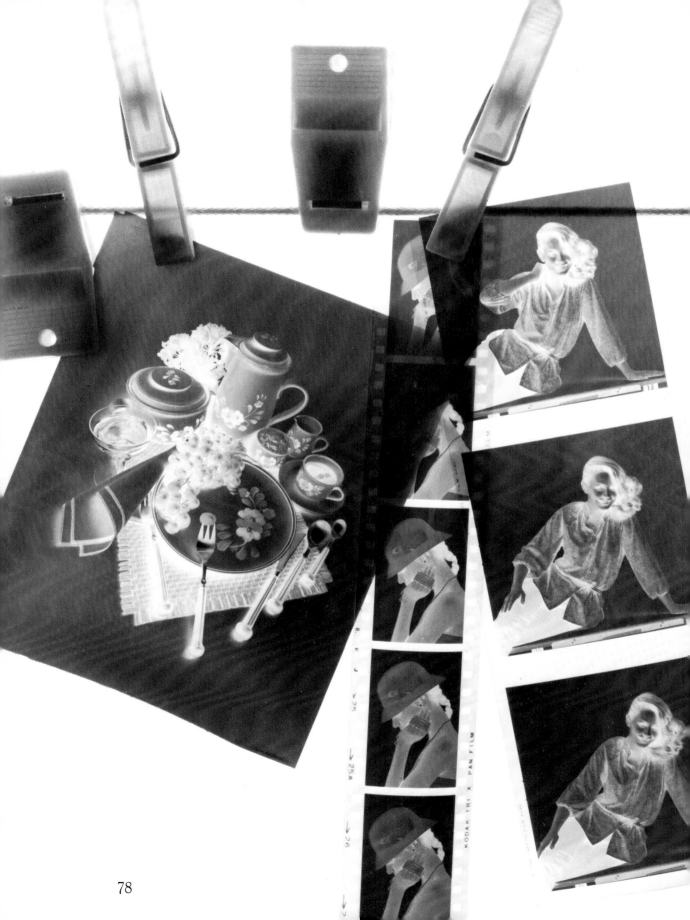

In the darkroom.
Controlling the contrast index.

Whenever I had to provide a black-and-white print for newspaper reproduction, I would dread the day it appeared. How much would it plug in? Would all the detail disappear? Would it print too light or too dark? And most of all – would the client hold me responsible?

Trying to outguess the newspapers became an obsession. In my attempts to stave off the impending disaster, I would spend hours in the darkroom pursuing the right balance of tone. But inevitably when the prints ran, they still appeared flat and lifeless. It seemed that all the general rules of pulling a print did not work.

As time passed and experience grew, it became apparent that the secret lay in producing prints to a very specific level of contrast. In determining this, it appeared that the higher the contrast, the better the reproduction.

When prints have a contrast level equivalent to a grade 3 paper, they have best chance for good reproduction. With prints of such high contrast, a small price has to be paid, this being a minor loss in detail. However, as the complete range of tones will never actually reproduce, one has, in fact, nothing to lose, but a great deal to gain.

The problem with newspapers is that their line screen is very coarse, either 65 or 85 lines to the inch. Compare this to a high-quality magazine where the line screen may range from 150 to 200 and it is easy to understand why a newspaper can never attain good half-tone reproduction. The screen holds the key to the amount of detail and subtlety of tone which can be printed.

In newspaper printing, another problem is the coarseness of the paper itself. Newsprint absorbs the ink, acting like a blotter. This spreads the ink and tones begin to merge until finally the image plugs in.

In producing prints with the correct contrast, two controls are in order. First of all, the lighting itself must have contrast. This can be achieved by using a silver-surfaced umbrella and positioning the light directionally so that it allows shadows to fall on one side of the subject.

For product photography, if you are using the Bron Hazy soft light or similar equipment, remove the frosted mylar cover. The resulting light will still be bounced, but not diffused, and will therefore have more crispness. In order to keep shadows rich and dark, avoid reflectors and fill-lighting. A single source of sharp, bounced main light is essential to achieving contrast.

The second control lies in increasing the contrast of the negative. Once this is done, the light gray tones will automatically drop out from the print, the tonal range will be compressed, and blacks will print up as pure black and not dark grays.

With the correct contrast built into the negative you can reduce printing time from hours to minutes. This is possible only by controlling the contrast index.

The contrast index, explained.

The contrast index is a number describing the amount of contrast in a negative. By following Kodak's recommended processing times, your negatives should theoretically have a contrast index of 0.56. This is intended to give you negatives which will consistently print well on a grade 2, medium-grade, or selective contrast paper with a PC2 filter. The basic contrast index of .56 for negatives applies to diffusion enlargers. For condenser enlargers, a contrast index of .42 is recommended.

The contrast index is plotted in curves on a graph and appears on the data sheets in the *Kodak Professional Black-and-White Films* booklet on processing. They apply to all films to be used for continuous-tone reproduction.

The contrast index is extremely useful when a number of different films are being used. For example, when a negative developed to a certain contrast index is found to be suitable for a given printing system, all other negatives, regardless of the kind of film or the developer used, can be developed to the same contrast index by referring to the appropriate curves.

There are a few other things to bear in mind. The amount of development time is not the only control over contrast. To obtain an accurate contrast index, other variables, such as developer, and the degree of agitation, must be carefully maintained. Also, the processing times in the Kodak data sheets are for large tank development with agitation at 1-minute intervals. But photographers who do their own processing generally use the small tank for which Kodak recommends agitation every 30-seconds. Usually, this means you will reach the correct contrast index more quickly and therefore you need slightly less processing time. Technical aficionados may enjoy computing the adjustments which are provided in the appendix of Kodak's booklet on film processing. But I have adopted a simpler strategy. In my darkroom, even though I use small tanks, all film is processed under the large tank development times with the specified 15-seconds of agitation at 1-minute intervals. This consistently gives me a higher contrast, which I favor for reproduction.

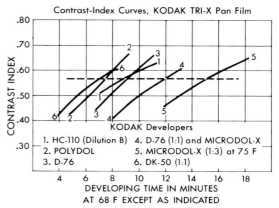

This graph shows the contrast index curves for Kodak Tri-X Pan Film. To use the curves, select the contrast index from the vertical column of figures on the left of the graph, and then read the development time needed from the times given just below the base line. If a contrast index of .56 produces negatives with a density that print well for you, then you can find the time for each developer by drawing a straight horizontal line at a contrast index value of .56 on the graph, as shown by the dotted line. For example, the development time for Kodak Tri-X Pan Film in Kodak D-76 Developer is 9 minutes with agitation at 1-minute intervals at 20°C (68°F). These times are based on negatives made under average conditions. If the negatives thus developed are too low in contrast, choose a higher contrast index value. If the contrast is too high, choose a lower value. – Kodak Professional Black-and-White Films, booklet No. F-5.

*Model Yanka photographed for an Eaton's
newspaper advertisement. Original negative was
processed to a contrast index of .65 to yield a perfect
high contrast print for newspaper reproduction.*

If your negatives are consistently too thin when developed for the recommended time, select a higher contrast index and then develop the test film for the time shown on the time scale below the contrast index graph. On the other hand, if your negatives are consistently too high in contrast, select a lower contrast index, and develop for the shorter time indicated on the time scale. When changing the contrast index, choose indexes which are at least .5 apart, to give you a noticeable difference in negative density. That is all there is to it.

In making adjustments to negative contrast by means of the contrast index, remember that the exposure range of your lighting, the type of processing that you are using, or even a nominal amount of lens flare, will affect these curves. To determine what corrections are needed for any of the above, you should refer to the *Kodak Black-and-White Darkroom Dataguide, No. R-20.*

The contrast index, applied to prints for newspaper.

The contrast index which I have determined to create the most reproducible prints for newspaper reproduction is .65. This is based on using the Omega Pro-Lab condenser enlarger which is the model I use. This .65 index produces

dense, contrasty negatives and creates prints which are approximately equal to a grade 3 paper.

This is an ideal contrast index when using diffused or bounced lighting. With hard, direct lighting or outdoor photography where there is a consider able brightness range, I lower the contrast index to .56.

When developing black-and-white prints for newspaper reproduction, I undertake one further step, and that is to print a wipe over with Kodak's Farmer's Reducer. This is a bleaching agent which reduces the density in a print. When gently wiped over a print it will remove the lightest gray tones. This is particularly effective when treating prints of fashion photographs as it adds sparkle to the model's eyes, makes skin tone appear whiter and smoother, and increases the contrast in fabric detail. In product photography, the cleaner highlights result in a print which has noticeably more depth and dimension.

To apply Farmer's Reducer, use a large cotton swab. Wipe over the area to be bleached while continually submerging the print in a tray of running water. This will prevent the chemical from overbleaching other parts of the print.

For small areas, such as eyes, use a Q-tip to apply the solution. With such tiny areas, the solution may be more difficult to control, and the best practice is to dilute the chemical with double the amount of water. This will make the process slower, but more manageable.

A word about labs.

If you are considering sending your film out for processing, take into account that most processing labs are color labs and generally do not process black-and-white film to any critical standard. Chemicals may not be replenished as often as they should and this can result in negatives which are thin and difficult to print. If you ask the lab to increase the processing time, it will represent a 'special run' and this is usually double the cost – if they will do it at all. And if you specify a contrast index number, you may be looked at rather quizically. Even with special processing, the supervision may be too casual to ensure that the film is processed exactly the way you requested. At least, that has been my experience.

Seek out professional labs which specialize in black-and-white film. Find out where the professionals have their film processed. But remember, only when you can produce negatives professionally yourself can you direct a lab to produce the quality you want.

H and coloring black-and-white prints is usually regarded as an amateur technique with little commercial application. The struggle to turn photography into art has yielded a number of visual embarrassments, examples of which frequently appear in amateur photography magazines. But with an understanding of the artistic techniques involved, fascinating fashion and beauty photographs can be created which blend the realism of photography with the fantasy of art.

Print quality.

Your print must have a flat, monotone quality in order to reveal the subtleties of hand coloring. Black-and-white infrared prints, which have a naturally bleached out appearance, can be extremely effective. Prints which are flat and sufficiently underexposed to give only soft shadows and outlines are the most suitable. Avoid hard, high contrast prints; the deep black areas will compete with the hand coloring and remove all reality from the photograph.

Print paper.

The best paper to use is a matt-finish such as Kodak Polycontrast rapid RC, surface N. Glossy prints are extremely difficult to hand color as the paint skips and runs. However, you can make these prints more manageable with a quick spray of Marshall's Pre-Color Spray which conditions the surface to accept various oil paints and pigments.

Toning paper.

If the photograph is of a model's face, the secret in creating a natural looking hand colored print is to copper tone it first. Copper toning imparts a delicate pinkish hue to the skin tone which can appear strikingly realistic. This is not to be confused with sepia-toning which gives prints a brownish antique effect. Copper toner is available under the name Berg Brown/Copper Toning Solution. It comes as a two-part solution to make one part of chemical, which will treat approximately 75 8x10 prints. By varying the proportion of part A to part B, and the amount of soaking time, you can create tones ranging from warm brown to copper-pink. The longer you leave the print in the solution, the more reddish the image becomes.

For the best effect, remove the pinkish hue from the highlight areas, especially the whites of the eyes. This can be done simply by rubbing the color off with a damp Q-tip.

Afterwards, the only areas of a face that need to be painted are eyes, cheeks, lips and highlight areas of the hair. Background or other areas of the print where you may want to eliminate the copper toning can be masked out by using Masquoid, available from any art supply store.

The delicate art of toning and hand coloring prints.

Note: prints which are to be copper toned must not be hardened during the fix stage of development, otherwise the results will be unpredictable; therefore, omit the hardener when making up the fix solution.

Adding color.

Select a color pigment paint which is transparent. This will allow the shadow and details from the print to show through. If you use solid, opaque colors over the print, chances are the final image will appear highly contrived.

My best results have been with Marshall's Transparent Photo Oil Colors. These tiny tubes of color come in kits of various size, complete with instructions and cotton-tipped applicators. Artists' paint brushes are unsuitable as they leave brush marks on the print. For very fine detail, such as the iris of the eye, use a toothpick covered with the fewest strands of cotton.

When applying color, use only a very small amount, and work it into the print with a circular motion. Then, with a fresh piece of cotton delicately wipe away the remaining oil paint, leaving only a delicate hue of the color. If the tone remains too light, apply further coats until you achieve the correct shade. To remove any mistakes or smudges of color, apply a little of Marshall's Marlene Solution, which is designed specifically for this purpose. The finished print can be varnished or sprayed afterwards with either a satin or gloss finish to protect its surface.

For beauty photography, hand colored, copper toned prints have limitless applications in advertising. A model can be given pure green or pure blue eyes. The vibrant colors of lipstick and finger-nail polishes can be excitingly presented by applying the color only to the lips and nails and leaving the rest of the print copper toned. The subtleties of eye shadow make-up can be emphasized. And if only the purest colors are desired, use Farmer's Reducer to bleach out the gray tone of the area to be colored in the print, before copper toning.

*The delicate art of toning and
hand coloring prints.*

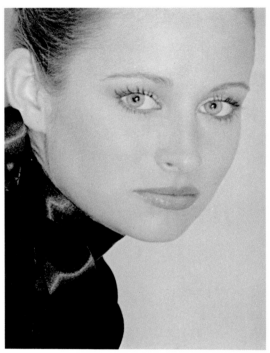

*Photograph of model Carolyn Patterson printed on
Kodak Polycontrast Rapid resin-coated paper,
surface N. Toners can be used on almost any kind of
photographic paper, including resin coated. Black-
and-white prints may be developed in the normal
manner but without the hardening agent added to
the fixing solution. This will leave the emulsion
surface more receptive to the toning treatment.*

*The print after toning for 12 minutes in Berg
brown/copper toning solution. Depending on the
length of time the print is treated, the toner will
produce a range of tones varying from warm brown
to a pinkish hue, eventually turning the print into a
deep metallic copper tone. The print can be returned
to its original black-and-white state simply by
removing it from the toning solution and immersing it
in the paper developer bath. This allows you to
continually experiment without ruining the
original print.*

*The photograph in final use, hand colored with
Marshall's photo-oil colors. The whites of the eyes
were wiped clean of the copper tone by using a Q-tip
moistened with water. The print was then mounted
in a black presentation card to form a still life
composition in an experimental campaign presented
to Benson & Hedges, of which this was one in a series.
Objective of the campaign was to develop visual
ideas which would hold the reader's interest to the
page longer and therefore produce higher brand
name registration.*

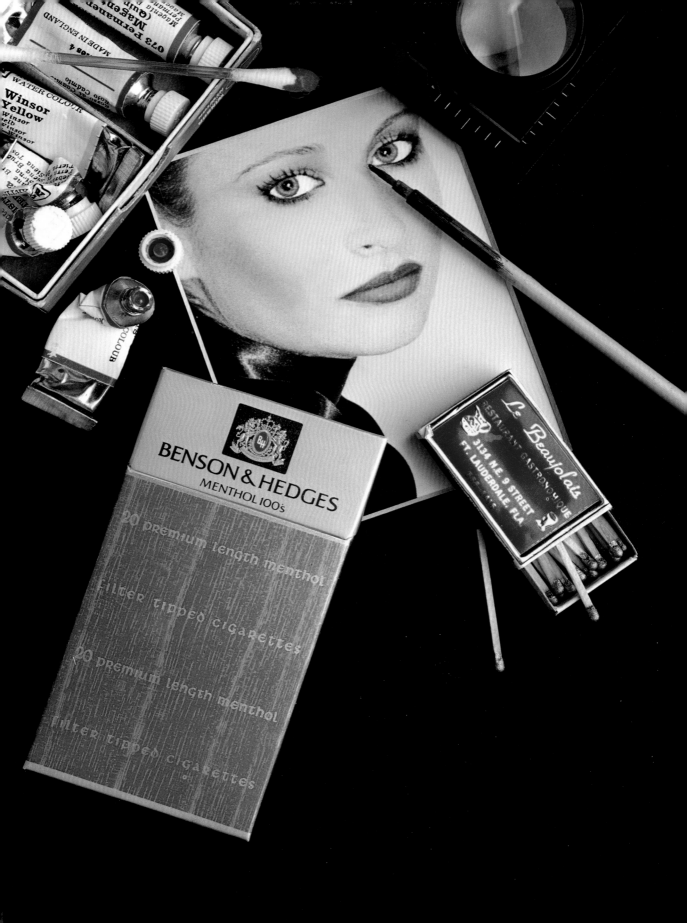

III
In search of gold.
An examination of the major
sources of income.

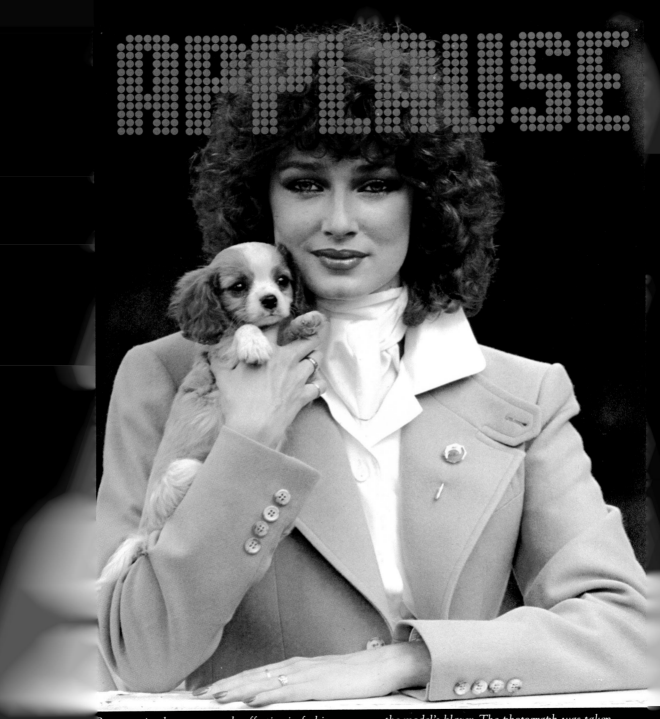

APPLAUSE

Pets or animals are extremely effective in fashion photography and can often be used to enhance the garment as long as they don't dominate the photograph. Here, in this cover shot for Applause fashion magazine, a small King Charles Spaniel the model's blazer. The photograph was taken outdoors in the shade with the model positioned against the dark green of a distant forest. Shot on 2-1/4 Hasselblad with a 300mm lens. A 10mm extension tube allowed close-up focusing on the model

How to break into fashion photography.

The thought of photographing beautiful women and traveling to exotic locations is a temptation which lures many into fashion photography. I was no exception.

With my portfolio clutched under my arm, and an air of undeniable confidence, I set out to make the rounds of art directors in the fashion trade. Only the most creative work went into my portfolio, the results of dozens of testings with models: grainy, romantic images, misty mood shots, and numerous artistic effects.

At *Chatelaine* magazine, fashion editors, art directors and assistants viewed my transparencies with great curiosity, and many other clients seemed genuinely impressed. But the work only trickled in and it gradually became apparent that I was not going to take the fashion business by storm.

Later, *Chatelaine's* fashion editor Eveleen Dollery quietly took me into her confidence. She explained that my portfolio, like that of so many other photographers, was simply too creative. Eveleen warned, "Soft images and exotic locations are lovely to look at, but we will never hire a photographer if this is all he has in his portfolio". She also added, "Photographs of wicket fences and rolling hills with a model occupying only a tiny portion of the image may be creatively artistic but will not persuade a fashion editor to give you work".

With fashion photography, the general rule is that the visual emphasis must be placed first on the fashion, then on the model, then on the location. When you change this order of visual emphasis, you invite opposition from the fashion editor. However, there are always exceptions and you should work out your basic approach with the art director at the pre-production meeting.

With editorial fashion assignments, you can expect considerable help from the magazine. The fashion editor or assistant will arrange the shooting schedule, book the models, and hire the hairstylist and makeup artist. Do not be surprised if the fashion editor selects the models. Until a photographer is established with a magazine, he will have little influence over who is finally chosen.

Getting started.

Fashion editors do not consider it necessary for a photographer to have either a studio or expensive lighting equipment. As most of the fashion for magazines is shot on location, all that is needed, besides a 35mm and a few lenses, is a portable flash for indoor work.

Even if a photographer does not have samples of published work in his portfolio, it does not prevent him from obtaining assignments. Fashion editors have an enormous amount of fashion to shoot during the year and they are always looking for new photographers with interesting new ideas on how to shoot fashion.

Once you succeed on a small project with a magazine, there is every possibility for you to become a regular contributor.

Probably the best way to build up your fashion portfolio is through the test shooting of models. Model agencies are always helpful in this regard for it is one way for them to promote their models, and for them, every new photographer is a potential source of business. Ask for the agency's head sheet and to be put on their mailing list for model comps.

To build your reputation as a fashion photographer, one surprisingly effective method is to have your photographs appear on models' comps with your name as credit. Model agencies send comps of their models to practically everyone in the fashion business: designers, buyers, people in retail and people in the trade. The publicity can be substantial. Once people become aware of your name, and your style of photography, they will be far more receptive to seeing your portfolio. Practically every fashion photographer begins this way. It is a proven route to success.

One final tip: in arranging appointments with art directors and fashion editors, explain that you are new to the business but that you have developed a number of new visual ideas for shooting fashion, assuming, of course, that you have. A request for an appointment will rarely be refused.

McCall's
*5741 *5742 *5743

McCall's
*5619

McCall's
*5705 *5675

A two-page magazine spread for 'sew-it-yourself country casuals'. When directing two or more models, the most practical method is to first work with each model individually, rehearsing the fundamental direction. Then, when the models are brought together, each will have their part to play and a great deal of wasted film and time will be saved. My own preference, is to carefully stage two models and concentrate on giving direction to the third. Most important of all, to allow for the maximum area of fashion to be shown when the transparency is enlarged, the models must be positioned to overlap each other.

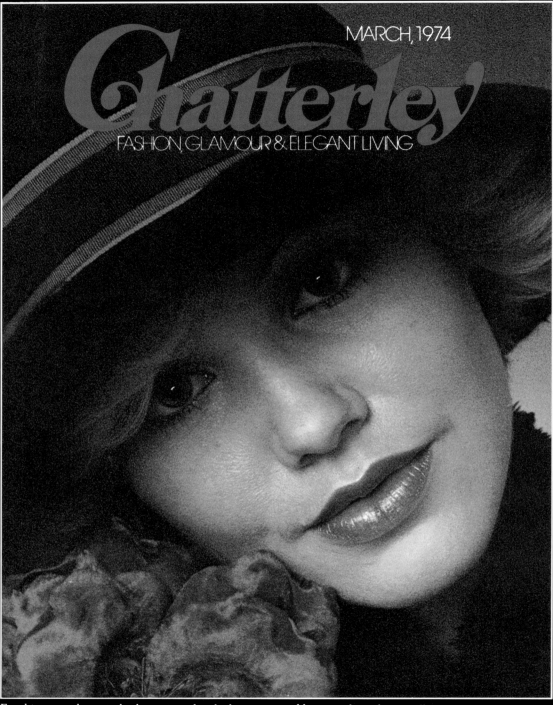

MARCH, 1974

Chatterley

FASHION, GLAMOUR & ELEGANT LIVING

For this cover photograph, the grainy, ultra-high speed of GAF 500 film was used to achieve a soft romantic effect, difficult to perceive here in reduced size but extremely effective when blown up and adding greatly to the overall artistic impression. Current average editorial rate paid by fashion magazines for covers is $400. Model: Trixie Schenk.

The truth about magazines. Glory vs money.

Perhaps the most sought after of all assignments in photography are the ones for the glamour pages of fashion magazines. For the uninitiated, a dream exists that fame and fortune comes to those whose work appears in these magazines. But such glory comes to very few.

A page of photography in even the most illustrious of fashion magazines pays only $200. Not a princely sum for professional photography.

To entice the professional, a tantalizing bribe is offered: your name will appear along with your work. But as these credits are set in such small type as to be discernible only to those who take the trouble to locate them, you may question their value. The only great advantage of having credits is that they represent proof of your work.

Shooting for magazines is never a simple task. Days of preparation precede every shoot. Meetings must be attended with the art director and fashion editor and time has to be reserved to search for a shooting location or to create a special studio set.

A major problem to be aware of is that if the gang from the art department insist on tagging along on the shoot, inevitable conflicts of opinion will arise as to how the shoot should be handled creatively. In this case, you will either have to fight for what you believe to be creatively right, or be bullied into making compromises. The latter can be a soul-destroying experience.

For the busy photographer with a studio and high overheads, magazine photography is often too demanding as well as being financially unattractive. But for the photographer with only a camera over his shoulder and no ties to inhibit his traveling, shooting for magazines can be a worthwhile endeavor. And for the newcomer, it is the route to recognition.

More about fees.

Even though a single page may contain more than one photograph the standard procedure is that the fee remains at $200. On the other hand, when a single photograph is printed across a two-page spread, the fee becomes $400. One makes up for the other.

Quite often, block assignments are given, consisting of six to eight pages of fashion to be photographed at one time. At the standard rates, this amounts to $1,200 to $1,600 for the shoot. Naturally, this makes the assignment more worthwhile.

Whether the assignment is shot in color or black-and-white, the fee paid remains the same. The cost of film, processing, and black-and-white prints, are normally reimbursed by the magazine.

The truth about magazines.
Glory vs money.

Magazine covers.

With magazine covers, the standard rate for photography is $400 before expenses. This is the current average in both Toronto and New York.

Because the cover has such enormous influence over the sale of the magazine, the final choice of photographer is subject to the opinions of many. Under such conditions it is not uncommon for an accepted photograph to later become rejected. Consequently, the policy of many magazines is to invite you to 'test' for a cover on the understanding that only if the photograph is published will you be paid. But you would be well advised to give these terms careful consideration. Professional models do not test for a cover without being paid, and neither should photographers.

Out of town assignments.

Being sent to a tropical island or a distant country with all expenses paid is the plum assignment for practically any photographer.

To capture a model's 'visual innocence' requires a certain frame of mind on behalf of the photographer. The temptation to direct a model to act is best avoided as the results are practically always met with disappointment. The most effective approach is to concentrate on giving a model the greatest degree of confidence on the set and to encourage her to experiment openly with different ways of conveying her feelings and emotions. Only when this attitude prevails can a model gaze into a camera with the degree of visual honesty as shown by top teen model Hayley Mortison.

These shoots usually take a week to ten days out of your working schedule and although you are never paid on a day rate for the actual time you are away, you are usually commissioned to shoot from eight to twelve pages. Based on average page rates, this amounts to $1,600 to $2,400 in net fees.

On speculating.

However anxious you may be to receive an assignment never suggest that you would be prepared to undertake the first shoot at no charge. The prestigious magazines never work this way. And other magazines, should they take you up on your offer, may not feel inclined to hire you the second time. Firstly, any service that is provided at no charge is considered to be of questionable value. And secondly, it is contrary to human nature to have to pay for something that was once free. Don't sell yourself short.

Landing a well-paying retail account requires skill, determination and a sprinkling of luck. It is 'big game' pursued by practically every commercial photo studio – for even a small contract can be worth several thousand dollars. For the professional photographer, every retail client represents a potential bread-and-butter account. With a guaranteed volume of work, overheads are paid and each job for every other client becomes pure profit.

The strategy initially is not to solicit the entire account, but only a single promotional event. With department stores, each promotion on its own is a possible contract: Mother's Day, Father's Day, Back to School, Christmas, January Clearance – and practically every promotion is supported with newspaper advertisements, posters, flyers, and credit card mailers. A number of retail stores have even launched their own catalogue-style fashion magazines. The amount of photography from these department stores can be substantial indeed.

Planning the attack.

The art of soliciting clients lies in seeing the right person, the one who truly has the responsibility for hiring new suppliers. Although many will claim to be so empowered, the authority to hire, even in the largest organizations, usually rests with only one or two persons. With retail accounts, you should see the advertising manager or the art director in charge – and no one else.

In any communications, try to avoid reference to yourself as a 'freelance' photographer; it implies instability. Appreciate the conservative mentality of large business; people authorized to hire suppliers for any volume of work cannot risk working with what appears to be a 'one-man-band'. Should you introduce yourself as a freelancer, in all likelihood you will be directed to see one of their present photo studios. If you have high ambition for your own studio, this direction will undoubtedly lead you nowhere.

When undertaking photography for competing retailers the only way to maintain each account without creative conflict is to establish a unique visual style for each. This can be achieved technically through reserving certain techniques in camera perspective for one particular account, or by establishing certain creative approaches for another retailer which will result in a different look or feeling to the photographs. In this manner, I have worked for Eaton's, Sear's and the Bay all at the same time and without conflict. In projects such as those shown, the average rate paid per photograph was $500 to $900, depending on the complexity of each. Fortunately, each project is quoted fresh, regardless if it is a repeat promotional event. This allows for cost adjustments for model fees, film and processing and the natural rise in rates by all suppliers.

How to land a good retail account.
A matter of strategy.

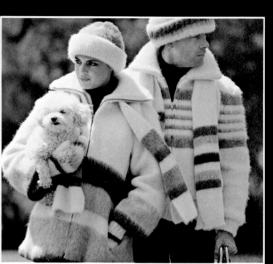

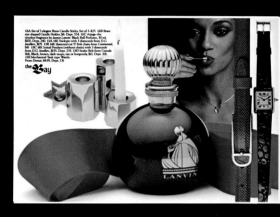

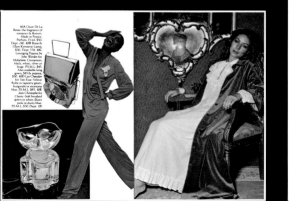

How to land a good retail account.
A matter of strategy.

To contract any volume of work from a large retail account, you must be able to handle all the art and assembly involved in the mechanical production of the job. For this, you will need to make an arrangement with an art studio to prepare the art boards. (This consists of drawing in key lines, placing stats or photographs in position, retouching, pasting up any type, and preparing an overlay mask for screening.) Then, when you introduce yourself to a prospective client, you can explain that you are representing your studio not only for photography but for production work as well.

Before soliciting any account the first step is research. It is a risky proposition to make a presentation without being familiar with the client's advertising. Collect tearsheets of the store's advertisements. Obtain copies of their flyers, booklets and catalogues and have them with you when you make your presentation.

Be prepared to discuss improvements and ideas, but avoid issuing negative criticism. Even if you find the client's advertising dull and uninspired, always reserve your opinion. Construct

Most fashion photography for department stores should not be treated with Vogue sophistication. It is simply not good salesmanship to be misleading. As well, high fashion models with trendy make-up and freaky hair styles are usually shunned by these mass market retailers; instead, pursue understated glamor that you are certain most people can relate to.

intelligent recommendations. This is the best weapon.

Expect to solicit a great number of accounts before you find one where you are enthusiastically received. In one art director's mind, your work may appear too creative; in another, your work may be just the inspiration he is looking for. After all, judgment of one's creative work is a highly personal and subjective matter.

The head office of any large retail store is a complex organization and opportunity may exist in more than one department. When I first approached the Hudson's Bay, I was given the impression that all of their advertising was handled by one department. But I later discovered that there was a national advertising office as well as a local advertising office, both in the same building. Few outsiders knew this. The manager of the local advertising department was unimpressed with my work and turned me down flatly. Yet the national advertising manager was overwhelmingly enthused and hired me on the spot. In the quest for business, leave no stone unturned.

When you are soliciting a major retail account, you will be pitting yourself against large, established studios. And it is the nature of the retail business that once a client has developed a comfortable working relationship with a studio, he will go to great lengths to avoid the trauma and inconvenience of training someone new. For these reasons,

How to land a good retail account.
A matter of strategy.

concentrate on winning only a small portion of the account. Your success will hinge on how well you present your case for the small, creative studio. Here is some ammunition:

1. Point out your working capacity. I always advise a potential retail client that I can produce at least one spread of photography a day based on an average of eight photographs to a spread. This immediately perks their interest.

2. Assure your client that because you will personally undertake all the photography all the work will have a single distinct style. This is always a tempting proposition. Many art directors will tolerate any inconvenience in working with a small studio in order to make this achievement.

3. Communicate to your client that you are in the process of building a creative reputation and that you will put more fire, energy and enthusiasm into producing good photography. Art directors know that large studios cannot sustain these drives.

4. Explain that you do not have the enormous overheads of a large studio

Most product photographs for department stores are of inexpensive, mass-market merchandise and therefore attention must be given to dressing the shot. In this chinaware setting, choice of color and props helped to enhance its pattern and design and thereby increased its appeal. The lace tablecloth was also required to be shown and one solution was to lift it and pull it taut so that the pattern could be clearly shown. This also added a strong element of graphic design to the overall photograph. Standard rate charged: $750.

and for this reason you can quote 15% to 20% lower than a large studio. This is an especially enticing reason for a client to consider directing part of his account to your studio.

If an art director decides to give you an opportunity to work on the account he is testing more than your creative ability. He is concerned (1) that you understand their advertising objectives and are capable of interpreting them, (2) that you can complete the assignment with the minimum discussion and without complications, and (3) that you can deliver the finished project to his office in the required time without delays, excuses or apologies.

When soliciting accounts, success often lies in keeping well-informed. Art directors and advertising managers move from one company to another with amazing frequency. With each new appointment the slate is usually wiped clean – the current suppliers are looked upon as belonging to the old *régime* and may suddenly find themselves replaced. Within those first months, new suppliers are asked to quote and new contracts are cemented. This is the time of greatest opportunity.

Marketing Magazine in Canada and *Advertising Age* in the U.S.A. are invaluable sources of information and *Retail Ad Week*, published by the Retail Reporting Bureau in New York, will keep you abreast of all the latest retail campaigns in North America.

How to quote.

Here are the standard rates charged by commercial photography studios for retail work. The rates are the same for color or black-and-white photography. Film, processing and black-and-white prints are normally charged as extra. Model fees are always quoted separately.

1. For catalogue photography.

The average rate charged for a single photograph is between $500 and $900. Additional inset photographs to show detail are normally charged between $200 and $350 each.

To quote for a catalogue assignment, multiply the number of photographs by their appropriate rate. For example, a 72-page Christmas catalogue which contains 150 major photographs quoted at $500 to $900 a photograph would total between $75,000 and $135,000 for photography.

Never attempt to quote from a verbal discussion. Always request a copy of the layout to accurately determine the number of photographs and amount of work involved.

2. For newspaper advertisements.

Here the average rate charged for a single photograph is between $350 and $500. Additional photographs for the same advertisement are normally charged at $75 to $125 each. These rates are usually based on a volume contract of no less than six advertisements. For one-time rates, charge as for catalogue.

3. Budgeting for models.

To determine the model budget on almost any retail assignment, allow yourself one hour of model time for each garment. This is the standard in the industry.

4. Quoting competitively.

Many photo studios may be asked to quote on the same job. As all studios charge approximately the same rates, you may be asked to re-submit your quote in order to be more competitive. This usually occurs when a client is especially keen to hire you but is forced to secure the lowest possible quote to satisfy his management. I have had this happen on a number of occasions.

Making money on production.

If you are hiring an outside service to prepare the final art boards, you should be able to mark up their charges by 15% and still remain competitive. If not, you need a more reasonably priced supplier or one who will give you a discount.

There is one other alternative which could prove more profitable: invite an assembly artist to join you and work out of your studio. A good financial arrangement would be to split the income on production.

To locate an assembly artist, contact the placement department of an art college. They will contact students who have graduated and who they believe to be the most suitable, and ask them to call you. All art colleges with commercial art courses train their students in the mechanical aspects of production.

Art assembly is usually billed out at $40 an hour and all quotes are based on the time assessed to complete the job. The standard invoicing procedure is to charge cost plus 15% on all typesetting, stats and materials.

Your assembly artist may not be qualified in air-brush retouching. This is a speciality and you will have to hire the services of an independent retoucher.

Air-brush retouching costs from $40 to $60 an hour and as there is no limit to the amount of retouching which can be done on a photograph, be very specific in your request. The best way to give instructions is to lay a sheet of tracing paper over the print and mark those areas to be retouched. By referring to the client's previous art boards you can safely determine the amount of retouching they expect. Also, every retail organization has their own set of specifications and a special way of doing things. Therefore, it is quite appropriate for you to ask for one of their previous art boards to duplicate their techniques.

For this full page magazine advertisement for Parker pens, a letter from an archaeologist on a dig in Marrakesh formed the story for this still life setting. An old weather beaten writing desk was located in an antique shop and the local museum gave permission for the shoot to be done on their premises where priceless artifacts could be used. By adding an antique watch, stamps, a magnifying glass, and a sprinkling of sand, the story began to unfold. For strong, diffused lighting indicative of a hot environment, a strobe head was aimed directly into a double thickness of frosted mylar. A white reflector card on the shadow side placed the long reflection on the pen and added the highlights to the gold arrow on the cap. To shoot life-size, the camera bellows were fully extended on the 8 x 10 and a multiple flash exposure was taken with the shutter left open in order to build up to the necessary depth-of-field. Fee for photography: $2,500.

How to get on the preferred list with advertising agencies.

Of all the areas of opportunity for a commercial photographer, one stands alone – the advertising agency. This is the creative mecca where visual greatness can be achieved. And here, art directors who represent their clients, are prepared to pay for the one great shot.

Getting on the preferred list is a matter of winning the respect of art directors whom you would like to work with, art directors who in themselves are making visual achievements and are seeking to forge relationships with photographers who see and think the way they do. This is a matter of marrying visual philosophies.

In my own instance, I have found that on the average, I have had to make presentations to at least 10 art directors before finding one who was excited with the visual possibilities of our working together.

Often, a great deal of money is at stake and reputations ride or fall on a single advertisement. Selecting the right photographer is the most critical decision an art director can make when working in print media and every new photographer is naturally approached with skepticism. The success of the relationship is based on your understanding what the art director is trying to achieve, and this requires an appreciation of how advertising is actually engineered into being.

At one time, I was under the impression that creative people in advertising agencies were magical geniuses, and that advertisements were created virtually out of thin air. Later, as a copywriter in the illustrious firm of Ogilvy & Mather Advertising, I learned that advertising was created according to very specific guidelines.

The master of the agency, David Ogilvy, ruled his brood of creative people with a disciplined hand. In his shop, advertising was not created willy-nilly. Instead, a set of principles guided the way. These principles were gleaned from years of research and readership studies. Advertising was shown to be a highly disciplined art.

In his book of *Confessions of an Advertising Man*, David Ogilvy encapsulated many of his ideas for creating effective advertising. Nothing has been more instrumental in my own personal success than abiding by the rules and credos he set forth.

David Ogilvy states, "On the average, five times as many people read the headlines as read the copy. When you have written the headline, you have spent eighty cents out of your client's dollar. Therefore, if you haven't done some selling in your headline, you have wasted 80% of your client's money". Such wisdom gave me respect for the power of a good heading.

In photography, never underestimate the importance of the heading. Often, it will be your sole responsibility to make it work.

As a copywriter creating advertisements, I had to know what constituted good photography. David Ogilvy's dictum provided the guidance, "The *subject* of your illustration is more important than its *technique*. As in all areas of advertising, substance is more important than form. If you have a remarkable idea for a photograph, it does not require a genius to click the shutter. If you haven't got a remarkable idea, not even Irving Penn can save you."

It is not uncommon for an advertising agency to spend over $10,000 on the creation of one single advertisement. When you consider that a further $100,000 may be spent on advertising space it should not be difficult to appreciate the near fanatacism with which agency people pursue creative and technical excellence.

Because of the creative nature of advertising, you will find no two agencies alike. Each has a unique philosophy, and a unique point of view. The smaller the agency the more creatively daring it tends to be; the larger the agency, the more it is governed by research, and the more conservative it tends to be.

The spirit of the agency is in the hands of its creative director. This is the person who inspires the creative team onwards. Art directors are responsible for the visual impact of the advertise-

ments and copywriters write them.

The responsibilities and titles vary with different agencies. With a small agency you may deal with the creative director while at a large agency you will certainly deal with the art director.

Art directors will rarely linger over a portfolio. They are looking for style and feeling, which they can see at a glance.

I always feel numbed when an art director flips through my portfolio non-stop from one image to another without pausing to give them close study. This can be disheartening, but the top art directors are usually the busiest, and I am amazed at the number of times I have made a presentation to an art director who seemed completely indifferent to my work only to receive a call from the same art director a few days later asking me to quote on a job.

Agency people, commissioned with the responsibility of spending enormous sums of their client's money, proceed with the utmost caution before committing to work with any new photographer.

The best way to encourage a prospective client into hiring you is to ask questions which demonstrate you know the business. If you appreciate the finer points on how to create good advertising you will have greater success in bidding for lucrative accounts than most of your colleagues.

It is most important to appreciate that every advertisement is conceived to meet precisely defined objectives. Therefore, the first question to ask is,

Large blow ups for posters and subway cards, such as this one for Yardley, should be taken from a transparency shot on 8 x 10 in order to have the lowest magnification and therefore retain the maximum detail. Because of this poster's unusual proportions, the layout was scaled down to a tissue tracing and placed over the focusing screen of the camera to facilitate accurate composition. Fee charged for the poster was $1,100 as well as a further $1,100 to adapt the composition to a full page magazine layout.

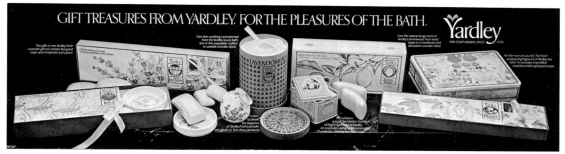

"What is the objective of the advertisement?"

An advertisement for a new brand of toothpaste may have the objective to introduce a new ingredient that results in 42% fewer cavities. An advertisement for Scotch whiskey may have the objective of promoting the fact that it has been aged for 12 years in oak casks in the highlands of Scotland. These facts have been predetermined by research as being the most influencing propositions which affect the sale of the product. The photographer's responsibility is to visually demonstrate the objective.

In creative meetings if you do not have a solution for a creative problem, resist the impulse to guess wildly. If you suggest visual ideas which are not in keeping with the image of the brand, you will undermine the client's confidence in your ability. Keep examining the objectives. The more clearly you understand the problem, the more apparent the solution becomes.

The second most important question is, "Who is the target audience?"

A new health-food cereal may be directed to parents with young children. A freckle-faced boy in some endearing situation may form the major illustration and the product shot may be used as a large inset in the advertisement. The cereal package may be surrounded with small sacks of grain and scoops of raisins, nuts and other ingredients. With this creative approach, the advertisement appeals to its audience with absolute clarity.

Probably the most commonly heard term in advertising agencies is 'concept'. This describes the general idea for an advertisement or commercial before the execution is completely worked out. If you are asked to work on a concept it means you are given creative freedom to interpret the objectives. To achieve this, you will need to know what the selling problems of the product are as well as its objective and target audience. From this information, you can develop concepts that solve the selling problem.

When you are given such creative license, inundate your client with recommendations. This is the time to establish yourself as a thinker and as a problem-solver. This is the time to win votes.

*How to get on the preferred list
with advertising agencies.*

Seemingly simple package shots present the
exasperating problem of how to avoid reflections on
their shiny paper surface. A polarizing filter
minimizes the problem, but rarely eliminates it. A
matte finish dulling spray may be applied, but this
usually leaves a stipple surface and can cause uneven
lighting. The best solution is to use a soft diffused
light source as this will automatically reduce specular
highlights and then to angle the light critically so that
it does not fall directly onto the package. This will
require extra fill lighting to prevent the package from
appearing gray or heavy in tone.
Fee for above was $1,250.

Shooting pictafilm.

Ideas for a television commercial are drawn up on a storyboard which is a layout sheet with rows of blank tv screens printed on it. Pictures are drawn into the tv screens to show the proposed sequence of events for a commercial. Once the storyboard is approved by the agency's client, the agency may then proceed to a test commercial which may be in the form of a pictafilm.

Photographs are taken which illustrate the storyboard and then re-filmed with a movie camera. Soft dissolves are often used so that one sequence flows into another and camera techniques, such as panning, create the appearance of motion. Combined with sound this gives a client a very clear idea of the way the final commercial will appear. If there are any major problems they can be resolved early before the expense of a full scale tv production. Clients on limited budgets may even air a pictafilm commercial or use it as a test pilot in a secondary market.

On a shoot for a 60-second pictafilm commercial for Nabisco, the production director from the advertising agency requested I use twenty rolls of 2-1/4 Ektacolor print film which would amount to 240 images even though less than a dozen prints were to be used in the final production. With pictafilm, be prepared to shoot a lot of film.

Establishing your rate.

The most important figure that you will need to establish is your day rate. With advertising agencies, art directors always need to know what it would cost to hire your services and studio exclusively for a full day. Advertising agencies are extremely demanding and they appreciate the time involved when pursuing creative excellence and they are therefore accustomed to working on a day rate basis.

Day rates range from $600 to $3,000 depending on the caliber and reputation of the photographer. The average day rate is around the $1,200 mark.

Generally, a day rate is not expected to include film, processing, prints, props, rentals, model fees or travel expenses. These are billed in addition to your fee.

When invoicing advertising agencies, the standard procedure is to show all charges as 'net'. This means without an agency discount. In the past, all photographic studios gave agencies a 15% discount off their total fee but this practice has lessened over the years. As one way of keeping up with inflation, studios and photographers have become less willing to discount their invoices. Some studios still cling to tradition, so you can expect an agency to ask if your billings are 'gross' or 'net'.

IV
How to crack the art market.

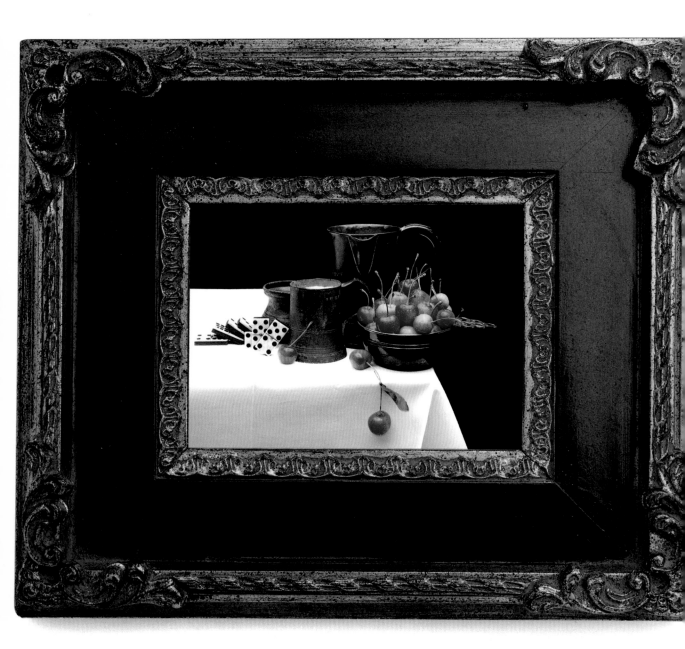

Packaging yourself as an artist.

The photographic art market is quietly gaining momentum in North America. Photo Art galleries are springing up everywhere. Photographic art is recognized in every auction house and commands increasingly high prices. At last account, an original print of Ansel Adams' *Moonrise, Hernandez, New Mexico* sold for a record $22,000 at auction. And prominent auctioneers agree they can see the day when a single photograph will fetch $100,000.

As with all art, the value lies not so much in the subject matter as it does in the value of the artist's name. Inevitably, the highest prices are commanded by the artists who are both recognized and prolific in their work. When an artist has the support of gallery exhibitions and press publicity, there may be no limit to what collectors will eventually pay.

The object in any endeavor, of course, is to be successful in the shortest period of time, and not have to invest a good part of your lifetime before you can reap any rewards. As with all achievements, only a disciplined, organized plan can bring you to realize the highest ideals. This means you must plan every step of your career and actually promote yourself into a successful name.

Tilted 'Pewter and Cherries', a limited edition of 15 prints were made, each priced at $1,500. Originally photographed on 4x5 Ektachrome transparency film, the final prints were made by the dye transfer process allowing the highest degree of color quality to be achieved.

The quickest way to rise from obscurity is to put on controversial exhibitions. In this instance, it may matter little if your work actually sells; the gallery owner is satisfied with having attracted potential new clients to the gallery, and you should consider the publicity you derive from the show as ample payment.

A controversial exhibition, whether it is shocking, revealing or humorous, will tantalize gallery owners into showing your work, and provoke critics into writing about you. In the art of self-promotion, it is unimportant whether or not they agree with your visual statement as long as they are talking about you.

Before you approach a gallery, you will need to prepare a special portfolio. Here is what it should contain:

1. A resumé outlining your education and art training, work in related fields, one-man and group shows, awards received, collections to which any of your work belongs, a list of publications in which your work has been reviewed.

2. Copies of any published material.

3. Selected prints for your proposed exhibition, mounted on gray or black artboard of at least twice the size of the print.

4. 2-1/4 color slides of other exhibitions or projects, mounted in glass and slipped into plastic sheet holders for easy viewing. (35mm slides are not practical for a presentation unless they are shown through a projector.)

For any photographer working with the human form, nude figure studies can be as invaluable to him or her as it is for an art student in anatomy. Lighting the human form to increase or reduce shape and to create aesthetic, natural poses with the least amount of folds and creases in the skin are a necessary prerequisite in fashion, beauty and lingerie photography.

If you are just beginning, and your resumé is short on background experience, concentrate on a viewpoint or story about your work. Arrange your resumé and any other printed material between protective acetate sheets and organize them in a simple, black binder.

The most important decision you will make in putting together an exhibition is a theme. If you are not in hot pursuit of controversy, examine the classic themes of still-life, landscape, and romantic period-style portraits. Here are the subjects which have enraptured painters for centuries and are the subjects the art market has been pre-conditioned to buying. Quaint fishing villages, a rolling wilderness emerging from the morning mist, a pounding panoramic seascape, or a rustic wicker basket spilling over with freshly picked fruit; these are the subjects that have proven their appeal and are the classic images that dominate the interest in the art buyer's mind.

If you put together a photo-journalistic essay on the poverty of the Eskimos, or the death of the great American Indian, although the study will have cultural significance, it will have dubious sale value to the public even though great curiosity may be aroused.

Nudes are another temptation. If the photograph is executed in the modern contemporary style which is often boldly revealing, it is doubtful whether a woman will encourage her husband to hang one in their home or in his office; and she certainly won't be enthusiastic about his buying one. But if the nude is successfully done in the classic, traditional manner, any offense is removed and its possibility of sale will increase.

Photo-journalistic essays of war, famine and poverty are equally discomforting, and generally not something one would want to live with day after day. Bear this in mind when developing ideas for themes. Remember: the art market exists because people wish to decorate their homes with what is fundamentally aesthetic, or pleasing to the eye.

*Graphic and artistic studies are most easily composed
from subjects having naturally inherent strong design,
such as this Westminster style bird cage. The doves
were coaxed into position, and our studio kitten
(which we inherited from another shoot) was
attentive long enough to allow me to fire the camera.*

Museums, galleries and art collectors are sticklers for quality, and when they purchase color prints they will rarely settle for anything less than the superlative quality of dye transfer prints.

Place a dye transfer print next to any high quality color print and the difference is usually astounding. Not only is the dye transfer process infinitely superior in color, but with this method of printing you will discover it produces deeper blacks, more separation in the grays, and a whole new range of subtle colors and tones – all the qualities that produce a print with more realism and dimension. By comparison, other prints appear disappointingly flat.

Apart from its extraordinary color quality, dye transfer prints are also more resistant to fading, and in the photo art market such permanence is an understandable necessity.

More than two-thirds of all gallery photo art exhibitions are in black-and-white for the very reason that most color prints are so unacceptable. And dye transfers, which are the ultimate solution, are rarely seen because they are considered prohibitively expensive and complicated to produce. Apart from this, the process itself is enshrouded in mystery to almost everyone other than color lab technicians.

Because it is such a highly customized method of printing requiring a great deal of hand work, the labs are justified in their charges, as most of the cost is for a technician's time. To pay $250 for an 11 x 14 print is not uncommon, but if you are producing dye transfer prints yourself, once you are set up, you can produce the same print for about $25. And to make repeat copies lowers the cost to about $7 a print.

As far as the process being complicated, making your own dye transfers is actually far less awesome than normal color-printing. If you have a darkroom set up for black-and-white printing and processing, you are amply equipped. No color-head enlarger is required. Your only special piece of equipment is a vacuum registration board which you can buy from Kodak. The great joy of working with dye transfer is that not only can the entire printing stage be handled in ordinary room light, but the process itself does not rely on critical times or temperature.

The principle of making a dye transfer print from a standard color negative is remarkably simple. (With a color transparency, more stages are required, which makes the process slightly more involved.) In the darkroom, using a regular enlarger and a set of three color filters, each primary color is filtered onto a sheet of film known as a matrix. In this way, three separate matrices are produced: one for cyan, one for magenta and one for yellow.

The matrix film is then processed and dried in a similar manner to black-and-white film. During processing, all the unexposed areas of the image are washed away leaving a positive image in

The magic of dye transfers.
The ultimate in color printing.

Berries photographed on 4 x 5 Kodak Ektachrome sheet film. A limited edition of 12 prints were made, using the dye transfer process, and each print was priced at $1,250. The berries were picked up from the street one day on the way into the studio and the wood section was taken from an old fence being torn down nearby. An overall spray of glycerine added the atmosphere of early morning dew.

The magic of dye transfers.
The ultimate in color printing.

The main components, clockwise from top:
Cyan, yellow and magenta dye for film
matrices. Paper conditioner for dye transfer
paper. Rubber roller. Registration board. Three
working matrices. Carton of Kodak matrix film.
Tanning developer, part A, rubber squeege, and
tanning developer, part B.

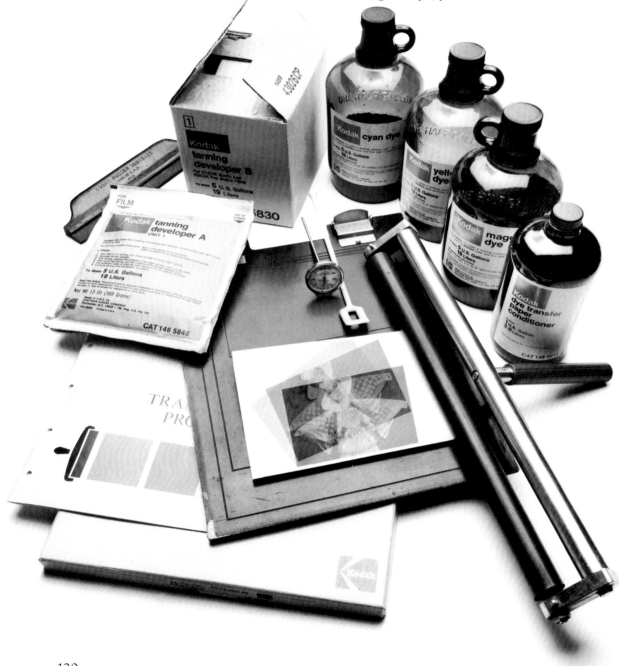

relief form. Each matrix is then soaked in a bath of its own color dye. The relief image absorbs and holds the dye much like a sponge.

By placing the matrix film face down onto a sheet of dye transfer paper, and by applying pressure with a small hand-roller, the dye is released. The remaining two colors are added on top, in perfect register – and a full color image emerges.

For the photographer making his own prints, the artistic control over the process holds its greatest fascination. You can manipulate colors making them purer or more vibrant. The contrast or color balance can be changed as easily. Highlights can be bleached giving the print greater brilliance. Shadows can be intensified giving the print greater drama. All this can be accomplished without altering the midtones.

With normal color printing the color emulsion lies in the printing paper in three separate layers. Critical exposing and complex color filtering are required in order to expose each layer. Temperature control must be kept accurate to plus or minus a half-degree, and prints must be whisked through printing baths with stopwatch timing.

But with dye transfer printing most of the printing process is controlled by altering the acidity of the dye and rinse baths. This is a process which can be done at a leisurely pace and with the lights on. The color-bath temperature is not critical, and the dyeing and rinsing of the matrix film is not subject to delicate chemical balance.

Equipment and materials.

To make your own dye transfers, here is what you will need:
- A vacuum register board, designed to keep all your color images in register.
- A soft rubber roller, at least 2" wider than the width of your print.
- Kodak Wratten Filters, No. 29 (Red), No. 99 (Green), and No. 98 (Blue).
- Kodak Pan Matrix Film 4149, for use with color negative film; or
- Kodak Pan Matrix Film 4150, for use with color transparencies.
- Kodak Tanning Developer, Part A and Part B.
- Kodak Fix, without hardener.
- Kodak Dye Transfer Paper.
- Kodak Dye Transfer Paper Conditioner.
- Kodak Matrix Dye Set.
- Acetic acid.

Before starting, obtain booklet No. E-80 *Kodak Dye Transfer Process*, available on request from: Eastman Kodak Company, Dept 412-L, Rochester, New York 14650.

This booklet explains in detail the steps and controls of dye transfer, including the making of color separations from color slides.

You can easily create the impression of an artist's water color print by using an antique printing method known as gum bichromate. Almost any negative can be used to create this artistic painterly effect, and all that is required are a few inexpensive chemicals and a reasonable degree of patience.

The gum bichromate process was developed in the nineteenth century when photographers were first experimenting with darkroom printing. With this method, you actually make your own emulsion, and then apply it to whatever paper you choose. The emulsion itself is made from a tinted, semi-transparent solution of gum arabic and light sensitive potassium bichromate, chemicals which are available in most art supply or science shops.

Unlike photographic paper which responds to light by darkening, the gum bichromate emulsion responds by hardening. After exposure, the print is developed in water under room light. The soft, soluble parts of the emulsion that were not exposed to light are washed away, leaving a delicate, water color image.

This printing method offers tremendous freedom not only in allowing you to use virtually any paper in any color or texture but also by allowing you to use a variety of water-color pigments to tint the emulsion. The image can also be re-exposed, adding a different color emulsion and gradually building up to a full-color print from only a black-and-white negative.

There are a number of stages involved but each time you go through the process it becomes simpler. As the gum bichromate print requires exposure from a high intensity light source and for an unusually long period of time, the print must be exposed through contact printing. This means that the print will only be the size of the negative and, in most instances, you will first want to copy your negative onto a larger sheet of film.

1. Preparing your negative.

To produce an enlarged negative, use *Kodak High Speed Duplicating Film, Type 2575*, available from a graphic-arts supply store. This film can be processed under a red safelight and will create a duplicate enlarged negative, thus avoiding the necessity of having to go through a positive stage.

Because gum printing works on such a short tonal scale, a detailed negative, with a flat tone appearance produces the best results. To achieve this low contrast on your duplicating film, use *Kodak Dektol developer*, normally recommended only for paper, and dilute the solution one part chemical to two parts water. The usual recommended developer with graphic-arts duplicating film will produce too high a contrast. But as technique in itself, high contrast negatives can be used to create interesting line drawing images which

Gum bichromate printing.
Revival of a classic art medium.

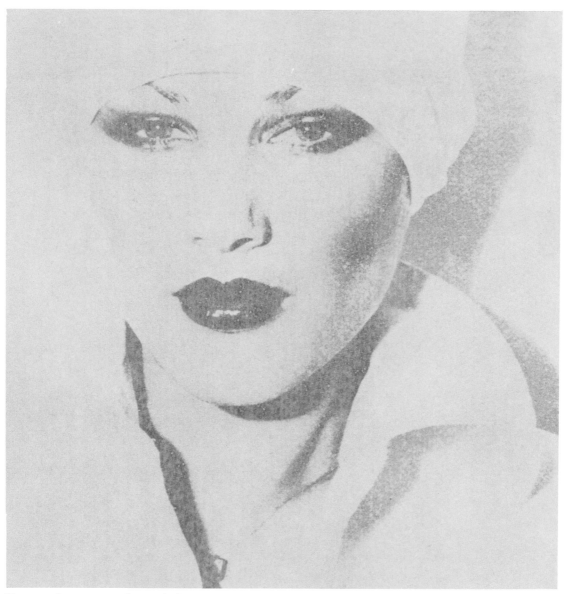

To create this vintage-style gum bichromate print, all tone was intentionally dropped from the original negative by copying it onto high contrast Ilford Ilfolith IH4 film. Burnt sienna water color pigment was added to the gum bichromate emulsion to give it a reddish-brown tint and the solution was then brushed onto a terra-cotta colored artist's paper.

are especially effective when printed on a coarse textured paper.

2. Choosing your paper.

Almost any paper can be used for gum printing as long as it is strong enough to avoid tearing after a lot of soaking in water. For a sharp image, use a smooth surface paper, and for a diffused grainy image, use a coarse paper. To avoid shrinkage and possible image distortion, soak the paper in a tray of hot water at 66°C (150°F) for 30 minutes, then hang it to dry. To prevent the pigment from sinking into the paper and staining it, a 'sizing' should be applied. To prevent the paper from curling when applying the sizing, first wipe over the reverse side of the paper with a damp sponge. Then coat the emulsion side of the paper with a sizing mixture consisting of two parts Liquitex gesso, one part Liquitex matte varnish and one part water. Most art supply stores carry these sizing ingredients.

3. Making your emulsion stock.

In advance, make up enough stock solution of your emulsion to coat several prints. The stock solution is a two-part system. To make part A, mix 28 grams (dry weight) of gum arabic powder to 56 grams of cool distilled water. As gum arabic is organic, this solution must be kept in a refrigerator after mixing. For a stock solution of part B, mix 14 grams (dry weight) of ammonium dichromate with 140 grams of water. This chemical is usually used in place of the slower acting potassium bichromate, but the result is the same. *Caution:* As all dichromate chemicals are potentially dangerous if inhaled or spilled on the skin, study the warning label on the jar before mixing.

Store the mixture in a dark cupboard since it is light-sensitive. However, the reaction to light is so slow that you can work with it safely under room light.

If properly stored, these stock solutions are usually good for two months or more.

4. Tinting your emulsion.

Measure 56 grams of gum arabic stock solution, add half a small tube of *Windsor & Newton* transparent artist's water color and mix thoroughly. Almost any dye or paint pigment can be used as long as it is water soluble. For a classic antique finish, # 006 Bright Red produces a deep, warm rose tone when exposed on a cream colored paper, and brown pigments produce shades of sepia. By varying the amount of tint, you can change the intensity of the color from the light and ethereal beauty of high key to the dark richness of low key.

5. Mixing your emulsion.

Add 56 grams of stock dichromate solution to the tinted gum arabic mixture. This emulsion should not be mixed until you are ready to use it.

6. Coating your paper.

Tape the paper to a work surface using artist's white paper tape. This tape will lift up easily without tearing the paper. Coat the paper with a thin layer of the mixed emulsion, using a wide flat brush to cover the maximum area with the fewest strokes. Spread the emulsion on using criss-cross strokes and work quickly, as the emulsion starts to congeal after only a minute or two. The emulsion surface must be smooth and any brush marks should level themselves out. Put the paper in a warm dark place to dry.

Note: If the coating is applied too thickly, the light will have difficulty penetrating the midtone areas. When this happens, the emulsion will not harden but will simply dissolve during development.

7. Preparing for exposure.

Exposure can be made without safelights and while working in ordinary low-level room light. Position the negative on the paper and secure it with small pieces of tape. Using push pins, make a pin-hole through two diagonally opposite corners of the negative and paper. These serve as registration marks for any future multiple printing. Place a piece of thick plate glass over the image area of the negative to contact the negative to the paper or use a standard contact printer which will apply the necessary pressure.

8. Your light source.

The ideal light source for exposure is a sun lamp as it emits a high degree of the blue-violet rays to which the dichromate is sensitive. Alternatively, a 500-watt photoflood bulb can be used but as it is low in blue-violet ray output it will result in a longer exposure time. Also, the heat from the lamp may bake the emulsion, prematurely hardening the print and causing it to become insoluble during the development process. Of course, the old fashioned way of using sunlight can be used, but it is the least practical.

A reflector should be placed around the light source to concentrate and direct the beam. Adjust the height of the bulb so that it distributes its light evenly over the picture. A recommended starting time for exposure is 20 minutes. *Caution:* When working with a sun lamp, protect your eyes with a pair of sunglasses.

9. Developing your print.

To develop the print, leave it for a few minutes face up in a tray of warm water at approximately 24°C (75°F) in order to soften the emulsion. As the emulsion is light-sensitive only when it is dry, all development can take place in normal room light. After two minutes have passed, gently remove the print and transfer it to a second tray of water, this time placing it face down. This allows the dissolved emulsion to sink to the bottom of the tray thus preventing the emulsion dye from settling on the surface of the print which, in turn, would cause staining.

As the water changes color from the dissolved emulsion, transfer the print to a clean tray of water. When the print is in this wet state, it is extremely delicate and should be handled with great care. To complete development will take from fifteen minutes to an hour.

Consider your first print to be a test print, and from here on you will be able to determine your exposure with more accuracy. On this first print, you may wish to use the standard 'wedge test' method of determining proper exposure in which a number of successive exposures are made on the same sheet of paper by drawing a piece of card across it at specific time intervals while the enlarger is on.

10. Multiple printing.

For increased depth and contrast, you can repeat one exposure on top of the other, applying a fresh coat of emulsion each time. Always use your pin-hole registration dots for lining up the print to the negative. For each successive printing, you will find you can reduce exposure to 1/3 of the original time.

11. Color printing.

You can print many colors on the same print working each time from the original black-and-white negative. For each re-exposure, apply a different color emulsion to those areas of the print where you want the color to appear.

12. Emphasizing highlights.

As the emulsion is very soft during development, highlight areas can be cleaned up by gently rubbing the remaining emulsion off with a small artist's brush. Doing so greatly improves the visual presentation. This method can also be used in multiple and color-printing either to remove an unwanted part of the image or to uncover an existing color.

If a yellowish dichromate stain should appear in the highlight areas, it can be removed by soaking the print in a clearing bath made from two tablespoons of sodium bisulphate diluted in one quart of water. A half-hour treatment should be sufficient.

The main ingredients, clockwise from left: A working solution of gum arabic and tinted dichromate. Dichromate crystals dissolved in water to make a stock solution. Sodium bisulphate in stoppered bottle. Dichromate crystals. Gum arabic crystals (although powdered gum arabic is actually preferred working material). A measured stock solution of dichromate. Tube of water color pigment.

Galleries usually take a commission of 50% on every piece of art they sell. But this is based on agreement beforehand with the artist, and is subject to negotiation based on the demand for the artist's work. The gallery has the best feel for what collectors will pay, and until your work begins to sell and you establish credibility you will need to rely on their expertise. With unknown artists, galleries will often set a ceiling on what any print will sell for and $200 is a common limit for black-and-white photographs. Draw up a suggested list of prices, but take the gallery owner's experience and recommendations into account.

In the final presentation of your work, a pencil signature and the date of the year is required on the bottom right hand corner. This indicates that the work is an original piece. If you are making copies, establish the limit you will print (25 is a standard edition for photo art), then mark each copy in consecutive order, and note it on the bottom left hand corner: 10/25 means the 10th print of a limited edition of 25. The fewer the numbers printed, the higher the value you can attach to each print.

The existence of the negative is the most controversial point concerning the sale of any photographs being sold as one-of-a-kind originals. One solution is to provide a sworn statement with the print, known as an affidavit, together with the original negative or transparency which could be rendered useless by the presence of paper punch holes. Some galleries will tell you this is unnecessary, but as the photo market is still in its infancy, it is only a matter of time before an art association or guild proposes such controls.

Enclose affidavit and negative in a clear, plastic pouch or envelope so that they are readily visible and attach it to the back of the picture frame. Normally, the gallery owner will also provide a guarantee certifying the work as an original piece, or as one of a certain number in a limited edition.

Such impressive documentation can only enhance the value of photographic art. If you violate any of the ethics of the art market, such as making and selling extra prints, the gallery owner will have legal recourse against you, especially in the event that one or more customers return any of your art; and once an artist's name is tarnished, it is a certainty his work will never command high prices.

Most galleries pay for the cost of mounting and framing and therefore keep the frames after the exhibition. Galleries rotate countless exhibitions through the same set of frames, changing

How galleries work.
Commissions and agreements.

only the mat. And some galleries require you to provide the die-cut mat cards, cut to a specified size to fit their frames with the photographs mounted in position. Naturally, if you pay the cost of framing, you should be either reimbursed by the gallery when any piece of work is sold, or negotiate a lesser agent's commission to defray the expense.

No work should be placed on exhibition without an agreement or contract between you and the gallery. This is standard practice. If this is not done at the outset, problems will inevitably occur which will dampen even the most jubilant enthusiasm.

Here are some other considerations: *Who is responsible for fire, theft, and damage?* It is the gallery's responsibility to insure for this. *Who has control of prices?* This is established before the exhibition between the photographer and gallery and cannot be changed without the consent of the photographer. *Who pays for the announcement cards or promotion?* The gallery usually undertakes this expense. *When can you expect to be paid for any sales?* The total amount from the sale of any of the photographs is payable in full within 30 days after the close of the exhibition. *What happens if a customer returns the work, or exchanges it for another piece of art?* Once you've been paid, this risk lies with the gallery. *Does the gallery have the right to rent the picture, and how much will you receive?*

Your permission is required in any matter affecting the use of your work, as it belongs to you by natural copyright. If you agree to renting, you should be entitled to the same percentage as that governing the sale of the work, or 50% of the income derived from the rental.

Galleries vary in their policies and you should have an agreement which spells out these concerns. By reviewing it with any gallery owner, you will be able to resolve all the questions of expense and responsibility which concern you. Even if the resulting agreement is only a verbal one, you will have greater peace of mind, as well as knowing you have adequately protected your work.

Practically every exhibition is done on a consignment basis. The gallery owner is risking valuable wall space, as well as any expense for promotion. When a gallery makes an outright purchase of the artist's work, it is because they believe that a genuine market exists for the artist's work, and that they are prepared to speculate on it. Therefore, they can re-sell the work at any price without further financial benefit to the photographer. But the higher the price paid for your work when it is re-sold, the greater the indication that you can charge more initially.

Exhibition costs are usually paid by the gallery or deducted from the first sales of the artist's work. These costs refer to the printing and mailing of invitations, transportation and insurance of works and opening night refreshments.

The best arrangement you can come to with a gallery owner is to put on a 'one-man' show. If your work is shown along with others, the impact of your presentation is diluted, and less significance is given to your name. To stand out, the best strategy is to stand alone. With a one-man show, fifteen pieces are considered a minimum exhibition but depending on the size of the gallery up to three-dozen pieces may be required. The average length of time for an exhibition is three to four weeks and an ambitious newcomer will want to be in a gallery, somewhere, every month if he is going to build up maximum exposure, as well as derive an income from his efforts.

In the photographic art market, there is a growing revival of interest in the techniques of early photographers. No technique has aroused more curiosity and experimentation than the gum bichromate method of printing. It has enormous appeal in the art market because of its resemblance to artists' water-color prints, and provides unlimited creative possibilities for the imaginative photographer.

The most successful photo art studies tend to have graphic or symbolic simplicity, as in this cover photograph for Epicure magazine on Oriental cuisine. This photograph evolved creatively by working with food stylist Jan Poon. The pink heart is actually salmon.

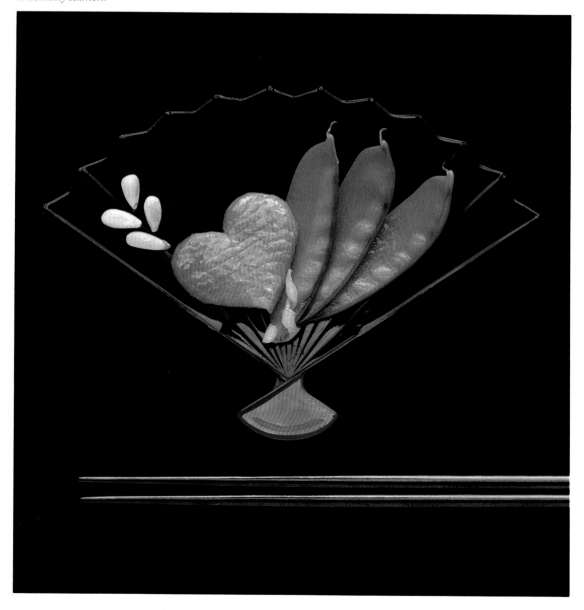

ARTIST/PUBLIC GALLERY STANDARD AGREEMENT

THIS AGREEMENT made in duplicate
the_____day of_____, 19_____,

BETWEEN: A, The "Artist"

— and —

B, The "Gallery"

WHEREAS the Gallery wishes to display the works of the Artist;

AND WHEREAS the Artist has assembled (or will assemble) the following works of art for display at the Gallery:

The Artist and the Gallery hereby agree as follows:

1. CONSIDERATION

1.01 The Gallery agrees to pay to the Artist the following sums:

a) rental fee $_____

b) lecture fee $_____

c) other $_____

TOTAL $_____

In consideration for which the Artist will deliver to the Gallery the works of art referred to in the preamble for display at the Gallery premises only, at_____ _____from the_____day of_____, 19_____, to the _____of_____, 19_____, both dates inclusive.

1.02 The Gallery may, at a further fee to be negotiated, and with the consent of the Artist, which consent shall not be unreasonably withheld, extend the exhibition to the_____day of _____, 19_____, and this contract shall apply so far as is applicable to the term of extension.

1.03 The said works of art shall be displayed in that portion of the Gallery premises commonly referred to as_____, comprising approximately_____square feet and shall not be interspaced with any other displays or works of art.

1.04 The said works of art shall be delivered by the Artist or his agent to the Gallery or its agent at_____ _____on the_____day of_____19_____, in a suitable condition for display, unless otherwise agreed. All costs once the said works of art have been delivered shall be the responsibility of the Gallery.

1.05 Upon delivery to the Gallery or agent no matter at what stage of completion the artwork shall be at the risk of the Gallery which will keep and maintain insurance against all risks and in the event of damage to the artwork (no matter how caused) the Artist is entitled to the proceeds of all policies of insurance and such further monies from the Gallery as may be necessary and sufficient to repair the said damage or compensate the Artist for same.

1.06 Costs of shipping the works of art to the Gallery premises shall be the responsibility of_____ and shipping costs returning the said art work to the Artist shall be the responsibility of_____.

1.07 Packing and crating costs of the works of art to the Gallery premises shall be the responsibility of_____ _____ and packing and crating costs returning the said artwork to the Artist shall be the responsibility of_____.

1.08 The Gallery agrees to purchase the following works of art at the hereinafter listed prices:

a)_____ $_____

b)_____ $_____

c)_____ $_____

TOTAL $_____

1.09 All of the works of art referred to in the preamble are to be displayed in the exhibition and no deletion is to be made therefrom without the consent in writing of the Artist.

2.00 CATALOGUE

2.01 The Gallery shall produce a catalogue listing, detailing and illustrating (in part) the works of art on display and shall be of the following specific description:

a) Number of copies _____

b) Total Cost _____

c) Dimensions _____

d) Pages _____

e) Containing _____color reproductions in the dimensions _____

f) Containing _____black-and-white reproductions in the dimensions_____

g) With an introduction by_____

h) The Curator to be _____

2.02 The catalogue shall be prepared with the co-operation, advice and consent of the Artist.

2.03 All expenses for the said catalogue shall be the responsibility of the Gallery.

2.04 The Gallery shall pay to the Artist the sum of $_____ for use in catalogues, posters and promotional material for sale, the following material:

a)_____

b)_____

c)_____

2.05 No use of the material referred to in paragraph 2.04 hereof or of any of the material referred to herein shall be made without the written consent of the Artist.

2.06 Any materials, copies of materials and/or slides, videotapes, audio tapes, photographs, etc. may be retained only with the consent in writing of the Artist.

3.00 INSTALLATION

3.01 The Artist shall assist and advise on the installation of the said works of art in the said space and for the purpose of so doing shall be available to the Gallery from the_____day of_____, 19_____, to the_____day of_____, 19_____.

3.02 By way of express exclusion from the general provisions of paragraph 1.04 the responsibility for framing, matting and glazing of the works of art listed hereunder shall be the responsibility of the Gallery and at the termination of this contract said frames, mattes and glass will/will not be surrendered to the Gallery:

4.00 PROMOTION

4.01 The Gallery agrees to promote the said exhibition of the Artist's work in all its regular publications and as a part of its regular campaign of advertising.

4.02 The Gallery agrees to sponsor an "opening" of the said exhibition. The said "opening" shall be held during the first week of the exhibition. It shall be specially advertised and notices shall be sent to all members of the Gallery and to a list of persons not more than_____in number to be supplied to the Gallery by the Artist.

5.00 Any monies owing by the Gallery to the Artist shall be paid within thirty days of the opening of the said exhibition; payments in default shall bear interest to be paid at the rate of 1-1/2% per month.

6.00 Any dispute (other than the validity of the agreement) shall be resolved conclusively by an arbitrator to be nominated by the Gallery and acceptable to the Artist. In the case of deadlock in the appointment of an arbitrator either party may apply to a Judge of the Court of Queen's Bench.

7.00 In the event of the Artist's incapacity to complete the artwork or to deliver the artwork to the Gallery premises this contract shall be void and of no further force or effect.

8.00 The artwork shall be produced and ready for installation or delivery by the_____day of_____, 19____, and variations in the delivery schedule may be agreed to from time to time by memorandum in writing and consent for such variations shall not be unreasonably withheld.

8.01 No assignment of this contract shall be made by either party without the consent in writing of the other.

9.00 This agreement shall enure to the benefit of and be binding upon the parties hereto and except as hereinbefore otherwise provided, their executors, administrators, successors and assigns.

IN WITNESS WHEREOF the parties have duly executed this agreement as at the year and date first above mentioned.

Contract reprinted by kind permission of CARFAC.

V
Building a reputation.
Advice to the freelancer.

People in the advertising business are sensitive to image, for the promoting of ideas and people are all part of their daily business. They thrive on working with 'heroes and stars' and photographers are often viewed as celebrities. Knowing this may affect the way you present yourself – in appearance and in conduct.

In establishing your image, the objective is to communicate success. This requires that you cultivate a look that separates you from the struggling artist. You may see yourself as a high-powered Ferrari ready to leap forward and take on the competition, but without a convincing image you will never be given a place on the starting line.

A common misconception is that it is your portfolio which sells you. Your portfolio may sell your ability, but it will not sell you, as a person. Do not underestimate the difference. An art director may look through hundreds of transparencies and page upon page of samples of your work and be suitably impressed but this will never be sufficient to convince him that you are the right person for the job.

In the back of the art director's mind dwells the nagging question: "How do I really know that he can shoot my idea or my product?" Unless an art director sees the exact solution to his problem in your portfolio, his judgment of you must be based on more than your ability. It must be based on confidence.

There are too many unknown factors which run through his mind as he thumbs through your presentation: Was the photographer the inspiration behind the photograph or was it the art director? How professional is this photographer? Can he pull the shot together quickly, without relying on me to solve all the details? Is he an established photographer, or only a gypsy with a camera? Does he have a studio, or is he working out of a van? Is he a struggling photographer who cannot afford to finance the shoot and who will annoy the accounting department with requests for advances or immediate payment? Will my client be impressed with him? Can I afford to take a chance?

Appreciate the nature of the creative business. Every advertisement or project that an art director is working on is of tremendous personal significance. It is testimony to his talent. It is a calculated risk with the client's money. His reputation is staked on the outcome. He has to believe you can do the job.

In your enthusiasm to impress the art director, or prospective client, with your abilities, avoid the blunder of giving

Without an image, you're only a gypsy with a camera.

negative criticism to his existing photography or advertising.

When I pitched the Fairweather chain of fashion stores, I proceeded to tell the advertising manager everything that was wrong with the company's advertising and how much I could improve it. But instead of being placed on a white horse as their saviour as I had expected, I was quickly shown the door. I have since cultivated the art of diplomacy.

Your image as a successful photographer can only succeed if you have integrity of purpose. This means that you must ruthlessly examine what you are capable of producing. If you conclude that you can produce work of a caliber equal to that of a high-paid professional, then leave no doubt in other people's minds that you can rise to the challenge.

Locating an address.

For the photographer establishing a new studio, acquiring premises in the least expensive part of town may be the line of least resistance, but may be of questionable economy. The first principle of good business is that you locate where the business is, for in the end, this course will always prove less costly.

If you are pursuing commercial and advertising photography, locate as close as possible to the source of business, even if you have to accept smaller premises. This usually means establishing your studio in the downtown core where potential clients, advertising agencies, suppliers and model agencies are in abundance.

One of the first questions an art director asks is, "Where is your studio?" You may be prepared to drive miles; he may not.

Creating a corporate identity.

Companies like to deal with companies. If you add the word 'studios' to your name, it draws attention away from the smallness of your enterprise. If you incorporate your business so that you are a limited company it assures clients that you are a 'going concern'. It implies stability.

Never attempt to design your own stationary unless you are a graphic arts designer. Your business card and stationery will be seen by a great many art directors and designers who have an extremely refined sense of visual esthetics. What impresses you may not impress them. If you are to promote yourself on a professional level, you must have a corporate identity that puts you into their league.

Without an image, you're only
a gypsy with a camera.

This graphic interpretation of your name or the name of your studio will convey an image about you and your business. This design should be memorable and impressive. Only a good designer can execute this with impeccable taste.

This design should be used on your letterhead, envelope, address label and invoice sheet. It can also be used on a small foil sticker which you can apply to your presentation boards or prints to identify your work.

Carry your image through with the utmost attention to detail: your appearance, your choice of words, your presentation. Polish everything. Invest in yourself as well as in your portfolio and your equipment. Every time you are called on to make a presentation, you are stepping on stage. An impressive portfolio combined with a polished image is a formidable package.

In conversation with prospective clients, avoid slang and chattiness. Be specific, be to the point, and strive to be articulate. A disciplined mind indicates a disciplined approach to problem solving. Present a portfolio which is meticulously organized and immaculately clean. Duplicate these qualities in your appearance.

This is not a charade. This is the game of business – and the art of survival.

A truck load of skis arrived at the studio with the request from *Ski Canada* magazine to do "something for their cover". The skis were laid flat on large sheets of black vinyl and a scaffold was erected to support both camera and myself. To avoid reflections from the lighting on the skis' slick, glossy surfaces and to achieve maximum color saturation, light from four strobe heads was bounced from a white ceiling directly above. Shot on 8 x 10 with a 121mm Super-Angulon lens. The lens plane on the camera was angled almost parallel to the skis in order to shift the axis of the depth-of-field so that it ran through the shallow depth of the skis and not through their overall length. This is what made the shot technically possible.

139

When it comes to the necessity of hiring representatives, I admit to being rather skeptical.

My first representative was an amiable enough fellow who claimed to be able to woo all the big art directors in the city. I should have been suspicious when he failed to arrive at the studio on the very first day, but he convinced me that he was making appointments from home and that I was to expect 'big things'.

Days passed, and then suddenly one afternoon he arrived at the studio announcing that congratulations were in order. He was distinctly under the influence of alcohol and boasting that he had just managed to take one of the most important art directors in the business to lunch – upon which he handed me a bill for the entire afternoon's carousing. With further delight, he added that he had not even needed my portfolio! This clearly was not a practice I could afford to support.

Many representatives view client entertainment as an instrument for winning influence and landing business. My experience has taught me otherwise.

I have never won business over the luncheon table. These occasions should be reserved for clients who have already entrusted you with business, not those who need to be convinced. If your work cannot stand on its own merit, no exotic cabaret or bill of fare will make the difference.

Another representative who joined me suffered from a classic case of executive syndrome – a passion for planning and managing coupled with an actual fear of selling. (Many representatives contract this malady without being aware of it.) Weeks were devoted to the development of a master list of prospective clients. The 'List of National Advertisers' was dissected and studied until the pages were tattered with wear. Advertisements were stripped out of newspapers and magazines until the files began to bulge with potential prospects and the name of every choice account was pinned to the wall.

But alas, when it came to making appointments, the afflicted representative was unable to fire up the enthusiasm needed, and I found myself faced with the burden of having to provide continuous motivation.

To make matters worse, I had committed myself to paying an advance on commissions. To continue with this approach would certainly have put me in the poor house. Now I am suspicious of these grand schemers. Ambitious planning does not guarantee an ambitious attack.

Promoting yourself.
Advice on working with reps.

Caution should also be exercised with representatives who say they 'control' business. Those who promote the influence they have over others, or who claim to know the politics and inner workings of those whom you wish to have as clients, may be eager to claim the same influence over you. More often, representatives of this ilk inevitably take the position that they are empowered to make all the decisions on behalf of their client, and this places you completely at their mercy – not a good position to be in.

Equally risky is the high-powered salesman touting guarantees and promising to provide a continuous stream of clients. Such a representative attains his reputation through the mastery of wheeling and dealing. Under his domain, you will find yourself subjected to making price deals and creative compromises. Unless you wish to become a photographic machine, stripped of your identity, the high-powered salesman should be left to the business of selling commercial wares and not creative services.

Seek representatives who are honest, sincere and prepared to work hard. The ideal relationship is to work together in equal partnership, splitting the income after expenses.

When a photographer is unknown, the income split may be 50/50. When a photographer is established, with his own source of clients, the income to the representative may be only 30%.

Paying commissions in advance of sales is a highly risky proposition. Advancing commissions on the strength of a promise borders on insanity. If a representative is going to share in your profits, then he must surely be prepared to share in the risk. Do not be swayed otherwise.

A representative should also pay his own expenses. Business cards, a separate telephone, gasoline – these are his costs; not yours. Never enter into any agreement where you have to bear someone else's expenses. The photographer who is struggling to establish a small studio must manage his finances astutely.

The representative's responsibility should be to track down clients, get through to the right person, and turn up new opportunities. These are the arduous time-consuming parts of the business. After your representative has made the appointment, determine the most effective presentation strategy. In practically every instance, I have found it more effective to accompany the representative and personally make the presentation of my portfolio. Once a successful relationship is established, client liaison can then be diplomatically transferred to the representative.

Finally, you should be aware that most art directors actually dislike

dealing with representatives. They often view them as annoying and unnecessary barriers between themselves and the photographer. A good representative must be able to sense this attitude in a client, and know when to bow out gracefully leaving the door open for you to deal with the client directly.

The relationship between photographer and representative is a tenuous one at best. Approach any new relationship with caution. Never invest in anyone unless he has proven himself first.

I know of one instance where a photographer hired a representative and immediately incurred the expense of printing enough personalized business cards and promotional literature to last for two years. Unfortunately, the representative resigned after three weeks.

To succeed in the business of photography, your portfolio must be on show continuously. Unless your work is being constantly updated and seen by art directors and potential clients, the assignments will be commissioned to those who are promoting themselves. Even for the top professional, the search for business remains perpetual.

My toughest technical challenge: how to convincingly recreate in the studio, a barbecue with flaming hot coals strictly with lighting. After much experimentation, this solution emerged: A bed of lava coals was laid over a sheet of 1/4" plate glass with two sheets of red gel acetate and one sheet of yellow sandwiched together and taped to the underside of the glass. Lava rock, available from a barbecue supply store, was chosen for its natural look of burnt coal. A sprinkling of talcum powder on top created the appearance of hot white ash. A cluster of four strobe heads was placed directly beneath the glass aiming upwards into the gels, and a single box light was positioned above the set. The light output on the strobe power packs was adjusted until there was at least a five f-stop difference between the light coming up through the coals and the light from above which illuminated the grill. This ratio gave the bottom light its intensity. By slightly smuding the filter in front of the lens with petroleum jelly, a soft haze was created, emphasizing the glow of the coals. Photographed on 4x5 with light readings taken on the ground glass using the Minolta III Meter with probe. Actual f/stop of bottom light: f/90; of top light: f/16.

On one occasion, Sears invited me along with a number of other studios, to quote on an eight-page fashion flyer for a Father's Day promotion. It was January at the time, and these summer fashions were to be photographed in a sunny climate to match the 'summer in the city' theme indicated by the layouts. I quoted as follows:

Photography: for 10 final transparencies. Fee based on two days photography at $2,500 per day – $5,000

Expenses: film, processing, on-location costs and miscellaneous expenses – 800

Model budget: based on 20 model hours at $65 per hour, plus agency commission and currency exchange to US dollars – 1,500

Travel costs: for photographer and assistant, including meals and hotel – 2,100

Client to pay: reasonable prop and rental expenses.

Total $9,400

After submitting this quote, my representative informed me that my fees were considered too high and although the client was keen on working with me, he could not justify my rates to his management.

The Canadian winter was settling in, and I could not conceal my anxiousness to escape to somewhere like Florida for a few days. I was vulnerable to negotiation so I lowered my quote by 15%. This took $750 off my fees. After re-submitting the quote, I was advised once again that my charges were still too high and I was requested to reduce my quote further. This time I held my ground.

The following day I was notified I had the job. With major retailers, tight-fisted dealing is standard procedure.

Who pays for client mistakes?

I was on my way to Florida. The shoot was finished within two days, as required, and the film flown back to Canada for processing. I was instructed to remain on location until I received word that everything was satisfactory.

Later the following day I received a distress call. The client discovered that the store's fashion buyer did not agree with the models wearing summer hats, an accessory I had used throughout half the shoot. Even though I had previously obtained the art director's approval, I would still have to re-shoot.

It is difficult to contain your frustration in these circumstances. But with retail accounts, disputes between art

When to be hard-nosed about money, deadlines and re-shoots.

directors and fashion buyers arise with such frequency that one has to learn to govern oneself accordingly.

I advised the client that I would have to charge for a re-shoot. With expenses, this amounted to an additional $2,181. Reluctantly, he approved.

The rule is simple. If a client rejects a photograph because the model was in the wrong age group, or because the merchandise was not shown properly, then the blame rests with the photographer and the photographer should be willing to remedy the problem at his own expense. But when the client approves the final photographs and you have acted on his instructions, you cannot be held responsible for the cost of a re-shoot which has resulted from a dispute between him and his fellow associates.

Deadlines are rarely deadlines.

Deadlines are another matter. I have never known a case where they were not inflated. This shoot was no exception, once again proving the axiom, "Regardless of the deadline, there is always time for a re-shoot".

I have undertaken scores of re-shoots when dealing with large retailers, almost always because they provided the wrong merchandise or inadequate information, or neglected to advise me exactly what details should be shown or not shown. Layouts do not always yield this information. Without exception, I have always charged the same fee over again

for a re-shoot, and have never lost a client by adhering to this principle. Problems with communication and errors with merchandise run rampant in these large organizations. Be forewarned.

Large studios whose very survival hinges on these large accounts can rarely muster up the courage to tell their client that they will charge for a re-shoot. And many photographers, being grateful for the opportunity to work on a large account, adopt the attitude that the client is always right, even when he is obviously wrong.

With disputes, diplomacy is the essence. When a problem occurs, discuss your position on the matter immediately and elicit your client's understanding. Most important of all, do not attempt to invoice your client for extra charges without prior approval. Such surprises are usually met with disastrous consequences. A business-like discussion of the problem at hand will usually serve to win the necessary approval and garner professional respect at the same time.

A sample sheet from my presentation portfolio. These transparencies include: a layout for a catalogue spread and the actual printed version; a set of three labels for shampoo and how they appear on the bottles; and an original 35mm transparency next to the final magazine reproduction. My portfolio is religiously kept up to date based on the premise that to every art director, "You are only as good as your portfolio."

How to build a dynamite portfolio. The case study method.

A photographer's portfolio is his calling card, his admission ticket to the big league. Not only must the work be right, but the presentation itself must be of the highest professional caliber.

I have seen would-be photographers present work that was either dangling from yellow plastic school binders, strewn in cardboard cartons, mounted on dog-eared card, or sitting crookedly in acetate sheets that were scratched and cracked from age.

Even a number of professional photographers are not exempt from committing these sins. One photographer who I know prepares his portfolio by dumping a pile of slides, transparencies and samples of printed work into a large shipping carton, and then letting his clients rummage through the box as if it were a hope chest.

Another professional photographer keeps two portfolios, one which contains his bread and butter assignments, (described as "uninspired but necessary"), and the other, which contains his personal creative work, (reserved for the more artistically appreciative clients). The trick here is to select the right portfolio for the right prospect. Unfortunately, this system is not fool-proof.

A good many photographers justify the disheveled state of their portfolio by saying, "What difference does it make how the work is presented, as long as the client sees it?" Even more prevalent is the attitude, "If the work is good, it will stand on its own." Such logic has merit only in the absence of a competitive environment. With talented newcomers surging into the business every year, and the fierce competition of photo studios, survival, let alone success, requires a presentation conceived with all the strategy and thoroughness of a military campaign.

The master plan.

The following is a technique I have refined over a period of years through countless presentations. It is patterned after the case-study method in which problem, solution, and how the solution was arrived at, are shown.

Assuming that you have achieved creative excellence in your work, this method of organizing your portfolio will create an edge that few photographers will be able to match.

After every assignment, mount the original layout on black card and photograph it on 2-1/4 format using Kodak Ektachrome EPR 64 film. Then, when the ad runs, obtain a tearsheet or proof and photograph it in the same manner. Mount these transparencies in 2-1/4 glass slides.

To complete your case study, you will need either the original transparency used in the advertisement, or a duplicate. When the original transparency is a 35mm, mount it in the center of 2-1/4 glass slide using a small piece of double-sided Scotch tape to keep it in place. Sheet film will have to be shown separately.

How to build a dynamite portfolio.
The case study method.

For a compact portfolio presentation, all of your best black-and-white photographs can be re-photographed on 2-1/4 transparency film and similarly mounted in slide sheets. Layouts, proofs of ads, and even Polaroid tests complete the case study of each project and clearly show an art director the degree of your contribution and most importantly, how you solve creative problems.

Organize these transparencies in a 2-1/4 slide holder sheet and place them in a black loose leaf binder for presentation. A portfolio arranged in this manner has impact. Consider what it reveals to a prospective client:

1. That you have worked from a layout and therefore can work within the disciplines of creative direction.

2. That you are organized and methodical in your work.

3. That you understand the importance of art direction, and are not given to unrelated flights of fancy.

4. That you are able to add the inspiration, style or imaginative touch that makes the layout work.

5. That you appreciate the importance of advertising objectives.

Presenting sheet film.

With 4 x 5 or 8 x 10 sheet film, the most professional way to mount them is on 11 x 14 matte black card with a die-cut window in the center. The opening should be custom-cut to match the exact final crop of the transparency.

For protection, leave the transparency in its acetate sleeve and tape the sleeve to the back of the card with artist's white paper tape. Regardless how small the die-cut window may be, the size of the presentation card should never be changed. When the cards are kept to one uniform size they look professional.

The black card recommended for presentation mounting is No. 89 Bainbridge board, available at most art supply shops.

For the best effect, the window opening should be cut with a 45-degree bevel. The white line created by this bevelling not only enhances the presentation artistically but provides visual relief between the transparency and the card itself.

Although a bevel-cutter can be purchased at an art supply store, you may find it more expedient to have a picture framer apply the meticulous craftsmanship that the task requires.

The black card serves an even more valuable purpose than artistic framing. It serves to increase the color contrast of the transparency. When a transparency is viewed on a light box, the surrounding light flares back into the viewer's eyes. This has the same effect as lens flare, reducing the intensity of color and causing the transparency to appear dark or underexposed. But when this same transparency is surrounded with black card, the flaring light is automatically blocked out. This now allows (1) the transparency to reveal its true color saturation and (2) exposure to be critically judged.

For presentation, exactly fifty of these boards fit perfectly into the standard 11"x 14"x 4" artist's fiber-board, print shipping case.

Abandoning the standard portfolio.

For showing print material, practically every photographer chooses the standard artist's portfolio with acetate sleeves. But this is a mistake.

The acetate sleeves are so susceptible to scratching that the friction from simply turning the pages scars the finish and eventually fogs the surface. Even more of a problem, the acetate is of such high gloss that it reflects every light in the room. I have witnessed art directors who found the reflections so distracting that they have had to place the portfolio on the floor, and view it with their back to the light. This does not contribute to an ideal presentation.

Another disadvantage of this type of portfolio is that the sleeves do not keep the photographs straight. Pictures slip and become cock-eyed every time the page is turned, and if you glue or tape your prints into position you risk damaging them.

Instead of the conventional portfolio, purchase an artist's case. These appear similar to the portfolio but do not contain the metal-ring spine.

Mount your photographs and printed material on large black cards. Not only is this an infinitely more impressive way to show prints, but it allows you to stand your work up around the art director's office during a presentation.

Adopt the 16"x 20" card size for mounting all 8x10 and 11x14 prints. Choose the 16"x 26" card size for mounting all editorial or magazine spreads. And for 16x20 prints, the next standard board size recommended is 22"x 28".

A beginner's portoflio.

When you begin your career in photography, your portfolio will be devoid of published work and impressive case studies. Therefore you will have to create samples of how you would solve advertising problems if you were given the opportunity. Here is the most potent presentation you can prepare:

Select a dozen advertisements from magazines or newspapers and re-shoot them. An impressive cross-section would include studies in: (1) fashion (2) cosmetics (3) jewelry (4) perfume (5) hair products (6) cigarettes(7) wine and spirits (8) glassware (9) chinaware (10) food (11) electronics (12) appliances.

Here is the strategy to employ with each advertisement:

Step 1. Produce a photograph that is a natural extension of the visual theme. Following the same creative approach used in the advertisement, closely execute a similar idea that could fit into the series. This demonstrates your ability to understand and to perpetuate an advertising campaign, for all product photographs use the 4x5 format.

Step 2. Produce a second alternative to each advertisement, one which represents a radical departure from the client's current advertising. This alternative demonstrates your creative ability and establishes you as a source for ideas.

Step 3. Mount the original advertisement on black card and photograph it on 2-1/4 transparency film for your presentation. Also photograph any

Polaroid tests which show how you arrived at the final solution. For this reason, when working on a shot, scribble lighting changes and improvements in composition directly onto your Polaroid tests for reference. This lets an art director see how you actually evolved an idea through to its finished stage. It shows him how you think, and the degree of effort you take in pursuing excellence.

With the above material, you can now organize your own case studies for your portfolio. This will present you with a range of expertise in 12 different categories, backed up with large-format transparencies. An impressive arsenal.

Technique for photographing prints.

For copying advertisements and prints, follow the lighting technique used by photographers who copy paintings. For this, you require two lights each placed exactly at a 45-degree angle to the subject and at the exact same distance away from the subject. This effectively cancels out shadows and reflections.

The material photographed must lie perfectly flat otherwise glare from the light will reflect off the surface.

Another caution: with electronic flash, most white paper has a tendency to reproduce on film with a slightly bluish cast. This is due to compounds or bleaching agents in the paper which become irradiated by the excessive ultra-violet radiation inherent in electronic flash. The resulting cast can be corrected with a CC05 yellow or CC10 yellow filter.

On leaving your portfolio.

Frequently, a client will ask you to leave your portfolio so that he can make a presentation to his colleagues. If you agree to do so, it is almost a certainty that damage will occur as soon as the portfolio leaves your care.

I have had presentation boards returned with crushed corners, obviously the result of having been dropped. I have seen my photographs stacked up against the side of a desk where they were accidentally kicked every time a person went by. And I have had clients remove transparencies from my portfolio without my permission, and send them out of town to a branch office.

When your portfolio is left to drift through the office, outright plagiarism becomes a definite possibility, especially amongst juniors in an art department. I have had ideas 'lifted' virtually intact, and seen them used in newspaper advertisements only a few weeks later.

If a client insists that you leave your portfolio for an internal presentation, diplomacy is in order: advise him that your portfolio is committed elsewhere for an appointment but you would be pleased to deliver it to him at the specified time and arrange to pick it up again after the presentation. A client should regard your portfolio with crown jewel valuability.

Every year, a rush of new businesses are started by budding photographers. Spirit, energy and imagination carry some of them through, but more often, the brutal aspects of running a business lay many of these enterprises to rest. Here are the three mistakes most often repeated:

Mistake No. 1
Hiring for the future,
rather than for the present.

Without fail, when most people start in business, their first concern is to hire staff. When establishing a photo studio, it appears necessary to have a secretary-receptionist, a studio assistant, a representative, perhaps even a stylist. But unless you have a very philanthropic attitude about sharing your hard-earned money when you first open shop, these can be very expensive thoughts indeed. To a great extent, it is not how much you earn that will determine your success, but how much you save.

In actuality, the first thing you need is a good answering service. This will cost you about $30 a month. Rather than leave the answering service to their own devices as to how to answer your calls, a few specific instructions are in order.

For a client to receive the answer that "no one is in" or "I don't know when they'll be back" can only convey amateurism.

Instead, advise the service to reply that you are "on location", "at a client meeting", "out on research", or whatever it may be. Always tell the service what time you expect to return and to let any callers know that you will return their call shortly. No client wants to feel that he cannot reach you easily in case of an emergency.

Under no circumstances should one entertain the thought of having a tape machine connected to the telephone to record messages. The usual directive "at the sound of the dial, leave your name..." implies that you are never in the studio, never available, and that an interminable amount of time will transpire before you are even heard from. Most callers are offended by this dehumanized process. It is not good business.

If you are opening a small studio, the one person you will need is a Girl Friday, or of course, a Man Friday. When you consider the duties this person will have to undertake, the running of a small studio unfolds. Your Girl Friday should be prepared to:
1. Handle mail and filing.
2. Unpack and organize incoming merchandise for photography.
3. Coordinate accessories with garments.
4. Determine client preference for hairstyles and model makeup.
5. Contact agencies and book models.
6. Arrange details of hair and makeup with the model's agent.
7. Coordinate travel arrangements and details concerning location shoots.

The classic mistakes to avoid in building your business.

8. Iron and prepare garments for photography.
9. Assist in dressing the models.
10. Take care of all pinning, sewing and other alterations which may be necessary.
11. Supervise shooting schedule.
12. Assist as set stylist by watching for bad wrinkles on clothes, twisted belts and unwanted labels.
13. Arrange for the return of merchandise, along with the corresponding paperwork.
14. Serve coffee to visiting clients.
15. Keep the studio organized and tidy.

Depending on her interest in photography, she may also become your assistant in the studio or perhaps your lab assistant, taking charge of processing film and making contact prints.

Never underestimate the amount of physical work required in running even the smallest studio. Sets have to be made and painted, props have to be collected together, large cartons of goods have to be moved, uncrated and assembled. If a photographer has to undertake all the work of running a studio without assistance, he will often become too mentally and physically drained to accomplish the creative work.

I know of a few instances, my own included, where the photographer is fortunate enough to have a wife who shares these interests and assists in these responsibilities.

But if there are young children in the family, you would be wise not to enlist the help of your wife unless you have a full-time baby sitter. And under no circumstances should your children be allowed in the studio. It never fails that they will make their presence known the moment you are on the phone. A screaming child can destroy the stoutest reputation.

In the daily running of your business, do not spend valuable time making pickup and deliveries of client merchandise. To do so signals to a client that you are not a busy photographer. Instead, hire the services of a reputable, bonded delivery service, one who will guarantee downtown pickup and delivery within the hour.

Mistake No. 2
Taking too long to invoice.
Waiting too long to collect.

As soon as the job is completed, issue an invoice. This is not looked upon as being desperate for money; to the contrary, this is good business.

Remember, it is common for most clients to take 45 to 60 days to pay their account, and 90 days is not unheard of. Advertising agencies are the worst offenders, but only because they must wait to accumulate all the invoices from the other suppliers involved in that particular job before they can bill their client.

As the nature of this business requires you to advance the cost of film and supplies out of your pocket, the sooner

you invoice the sooner you can settle your own accounts.

With model fees, whenever possible, suggest to the client that the model agency bill him directly. It will save you an enormous amount of paperwork and complicated book-keeping. On the other hand, with large retail accounts, studios are requested to submit one total invoice at the end of the assignment. In this case, the model agencies bill you directly, and when you are paid, they are paid; this is the usual practice. In this case, to simplify accounting, accumulate all invoices in a docket and specify to agencies that their invoice must not only indicate the model's name and the amount of time billed but must also refer to the actual job worked on.

The fastest way to go out of business is by accumulating unpaid accounts.

When I undertook assignments for boutiques and small shops at the outset of my career, I quickly amassed unpaid accounts at a ratio of one invoice out of every three. Many small stores and fashion boutiques are notoriously undercapitalized, and the rate of bankruptcies is unbelievably high.

Suing a client may not resolve the matter either. I sued one client and obtained a judgment against him, obligating him to pay, but seven years later I still have not been able to collect.

Judgment against a client for an outstanding account does not mean that you will get paid. The second part of the ordeal is collection. With judgment, the court grants the right to garnish wages, seize assets or register liens. But each step along the way must be handled in the manner prescribed by law and as the legal machinery turns, the cost of collection soon outweighs the amount of the debt. To prevent accumulating bad debt, avoid working for dubious accounts.

Mistake No. 3
Ignoring proper book-keeping and accounting.

To manage your business, however small it may be, it is important to set up a proper accounting system. If you do not attend to this problem when your business is small, it will lead to awesome accounting problems later.

Set up a file for each of the following: Accounts Receivable, Accounts Receipts, Accounts Payable, Accounts Paid.

In the Accounts Receivable file you should put a carbon copy of each invoice you send out. Attach a ledger sheet to the inside of the file and record each invoice by number and by date. This will give you a running series of invoice numbers so that you will always know which number to use next.

As soon as you have received your check, remove the corresponding invoice from Accounts Receivable, mark

it paid, together with the date, and place it in Accounts Receipts.

At the end of each month, go through your Accounts Receivable file and send out statements to all accounts overdue by more than 30 days. A polite reminder call to your client's accounts payable department on the 45th day is essential.

Keep all your outstanding bills in Accounts Payable. When you pay a bill you should write the check number and date of payment on the top right hand corner and then file it under Accounts Paid.

At the end of each year of business, transfer the contents of Accounts Receipts and Accounts Paid into separate storage cartons or large envelopes, and label them accordingly.

You must also set up a ledger book to record all business expenses and income. This should be done with the help of an accountant. Once you are shown how to enter the figures, it is a simple end of the month task to keep your books current. This is the only way to know your true financial position and to control the finances of your business.

All expenses that relate directly to the production of photography are an allowable deduction from your taxable income. Keep receipts.

For organizing records and details of each shooting assignment, the standard large brown envelope makes a perfect docket. This is the place for negatives, contacts, film, expense receipts, model vouchers and any other signed releases.

Any paper work concerning return of merchandise also goes into the docket. As extraordinary as it may seem, I have had calls from a client up to 18 months after a job was finished, asking if the merchandise was returned, and if so, on what day, by whom, and what verification is available. This is also another important reason to use a courier service for returning all merchandise – they keep a record and obtain signatures upon delivery.

Because of the problems of combining two planes of perspective during photography, as in this case where the stereo and speakers are each on a different plane, the solution is usually to photograph each component separately and strip them together afterwards.

VI
How to take great photographs.
Professional techniques and ideas.

Successful fashion photography thrives on visual honesty. Models should not be permitted to pose in a rigorous, studied manner, but instead they should be directed to 'feel' the fashion, and to show it the way the designer intended it to be worn.

In sports clothes, models should exude energy and fun. In casual wear, a cool elegance may be appropriate. In evening wear, romance should sparkle in the eyes. The mood makes the fashion.

To achieve this, you will need to direct an easy, relaxed shoot and to encourage the little offbeat incidents that make a fashion photograph an eye-stopper.

Shooting models in action.

Models dashing through airports, stepping off escalators, strolling through cafés – these are the visual stories that add excitement to fashion photographs.

When shooting models in action, it is never sufficient to rely on natural movement. The toss of the hair, the gesture of the hands, the swing of the arms, and the step itself will all have to be taken to the extreme.

To convey the greatest amount of motion and energy, direct the model to walk quickly across the set in front of you, and follow the model by panning your camera. When panning, always set your camera on a tripod so that the swing of the camera will be smooth and level. Set your shutter speed at a minimum of 1/250th.

How to shoot fashion and accessories.

s...this fall's versions of the things —and at these prices & colors—who could resist!

...nd!—genuine reptile
s. $10.

To have by the stack.
From $4 to $6.

Plaid Knee-Hi's for cords,
denims, skirts. Pr. 2.50.

Terrific 'news' in shoes.
From $12 to $35.

The 'Cowl'...
your basic
for Fall 77'.
From $9 to $23.

Textured
legs for
Fall.
Pr. 2.75

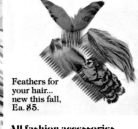

Feathers for
your hair...
new this fall,
Ea. $5.

the Bay

Cozy 'Popcorn' Mittens,
Pr. 4.50.

The
Snakeskin
Clutch.
$42.

A good sense of design must be developed in order to produce a spread of photography quickly and easily. This can only come from repeated study and practice of the principles of design. This particular spread had to be shot in one day, and no layout was provided – only the basic space allocation. Fee for photography was $3,750 based on a volume rate of $250 per photograph.

How to shoot fashion and accessories.

For this leaping shot of super teen model Hayley Mortison, over 50 frames of 35mm film were exposed with the model repeating the leap each time until all body movements and the flare of the dress were correct. Minimum strobe power was used in order to obtain the shortest flash duration; in this instance, an Ascorlite QC8 set at 200 watt seconds was sufficient for exposure and gave a flash duration of 1/1650. Even at this high speed there is still a slight blur. With extremely fast moving shots, always check the flash duration table provided with your flash equipment to determine the power output that will provide you with a minimum flash duration of 1/1500. Panning with the camera will help improve the results. Film used here was Kodak Tri-X Pan, pushed 1-1/2 stops for maximum grain and processed in D-76 with a 75% increase in development time.

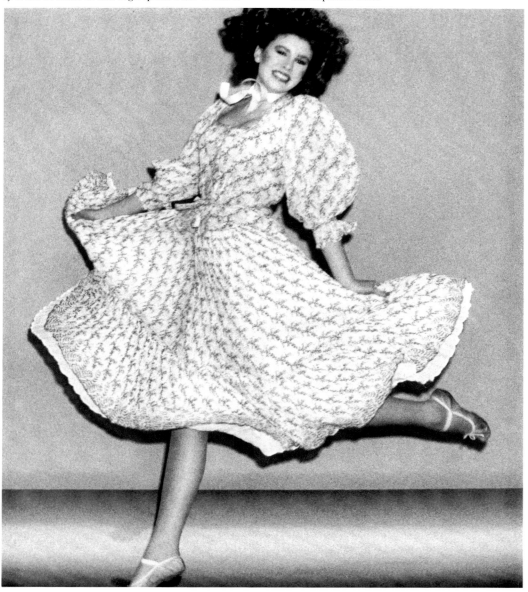

Broad exaggerated steps greatly enhance the impression of speed. In this instance, the model must always push off on her back leg at the same moment she raises her forward leg. Shoot at the peak of action when neither foot is flat on the ground. But the model must be directed to carry through the feeling of motion to the very tip of her fingers if the action is to appear real.

To photograph a model running, leaping or even jumping can be exceedingly difficult, yet it is often called for when photographing teenage and young women's fashions. A favorite request of art directors is for the models to be photographed walking face-on towards the camera.

To shoot this kind of action, position yourself in front of the models, and as they step forward, you step backwards, firing the camera while you walk. This may appear humorous at first, but this is how it is done. Take only three or four steps at a time then stop to check your focus; it is almost impossible to maintain a precise distance between you and the models when you are moving.

Needless to say, an assistant is necessary for clearing the way through pedestrians and traffic. If you feel inhibited by onlookers, remember that more than likely they will be watching the models and not you.

The walking action of models can also be exaggerated by instructing them to criss-cross their legs with each step they take. Two or three models can walk together this way in perfect harmony.

The preferred focal length.

Fashion photographers prefer telephoto lenses. The reason is this: the greater the focal length of the lens, the greater the compression of the image. This effect removes perspective and flattens the subject. It concentrates more image into the frame, and as a result, draws more attention to the fashion.

Compression also prevents a model's arms and legs from appearing out of proportion when she walks toward the camera. Or when the model is sitting facing the camera, the lens compresses the entire body to one visual plane, which in turn allows more fashion to be visible.

For shooting fashion with a 35mm camera the minimum focal length lens recommended is 85mm. But you will need upwards of 180mm to produce any noticeable degree of compression on the model. An 80mm – 200mm zoom is among the most valuable of lenses for shooting fashion. On location, its distinct advantage is that you can quickly compose your shot from one position. And then by adding only an extension tube to the lens you can move in for close-ups of belts, buckles, cuffs, jewelry and other fashion detail.

The beauty of direct lighting.

Fashion lighting changes enormously with the years. It is as much a statement of the time as are the fashions. Hard shadows with the model's image cast as a shadow on the background, once considered dated, is now *avant-garde*. Harsh lighting aimed directly at the model, which was once considered abominable, is now recognized for its unique possibilities.

One of the most stylistic forms of direct lighting is obtained with a ring flash, a circular flash tube which fits around the front of the camera lens.

Ring flash was originally designed for use in extreme close-up photography for medical and scientific purposes. Since the light was designed to be within inches of the subject, it does not have the power output needed for shooting fashion at a distance. To overcome this, fashion photographers have these ring lights adapted or custom built.

With this form of lighting practically all shadows are eliminated, except for a slight shadow edge around the model which resembles a pencil outline. Ring lighting has been the rage with fashion photographers in Europe for years.

As an alternative, you can place a single flash head directly above your lens, almost touching the lens barrel. This (1) reduces the angle of light falling onto the subject and (2) casts a small shadow beneath the nose, lips and chin which are the only parts of the face where shadows should be seen.

To prevent the set behind the model from appearing a dirty gray due to the fall off of light, place the model as close to the background as possible. This results in more even lighting.

A cluster of three flash heads around the lens of your camera provides another interesting variation to ring light, and distributes a rim shadow all around the model.

For lighting technique and creative ideas draw inspiration from *Vogue*, *Linea Italiana* and *Mode International*. These magazines represent the hallmark of fashion photography and they will influence your thinking.

When models are walking together, it is essential to keep them as close as possible to each other. Shoulders and hips should be touching and one model may even overlap the other. Any gap between them becomes disturbingly more noticeable as you enlarge the photograph.

To capture the natural gaiety of models rushing down the street takes repeated practice. And if a courageous leap is required, frame after frame of film will have to be exposed until you have one perfect shot. A motor drive and a good deal of patience will make the task easier.

For a fashion spread on tropical floral fabrics, a parrot was found with virtually identical colors and added to the photograph. A large sheet of cane matting formed the background. Shot on 35mm and with a 200mm lens to compress the models' knees and legs. Lighting was from direct flash using an Ascorlite QC8.

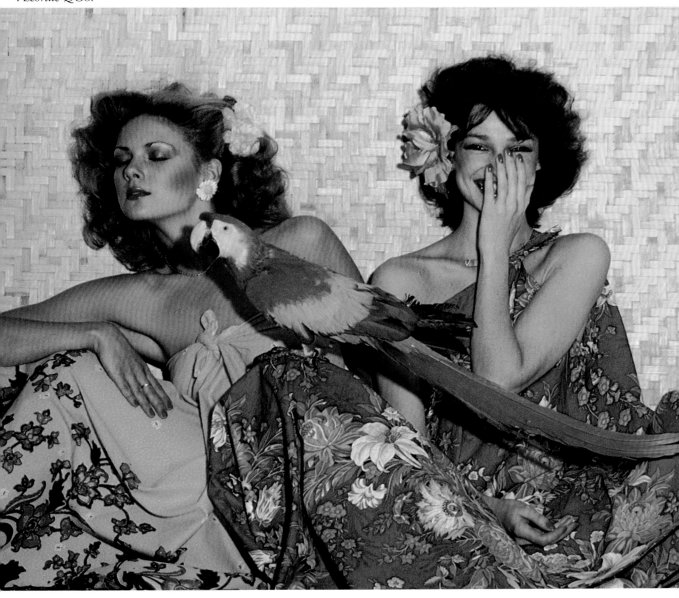

How to shoot fashion and accessories.

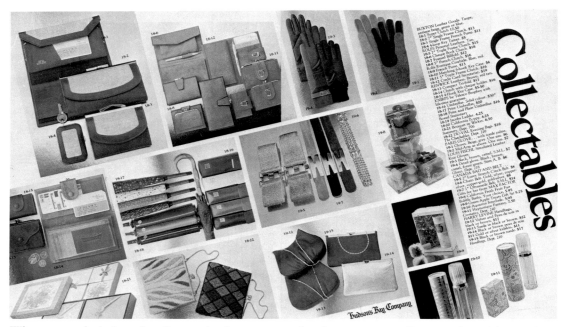

When a great deal of merchandise is to be shown on one spread, as in this example, it is essential to maintain visual uniformity throughout. Background, perspective and composition should be as simple as possible. Merchandise should be lined up carefully so that there are no visually jarring lines. Silver and gold foiled surfaces make excellent backgrounds because of the way they reflect light and are sufficiently neutral not to conflict with a range of colors placed on top.

Rehearse the model.

Before you shoot, invest a little time with the model. Study how the garment flows, determine if certain movements make unsightly creases. Tight skirts and snug fitting jacket tops are best photographed without excessive motion. Men's suits also cannot be photographed well in motion for as soon as the model starts walking an unforgivable collection of wrinkles appears. Well-structured photographs are the answer and rehearsal with the model is essential.

Decide on the important details to be shown. If the emphasis is on the neckline, remind the model not to block it with her arms. If a pocket needs emphasizing, suggest she tuck her hand into it to guide the viewer's eyes.

No shoot should proceed without a fitting. As models charge for these fittings, most clients try and avoid the expense. To stint on prepatory work is an error. Garments can never be expected to fit the model perfectly unless the necessary alterations, however minor, have been made. With fashion photography, the fit is everything. Stress the importance of fittings to your client.

A few valuable pointers:

1. Concentrate on taking photographs which are casual and candid. Do not place models in regimented positions.

2. Choose backgrounds which provide contrast for the fashion. Contrast soft against hard, light against dark.

3. When shooting on busy city streets, choose a long lens and keep the depth of field shallow. Let the backgrounds and objects merge into indistinct shapes. This provides contrast and shifts the visual emphasis to the fashion.

4. Do not shoot when a model's hands are in an awkward position – she will look clumsy. Do not shoot when a model's wrist is bent forward concealing her hand – she will look deformed. Do not shoot when a model is talking – her facial features will look distorted.

5. In fashion photography, never underestimate the magic of a model's smile or laugh.

Auditioning beautiful models for lingerie work may appear to be a delightful undertaking, but in actuality it is more likely to turn into an exasperating experience.

Models, by nature of their profession, are usually tall and lean. And many of the most beautiful faces belong to the least shapely bodies.

In search of the perfect lingerie model bear in mind that she must be neither slender nor curvacious. A voluptuous figure usually connotes brazen sensuality, an image lingerie clients are careful to avoid.

Casting models for bra assignments.

The ideal bra size for photography is a 34 B cup, and this is usually the size of bra that the client will provide.

When casting for models, do not assume that when a model's comp describes her as fitting a 34 B bra that she really does. Bra photography pays at least double the model's regular rate, and most often in excess of $250 an hour. Naturally, any model with a reasonably good bustline will be financially motivated to try and fit into a 34 B.

The best way to organize a casting session is to advise the model agencies that you wish to arrange a Polaroid testing of the most suitable models.

Request an extra set of bras from your client to use for model testing and for fittings. These garments quickly become soiled with body makeup, rendering them useless for photography.

When each model arrives at your studio, permit her the privacy to try on the bra and to make any necessary adjustments. When the model is on the set, take a minimum of three Polaroids: one with the model facing the camera, one in three quarter view and one in profile.

After the casting session, with Polaroids in hand, you can deliberate over the right choice of model. Then mount the Polaroids onto a black presentation board and send this to your client for final model approval.

It is not uncommon to test up to a dozen models to find one who is suitable for bra work. As the assignments may call for a number of models, the time spent on auditioning can be enormous.

There are a number of peculiar problems which arise in lingerie photography that one never expects. Here are things to look for:

1. Even-toned skin color without bumpy 'gooseflesh', blotches or suntan markings.

2. A smooth bodyline with well-defined waist and hips, and slender neck and small shoulders. A model with broad shoulders or stocky trunk is considered unfeminine for lingerie work.

To provide soft shadows on the bustline to create a full round shape, diffused lighting from the Broncolor Hazy was used together with a six foot white reflector card on the shadow side of the model. From a shoot for Warner Bra.

How to shoot lingerie.

3. The rib cage and breast bone must not protrude. Neither should the collarbone as this will prevent the bra straps from laying flat against the shoulders.

4. The chest should be clear of blemishes and moles. A few freckles may be acceptable. The navel should not protrude or be misshapen and any appendix or other scars must not be visible.

5. For transparent or stretch bras, the model's nipples must not be too large, dark or protruding.

6. As the model must not distract from the merchandise, clients prefer the quietly pretty face to one that is strikingly beautiful. Look for a well-defined jawline and long neckline. This is most flattering to a model's profile.

7. Smooth long fingers, immaculate nails and elegant hands will contribute enormously to the photograph. Models who have studied ballet have a natural grace and should always be considered prime candidates.

Photographing bras.

During photography, if the model has a tendency to hunch her shoulders forward, as most do, this will cause the line of the bra to curve inwards. To correct this, place a thin, hard cover book in the back of the bra, so that it spans across the model's shoulder blades. This forces the shoulders back and creates an upright posture.

Always work with a stylist on the set so that there is someone who can watch closely for wrinkles. The bra cups and elasticated sides curl and twist out of shape with the slightest movement. Many a beautiful shot has been ruined by creases almost undetectable through the small viewfinder of a camera. As a word of caution, do not suggest to a bra manufacturer that wrinkles are natural, otherwise you will find these assignments become preciously few.

Bra clients traditionally object to seeing too much skin, especially from bare arms. One solution is to drape a length of satin around the model's arms and shoulders and if you are shooting a series of packages you can maintain visual continuity simply by changing the color of the fabric.

Unless specifically requested by the client, avoid glamorous makeup and trendy hair styles. Not only will this date his packaging, but it tends to make the model look more sensuous than most lingerie clients find acceptable. For this kind of work clients prefer a soft, natural look. To disguise blemishes, any theatrical makeup will do, and Max Factor's Pan Cake is particularly recommended. This will also conceal freckles or other small blemishes.

Panties and girdles.

Unlike bras, panties and girdles photograph best on a model who has virtually no bodyline or curve. Small hips and straight thighs are the most flattering. Models with even the slightest amount of cellulite or fatty tissue around their thighs are unsuitable. Models in their

late teens, not surprisingly, have the best figures. Do not select a model who has a protruding hip bone as this will spoil the line of the garment.

Sheer panties, or even those made of white nylon, present the problem of pubic hair. With black-and-white photography, the print can easily be retouched, but with color photography, time and expense make this impractical. As most models understandably refuse to shave, there are two other alternatives:

One solution is to have the model put on a pair of flesh-colored panty hose, then have her cut off the waistband and legs of the hose. This must be done while she is wearing the panty hose in order to reduce the runs in the nylon. This snug fitting, improvised undergarment should flatten out the pubic hair and mask its color sufficiently so that the hair does not show through the panties.

If the panties are extremely sheer, the other solution is to make a duplicate panel of the front of the panties either from flesh colored or white felt fabric. This panel is then sewn inside the panties. It will have to be a perfect fit so that there are absolutely no wrinkles.

Panty girdles usually have an opaque front panel so they do not present any of these problems.

When photographing slips and nightgowns, you do not need to observe strict figure requirements. One beautiful flat-chested model I know has developed a technique of artfully applying contour makeup to give herself cleavage.

In an attempt to add more energy to a lingerie photograph, there is a natural inclination to reach for a fan to blow some drama into the garment. Although the live motion effect caused by a fan or wind machine may appear exciting to the eye, it is rarely suitable for photographing lingerie. The problem is that these garments are usually made of nylon or other synthetic material and consequently they attract static electricity, causing the fabric to cling to the model's body in unsightly folds and creases. If you work with a fan be prepared for an exceptionally high percentage of rejects from your shoot.

On lighting.

1. Always shoot with umbrellas or with bounced light diffused through a large scrim.

2. Be cautious about using any hard or dramatic lighting. This will accentuate the texture of the skin and exaggerate even the slightest folds and creases in the body.

3. For fill light, place a large white reflector card on the shadow side of the model, and as close to her as possible. Alternatively, use diffused fill lighting at half the output of the main light.

4. Avoid direct lighting, such as from a ring flash which is so popular in fashion photography. It is unsuitable as it reduces the shape and form of the bust.

One of the things I dread most is working with makeup artists. The problem, unfortunately, is that many of them believe that a model's makeup has to be exaggerated for photography. A pencil line around the lip to give a finished edge to the shape of the mouth, or a bold brush stroke with contour shading down the center of the nose to straighten out the line, may be acceptable techniques on the stage where the viewer is at a great distance, but in a photograph where the model's face falls under the close scrutiny of the viewer, any fabrication of makeup tends to become alarmingly apparent.

When a makeup artist is provided by the client, the photographer must be prepared to take charge, for in the end, he alone is responsible for the visual results. I learned this the hard way.

On one occasion, I was commissioned to shoot a campaign for a major cosmetic company whose name I must regretfully conceal. Their cosmetician proceeded to apply the makeup with such a heavy hand that the models looked positively clown-like. I repeatedly voiced my concerns but he dismissed my protests with a wave of his hand.

Needless to say, when the client saw the final transparencies he was appalled. "The models look like tarts!" he exclaimed, turning a deaf ear to my explanations. Naturally, he never hired me again – an expensive lesson indeed.

If a client leaves the choice of model to your discretion you should never rely on what you judge to be beauty. Clients who are in the business of continually evaluating beauty and trends have some very specific opinions as to what constitutes beauty. Spare yourself the possibility of a re-shoot by always submitting the model's comp for approval before the shoot takes place.

The most photogenic features to look for when casting models for beauty shots are large expressive eyes, prominent cheek bones, a well defined jaw line, full lips, sparkling white teeth, and an engaging smile.

In search of the 'perfect face', it should always be borne in mind that the camera records facial features with brutal honesty and the slightest imperfections are often presented with disturbing clarity. Any pretty model may appear to be a candidate for beauty photography but if her cheeks are a trifle plump, her lips thin, or her eyes noticeably small or close set, these problems will only become more evident in photography.

The secret to beauty photography is extreme attention to detail. Make-up must be flawlessly applied and hair must be professionally styled, even if it is going to be wind blown. Soft, delicate lighting was achieved with a white semi-translucent umbrella directing light to one side of the model and a strobe head bouncing light into a large white reflector card placed on the shadow side of the model. A filter pack of CC05Y and CC05R was placed in front of the lens to warm the skin tone. Photograph for a campaign for Boot's drug stores. Model: Sue Pace.

Even seemingly insignificant problems such as downy facial hair or tiny bumps and blemishes can be a nightmare to deal with in front of the camera.

Makeup will disguise slight skin discolorations and suntan marks, but when used in an attempt to conceal pimples, large pores or wrinkles, it will only 'cake' and draw more attention to the problem. Clear, healthy glowing skin is a prerequisite for close-up photography.

Camera format, lenses and film.

For glamour photography, the 'mood', 'look' and 'energy' from the model are the magic ingredients, and to capture these elusive emotions and subtle facial expressions nothing quite matches the speed and flexibility of a 35mm camera, especially if it is accessorized with a motor drive.

For close-ups of a model's face, lenses in the 200mm – 300mm range produce the most flattering results. With this degree of telephoto compression the model's nose recedes (particularly appropriate should it be a little too long to begin with), the shape of the mouth becomes more prominent, lips glossed with lipstick appear more graphic, eyes seem larger, and the overall shape of the face becomes more striking.

When you wish to soften the image, I suggest you avoid the standard soft-focus filters as they are usually too extreme. Instead, you can soften the image more gently by slipping a piece of nylon stocking or pink gauze over the lens, or by very lightly smudging the UV lens filter with the natural oil from your finger. The only special effects filter I have used with success in beauty and fashion photography is the single-grid cross-screen diffusion filter. It diffuses the image sufficiently, but without distraction. All other creative filters are gimmicky and draw attention to technique and should be avoided.

The first choice of film for beauty photography is Kodak Kodachrome ASA 25, or ASA 64 if you need the additional speed. The extremely fine grain and outstanding resolution of Kodachrome make it superb for reproduction. The emulsion of this film leans to the rich, warm tones and is extremely complimentary to the model's skin.

Ektachrome films, on the other hand, lean to the cool tones, and in my experience, a filter combination of CC05-magenta and CC05-yellow placed in front of the lens is sufficient to increase the warmth of skin tone.

Lighting.

When arranging your lighting, your greatest concern should be to light the model's face evenly and to prevent any gray shadows from falling onto the skin. These shadows should not be

confused with the deliberate portraiture-type shadows which may appear beneath the model's lip and nose, but refer to the light gray shadows which result from inadequate fill lighting.

For beauty lighting, one preferred technique is to use twin umbrellas and position them as close to the model as possible. This eliminates the need for any separate fill lighting, and the soft, bounced light merges to become one main light without conflicting shadows. To remove any shadows that may fall onto the model's neck, place a white reflector card beneath the model's chin and angle it to bounce back the light.

Close-ups on eyes.

When taking a close-up photograph of the eyes for an advertisement, such as for eye makeup, careful attention should be given to the shape of the highlight in the eye. This highlight should be large and rectangular rather than a pin-point dot of light.

One way to achieve this is to place a large, white reflector card directly in front of the model and cut a hole in the center for the camera to peer through. Then place a strobe light on each side of the model and aim them directly into the reflector card. The lights should be at a sufficient distance to light the card evenly, without producing a hot spot, and at an angle of 45 – 60 degrees away from the camera to prevent lens flare. The light bounced from the reflector card will flood the model's face with soft, shadowless lighting and at the same time produce large clean highlights in the eyes.

If sunglasses or glasses are added as an accessory to the beauty photograph, choose one of the following approaches. Either completely avoid any reflection on the glasses by positioning your light well to the side or above your model, or intentionally direct a large, crisp white highlight onto the lenses from light diffused through a large rectangular scrim. When reflections are to show, umbrella lighting should never be used since the ribs and flash head are seen in the reflection, and the unnatural shape of the umbrella adds to the distraction.

Makeup problems.

Due to the amount of lipstick or lip-gloss a model wears for photography, there is one problem that repeats itself without fail – lipstick spreading onto the model's teeth. It is almost impossible to notice the smudged lipstick while squinting through a 35mm viewfinder and I have had more beauty shots ruined by this occurrence than by anything else.

Now, I take the precaution of having an assistant or stylist stand discretely near the model and signal to me if any makeup problems are suspected.

Photographing perfume.

A bottle of Nina Ricci perfume with its sculptured doves or the classic shape of a bottle of Chanel take on an extraordinary degree of beauty when they are photographed against the stark simplicity of a black background.

To reveal the color of perfume, which is completely lost against a dark background, place a small white reflector card behind the perfume to reflect light back through the bottle. As the shape of the card itself determines the shape of the highlight reflected in the bottle, begin by cutting the card to the rough shape of the bottle, then place it behind the perfume to determine how much trimming is necessary.

To create the most convincing reflection cut the edges and corners so that they are round, wavy and flowing. An assistant should angle the card for you while you watch through the camera, as the reflection will appear and disappear with the slightest movement. When the correct angle is determined, keep the card in position by concealing a small twist of artist's putty behind it.

Perfume with ribbon photographed for a Christmas catalogue. Hours were spent painstakingly adjusting the rolls of the ribbon and supporting it from behind to give it a natural, round flowing shape. The composition was photographed on white no-seam for close-cropping. The shadow was kept close and tight to the product in order that it could also be close-cropped and maintained as part of the final image. Photographed on 4x5 format and with a 150mm lens to keep the shape of the bottle full and round.

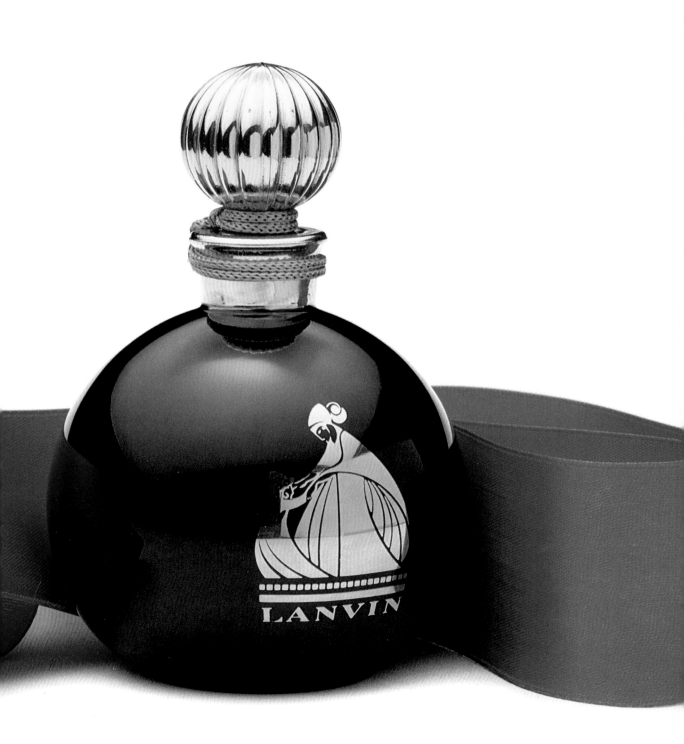

Surfaces.

With perfumes and cosmetics, the wisest approach is to convey visual elegance. Surfaces which are slick, glossy and reflective make superlative backgrounds, especially black ceramic tile, richly veined marble, black vinyl (which can be rippled to catch the light), and gold or silver foiled art card.

A sheet of plate glass mirror provides unlimited creative possibilities simply by what it reflects – a splash of color or a sweep of light directed onto a background and then reflected into the mirror makes an imaginative, original background.

One difficulty, however, in working with a mirror is the ghosting of the image around the reflection. This is due to the refraction of light through the glass before it reflects off the silvered layer. The thinner the sheet of mirror, the less ghosting there will be. The ultimate solution is to have a top-silvered mirror custom made by a mirror manufacturer.

Bottom lighting.

A greatly favored technique of commercial photographers is to shoot on a bottom lit surface and allow the background light to gradually fade into darkness. The merging of tones from white to black allows the product to stand out with sharp contrast from the background and enhances its three-dimensional quality.

To construct a light table you will need a sheet of white acrylic at least two meters in length and 4 mm thick. Support the acrylic with stands and clamps, or rest it along the edges of boxes. Place a large white reflector card beneath it on the floor, and enclose the sides with other reflector cards. Then position two strobe heads beneath the light table, one at each end, and angle them downwards so that the light bounces off the reflector cards producing soft, diffused illumination over the entire surface of the light table. For contrast lighting, the strobe heads may be aimed directly upwards into the acrylic and drama may be added with colored gels placed over the lights.

To create a soft, smooth grading of light at the end of the light table, curve the far end of the acrylic upwards and the light will fall off naturally. To further soften the transition from white light into darkness, it is necessary to put the background out of focus. Choose a lens with at least twice the focal length of the camera's standard lens, such as a 300 mm on a 4 x 5, and set the aperture as wide open as possible. This will ensure the shallowest depth-of-field.

Product tips.

When you open a jar of foundation cream or a pot of cheek blush you will find that the contents do not at all resemble the whipped cosmetic cream seen in advertisements. The reason is

that the cream settles during packing and shipping.

Before photography you will have to restore it to its original consistency. Empty the contents from at least half a dozen jars into a bowl and whip the cream briskly with a fork to aerate it. Then with a round-ended knife, spread the cosmetic cream back into the jars swirling it into a soft peak. Select the best for photography.

Guest soaps, shampoo and bubble bath lotions can be given greater appeal by adding soap bubbles.

To create large soapy bubbles, mix a teaspoon full of liquid dishwashing detergent with a quarter of a cup of water. Then with a drinking straw blow air into the mixture until the bubbles pour out in a continuous stream. Since the bubbles will collapse within seconds, add them to the composition at the last instant before snapping the shutter.

Shooting a spread.

When the layout indicates a number of product photographs to be shown across a spread, the photographer is faced with the responsibility of creating visual continuity.

If the products are shot on a split background the split must line up in every shot. And if a wide angle perspective is chosen, every product must be shot with the same angle.

Nothing more quickly destroys the look and visual integrity of a series of photographs on a spread than switching backgrounds, changing camera angles, or altering the style of lighting.

Remember: keep the style visually uniform throughout each individual spread. When you are involved in catalogue photography where other photographers are working on the same spread, unite your efforts so that the spread appears to be the work of one and not of a multitude.

On my first jewelry assignment, I was handed a small white envelope stuffed with a dozen tiny tissue-paper parcels. Inside each parcel lay a minuscule piece of jewelry. There were fine gold chains twisted in knots, earrings, rings, a tangle of bracelets, stick-pins and pendants. At the time, how to shoot such small objects put me at a complete loss. Ironically, I later discovered it was the very scale of jewelry that gave it endless creative possibilities. To start your imagination, envision the following:

1. Tiny earrings for pierced ears, arranged like drops of dew on the petals of an exotic plant.

2. A jewel-encrusted ring clutched in the claw of a lobster.

3. A dazzling rhinestone pendant graphically placed in the center of an artichoke heart.

4. A golden bracelet dangling at the end of a fish hook.

5. A watch lazily coiled inside the shell of an egg.

6. A pearl necklace sinking into wet black sand as though it had just been washed up by the sea.

Surfaces to shoot on.

Slate is a particularly effective surface to shoot jewelry on. Its deep neutral gray is a perfect contrast for the subtle shades of silver and gold. It becomes an even more striking background when it is wiped with baby oil. This turns the slate into a black glistening surface. Or sprayed with water, slate takes on the appearance of a seaside rock, drenched by the pounding surf – a perfect background for shooting waterproof watches.

Other materials which are excellent surfaces for composing jewelry on are chunks of quartz rock crystal, small slabs of colored marble, mineral stones, black aquarium sand, and unusual sea shells like the spiral nautilus.

Another beautiful effect is to use tiny flowers and plants. Place jewelry along the stem and leaves of a flower as though they were growing from the plant itself. To create the most graphic composition, lay the plant and jewelry on a solid black surface.

Front screen projection.

You can create images of jewelry floating through outer space by the use of front screen projection. Breathtaking transparencies of the Milky Way, spiral nebula and super novas are available from observatories, museums and science centers.

When using front screen projection, suspend the piece of jewelry between your camera and the projection screen, either by using invisible thread or by placing it on clear glass. Light only for your jewelry. A flash tube within the projector flashes the transparency onto the screen. Disregard any background image which you see reflected on the jewelry. It will be canceled out by your lighting.

How to shoot jewelry.

This tiny exotic plant was found in a local Chinese grocery store and made a perfect prop for shooting jewelry. The plant was placed on black vinyl and kept upright with concealed pieces of putty. The jewelry chain at the bottom was pulled taut and held in place by weights at each end. To diffuse the lighting and prevent shadows from appearing on the sides of the plant and jewelry, large scrims were placed at 90-degree angles on each side of the set. Photographed on 4 x 5 with a 150mm Symmar-S lens.

How to shoot jewelry.

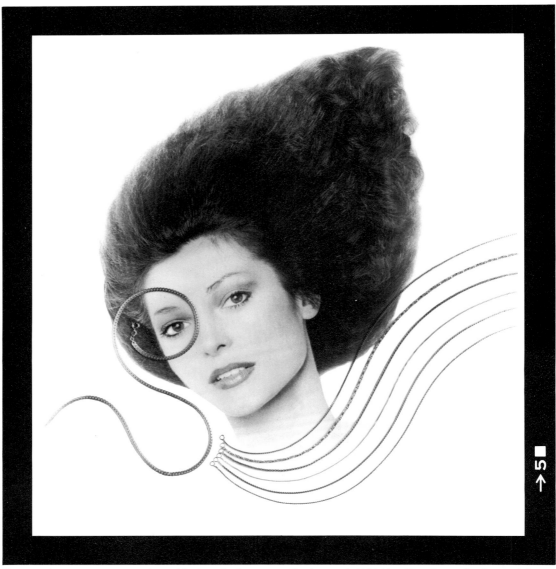

For an advertisement on jewelry, a black-and-white print was first made of model Lucy and the jewelry was then carefully composed on top of the print and re-photographed on 4x5 using Kodak Plus-X Pan Professional 4147 film. To achieve the shape of the model's hair, the model was positioned lying down on white no-seam. In all, over 20 hours were spent creating this photograph.

To determine the correct f/stop take a meter reading of the light reflected from the screen. Confirm this reading with a Polaroid test. Balance the lighting for the jewelry so that it gives you the same f/stop. Then confirm that you have the correct lighting balance by taking another Polaroid.

To project printed material, Balcar have designed a front projector unit that will project images directly from prints, books and magazines. This unit is called the Episcope EPI-138 and it can even project three-dimensional objects.

For shooting jewelry, the deep blue-black of stellar space makes a perfect background. A fiery-red ruby ring blazing through space like a meteorite, a diamond bracelet tumbling in orbit around a moon, or the face of a futuristic watch rising behind a glowing sun – these are the imaginative types of photographs that command high prices.

Necklaces and chains.

When a number of pieces of jewelry have to be shown together in one photograph, such as a collection of gold chains, choose a dark background for contrast and swirl the necklaces into imaginative graphic designs. An art supply tool known as a Letraset burnisher is perfect for this purpose. Its soft round tip lets you smooth out the links without disturbing the line of the chain. You can easily trace them into patterns by traveling the burnisher tip along the edge of the chain nudging it into place.

Another way of keeping the chains in position is to suspend them against an upright background by taping their ends. Gravity will take care of the rest.

Watches.

Lighting watches presents a peculiar problem. Any reflections of light on the crystal will cause the numbers on the watch face to appear burned out. When photographing a single watch, this can easily be controlled by angling the light so that its reflection is not seen on the crystal. But when photographing a number of watches together, reflections inevitably show up on some of the crystals due to their different curves.

In this case, it will be necessary to remove the crystals from the watches; in fact, many watches are shot this way.

In a group shot, unless all the watches are set to the exact same time, they will appear inaccurate. The classic positioning of the hands is ten minutes to two. This way the manufacturer's name is not obscured and the watch hands are aesthetically balanced.

The light from an L.E.D. (light emitting diode) watch is too weak to register on film under electronic flash. Therefore, a time exposure is required.

Place the studio in complete darkness, take your flash exposure, then leave the

shutter open for at least two or three minutes, depending on the f/stop, to record the diode light. A Polaroid test is the only way of determining the time exposure required.

As the numbers on the diode face change during these long time exposures it is unavoidable that some degree of retouching will be required afterwards.

To balance the tungsten-type light from the watch diode with the color temperature of daylight film, a Kodak 80A blue filter is recommended. But frankly, I have never found this necessary, as the color shift is so slight as to be imperceptible.

Liquid crystal watches are free from this problem as the time is displayed through the properties of crystal and not light. The numbers, however, may be faint and require retouching.

When a layout indicates that a watch which has a one-piece expandable bracelet must be shown lying flat, the only way to accomplish this is to split the bracelet in half with cutting pliers. Advise your client first as he may prefer to adjust the layout or to obtain a demonstration model from the manufacturer.

Instead of placing a watch on a model's wrist, consider wrapping it

In lighting the jewelry for this photograph, the scrim was removed from the Broncolor Hazy lighting unit and the interior shell of the reflector was allowed to reflect into the carefully rippled vinyl background. This effect created the impression of smoky, moonlit clouds. Exposure was increased by one f/stop to compensate for the absorption of light into the black.

around a lucite rod which is glimmering with light from a strobe head aimed directly into one end, or by placing it graphically around an egg sprayed black, silver or gold.

Earrings and close-ups.

If the surface you are photographing jewelry on is a soft material such as vinyl or velvet, place a sheet of styrofoam or foam-core card beneath it. This will give you a surface to stick the earrings through to keep them upright. If the background is hard, you will need to carefully conceal putty beneath the base of the earrings to keep them in place. Putty is also invaluable for keeping rings and bracelets upright.

Shooting jewelry against the bare skin of a model presents an annoying problem. Because of the small scale of the jewelry, any magnification of the photograph will draw attention to the pores, creases and texture of the skin. Also, unless the model is either dark skinned or well-tanned, you will find that close-ups of jewelry against bare flesh are decidedly unappealing.

With macrophotography, where you are magnifying the image to greater than life-size, the depth-of-field drops into the millimeters. To accurately place the object in the center of the depth-of-field, the secret is not to move the camera but to move the object instead.

To do this, design your composition on a small background and place it atop the platform on a tripod. Then move

the tripod into position beneath the lens of the camera. Extend your camera bellows to give you the largest image possible. Now crank the tripod's handle, gently elevating the subject into the camera's field of view. With this precise a control, you are then able to critically establish your working depth-of-field. To determine exposure compensation for extreme bellows extension, refer to Kodak Professional Photoguide, No. R-28.

Lighting.

When you are lighting jewelry, bear in mind that silver and gold are highly reflective and therefore should be completely enclosed with reflector cards. To help retain the delicate warm color of gold, yellow reflector cards may be used instead of white. Be certain to use fill lighting and reflectors to remove all shadows and dark reflections on the jewelry; otherwise it will appear dark and heavy, as if made from iron.

Umbrella lighting is not appropriate for jewelry. It cannot be placed close enough to the jewelry to be manageable, and the circular shape of the light

In designing this photograph, the bottle was placed on its side on a light table and the jewelry was actually composed an inch and a half beneath the neck of the bottle. Compression from a telephoto lens merged the jewelry to the lip of the bottle. Lighting from beneath the light table was adjusted until it gave the same meter reading as light falling onto the jewelry from the main light above. This effectively cancelled out the shadows so that the jewelry appeared to be suspended or pouring from the bottle.

reflects as a hot spot. The rectangular shape of diffused light through a scrim or from a box light creates the long, smooth highlights that jewelry needs.

Insure yourself.

Most clients will not leave valuable items on your premises unless you are adequately insured – especially if the valuables are jewelry. Fortunately, insurance can be arranged for as short a period as one day.

For your own protection, it is worthwhile insuring any jewelry that comes into your possession. It is amazing how so few pieces can total $10,000 and more – and how easily they can disappear. But you should always understand exactly what you are insured for.

A case in point: At the end of one shooting session, I discovered that six rings, worth a total of $1,000 were missing. There had been a number of people on the set that day, and I suspected that the rings may have accidentally become mixed up with the costume jewelry belonging to one of the models. Checking yielded no results. And after several days, when the jewelry did not reappear, I called my insurance company to submit a claim. The response: I was informed that this claim came under the category 'mysterious disappearance' and therefore was not covered under the policy. Painfully, I had to subtract the $1,000 from my invoice to my client. Lesson: buy insurance, but make sure you are fully protected.

To create this shot of a sparkling white wine on ice, the bottle and ice cubes were arranged in a clear glass dish and then placed onto a light table. To achieve the correct lighting balance between the bottom light and the top fill light, the Minolta Flash Meter III with a probe for reading light on the camera's ground glass allowed the difference in f-stops to be read from the brightest area to the darkest. The lighting ratio was then adjusted until the bottom light was within 2:1 to the main light preventing the ice cubes from burning out on the transparency.

How to shoot liquor.

Liquor, wine and beer, or 'booze photography', as it is known in the business, is one of the highest paying specialities. The main reason for this is that it requires the highest standard of technical excellence. It is also deceptively difficult.

In photographing any beverage, knowledge of certain techniques makes the difference between success or failure. In practically every liquor advertisement, the liquor is shown 'on the rocks' or in a tall mixed drink swirling with ice cubes. But one is never aware of how quickly ice cubes can melt or of the problem they can cause until one has to photograph them.

Ogilvy & Mather, the advertising agency handling the Wolfschmidt Vodka account, asked me to do the photography for one of their advertisements in the campaign "The spirit of the Czar lives on". The layout showed the graceful hand of a czarina, and the military, white-gloved hand of a czar, each cupping a crystal goblet of vodka on ice. A romantic interlude would be captured only by the gesture of their hands. Sitting on the table between their glasses was the classic bottle of Wolfschmidt Vodka.

On the day of the shoot, the bottles and glasses arrived at the studio, each wrapped with clear acetate to protect the labels which were retouched to perfection. In directing the shoot, the success lay in capturing just the right movement of the fingers, the tilt of the arm, and the grace of the hand. The glasses were critically positioned and the models rehearsed. Twenty sheets of 8x10 film were loaded and a bucket of hand-picked ice cubes were whisked onto the set.

No sooner had the ice cubes been placed in the glasses than they melted and submerged in the vodka, flooding the drink. The glasses could not be moved so my assistant had to work furiously with a hypodermic syringe to drain off the rising liquid and attempt to fish out the dwindling ice cubes and replace them without disturbing the set – an ordeal that had to be repeated every five minutes.

All the while, the models had to keep their hands in position. To make matters worse, prolonged elevation of the 'czarina's' arm caused bulging blue veins to appear on her hand; and the 'czar', with his hand and body contorted around the lighting, was driven to letting out periodic moans of agony. We were completely at the mercy of the ice cubes and three hours of mental anguish replaced what should have been a relatively pleasant and inspired hour. With no end in sight, I elected to continue the shoot the next day – at my own expense.

I came to the conclusion that it was impractical to continue with the purist

approach. Fake ice cubes were needed.
A photographer whom I knew gave me
a number to call and within a few hours
I held in my hand one dozen precious
jeweler's bags, each one containing a
beautiful, hand carved acrylic ice cube.
I willingly paid $250 to own them. The
re-shoot was an absolute pleasure.

Any photographer who is seriously
pursuing liquor photography should
approach an acrylic supplier and have at
least six cubes specially made. These
should be chunky in shape, approxi-
mately one-inch square, and should not
resemble the small, rectangular shaped
ice cubes normally found in refrigerator
trays. It is a matter of aesthetics.
Interestingly, ice cubes made of glass are
not suitable for photography as they
have a distinct greenish cast.

If the circumstances force you to use
real ice cubes, bear in mind that the
cubes must be perfectly clear to com-
municate purity. To make them, follow
this procedure:

Boil the water first, to remove the
oxygen. This will prevent bubbles from
forming in the ice and causing a cloudy
appearance. Then freeze the cubes
slowly by setting the freezer temperature
to minimum. This will help to allow any
remaining air bubbles to rise to the
surface and escape. To remove the cubes,
immerse the tray in warm water for a
few seconds so that the ice cubes will slip
out easily without cracking or chipping.

The cold, frosty look.

Every professional photographer
has his own secret for creating a frosty,
cold appearance on a glass or bottle.
Here is mine:

First smear a fine film of petroleum
jelly over the glass. Then spray on top
with a mixture of one part glycerine to
one part water using a perfume atomizer.
The petroleum jelly gives the icy, frosty
appearance while the glycerine provides
the cold beads of condensation.

Spraying with water alone is ineffective
as the droplets only collect together and
roll down the glass. Glycerine, however,
is a viscous fluid and holds its beaded
shape longer, especially when sprayed as
a fine mist.

For dramatic effect, a few particles of
dry ice dropped into the beverage will
cause a gentle rolling cloud of icy steam
to spill over the glass, as if the drink had
just been taken out of the freezer.

Afterwards, garnish the beverage with
a spring of mint leaves, a slice of lemon
or lime, or a curl of orange peel –
whatever is suitable for the drink. This
serves more than adding touches of
color, it conveys the sensation of taste
and flavor.

Note: to restore the fizz to ginger ale,
champagne, beer or any carbonated
beverage, sprinkle Bromo Seltzer into it.

The classic lighting technique.

With lighting, attention must be given to bringing out the maximum shape of the bottle. To do this, place a large source of diffused light from a scrim or box light directly above the bottle. This will place reflections on the shoulder of the bottle and add a bright, crisp highlight to the cap. To create a stripe of light along the side of the bottle, position a second source of diffused light next to it. Then place a reflector card on the shadow side of the bottle to relieve the darkness, and position a second reflector card in front of the bottle, to reflect light onto the label. This is the classic method of lighting.

When the photograph is to be taken against a dark background, which is usually the case, place a small, hand-cut reflector card behind the bottle or glass. This is the only way to bring out the mellow amber color of whiskey or the pale, golden yellow of white wine. The trick is to cut the reflector card about the same size as the bottle or glass and trim the edges into round, flowing curves so that they appear as natural reflections through the liquid. Place the reflector only a few inches behind the bottle or glass, angled to catch the light, and secure it in position with a small lump of putty.

With clear spirits, such as gin or vodka, there are two schools of thought on lighting. One school is to follow the above method, reflecting pure white into the liquid from a reflector behind the bottle. Even though this creates a rather unnatural look, this is the traditional approach most clients prefer. The other school of thought is to avoid using any reflector behind the bottle allowing the background to show through, with only a single light from above to highlight the shoulders, curves and bevels of the bottle, creating only an outline shape. This technique has the added advantage of drawing maximum attention to the label.

In liquor advertising, the visual emphasis is always on the name of the brand. This means showing the label with unquestioned clarity. Examine the label on a bottle of Martini & Rossi Vermouth or Chivas Regal Scotch; they are miniature works of art – one is vibrant with color and the other is rich with gold embossing. To assure the highest quality of reproduction, 8 x 10 transparencies are expected, and to supply anything less in size is only an admission that liquor photography is not your forte.

No field of photography requires more creative wizardry than that of shooting food. Specialists command high fees both for the secrets they hold and the skills they display in making food appear luscious and tempting.

At one time, photographers had unlimited creative license to doctor a food shot: shaving soap instead of whipped cream, mashed potatoes in place of ice cream, even shoe polish to brown a turkey.

But now there are government restrictions which forbid the use of substitute food in advertising, and a strict code of rules applies to assure that the product is accurately represented.

For instance, when photographing canned soup for an advertisement, you are not allowed to add one more noodle, one more alphabet letter, or one more tomato. You can open a hundred tins to find the one with the contents you consider to be the most appealing, but you cannot mix or alter the ingredients in any way.

You may also be required to sign a legal form to verify that all food used for photography was the actual food supplied by the client and that no substitute or fake food was photographed in place of the original.

Food coloring or stabilizers may be allowed as long as they are edible, and cooking times may be cut short to keep food from collapsing or losing its color. Restrictions are lifted when food is to be photographed for cookbooks, magazines, or recipes. But for safety, one should always check with the client to find out what is permissible.

What food editors look for.

Food editors favor photographers who know how to inject atmosphere and story appeal into their photographs. Here are some guidelines for creating images that win their approval:

1. Display imagination in the presentation of the food. Strive for graphic simplicity: the golden crown of a cheese *soufflé* puffed high above its fluted white bowl is contrasted against a royal blue background.

2. Create still-life settings with antiques and props. For a classic French pot of *bouillabaisse*, a black cast-iron pot may be chosen to contrast with the spicy red tomato broth. In the background, an old, weather-beaten lobster trap could be added. In the foreground, a fish net might glisten with a fresh catch of pink shrimp and black mussels.

3. Enhance the atmosphere of your shot by selecting surfaces which add story appeal. Rustic pine for a colonial dish of corn muffins, polished mahogany for an elegant serving of *crêpes*, a checkered tablecloth for lasagna, or a lacy tablecloth for strawberry *frappé*.

4. Establish the time of day with your lighting: Soft early morning light streaming through a window across a breakfast tray. The mellow golden light of late afternoon sun spilling through

How to shoot food.

Pub lunch theme for cookery book English Country Fare. Photographed on 4 x 5 using a Symmar-S 150mm lens and Kodak Ektachrome 64 film. A single source of diffused lighting was placed directly *above the set and white reflector cards were positioned around the set to relieve heavy shadows and bring up detail.*

191

shutter slats to reveal afternoon tea and crumpets. The cheerful glow from a kitchen hearth at dusk flickering across a country-style dinner of roasted leg of lamb and mint jelly. And for after-theater snacks of caviar, *hors d'oeuvres* and champagne, the glimmering of candlelight adds romantic atmosphere.

5. Create appetite appeal. Exaggerate the taste sensations that food conveys. Meat should appear juicy and succulent. Fruit should appear fresh from the garden. And soups and stews should look like they are piping hot.

6. Shoot on 4 x 5 or 8 x 10 transparency film to capture the richness of detail and subtlety of color so necessary in photographing food. As with all product photography, the large transparency is the mark of the professional photographer.

Hiring home economists.

With magazines, the food editor and assistants are normally on hand to prepare and organize the food. Most food advertisers have their own home economist who will be at your disposal during the shoot. When you need to hire a home economist yourself, you will find that as freelancers they charge in the neighborhood of $150 a day for their services. This expense should be quoted as additional to your photography fee; food clients are accustomed to this charge and do not expect a photographer to bear this expense as part of his own production cost.

When the client is on a limited budget, as often seems the case, you may be forced to 'go it alone'. In these instances, you will find the following information invaluable.

Ice cream.

In preparing food for photography always begin with a large quantity. It is a standard procedure to have at least five times the amount you will actually need.

With whole-fruit ice cream, for example, you may scoop your way through three gallons to find enough scoops where the fruit has not softened to an unrecognizable pulp.

Scooping ice cream until it looks photographically acceptable for a sundae is much more difficult than it appears. The objective is to produce the rough, rippled texture traditionally associated with ice cream.

The first point to remember is that it is virtually impossible to scoop from a block of frozen ice cream. To make it more manageable, remove the ice cream from your freezer compartment fifteen minutes ahead of time and place it in your refrigerator.

You will need a proper ice cream scoop. If one is not available at a kitchen supply shop you should be able to obtain one from a restaurant supplier. Avoid the commercial style scoop which has a built-in lever for releasing the ice cream as this smooths the ice cream concealing its texture.

With the first quart of ice cream, prac-tice your scooping technique. A straight-down thrust, with a quick, forceful turn of the wrist is necessary. I have watched home economists turn out perfectly shaped ice cream scoops by the dozen at the rate of almost one a second. In the beginning, you can expect to scoop up an average of six in order to find one that is usable.

Ice cream is one of the most difficult substances to photograph. Unless special precautions are taken, you will have less than five minutes of working time before the warmth of your studio destroys the appearance of the ice cream. Even with the temperature turned down in your studio the heat from your modeling lights and from your body are working against you.

To prevent your scoops of ice cream from melting, place them on a cookie sheet over a tray of dry ice. Then freeze the surface of the ice cream scoops by grinding shavings of dry ice over the top. Do this by pressing the dry ice through a metal sieve with the flat edge of a wooden spoon. (Warning: handle dry ice carefully as it maintains a tempera-ture of $-127.8°C$ ($-109°F$) and will burn your skin if you touch it.) Ice cream, in this rock hard state, should stay frozen for twenty to thirty minutes in the studio increasing your working time.

Chill the glassware or serving dishes beforehand. To move the dishes of ice cream into position on the set, use wooden utensils or bamboo darkroom tongs as they will not conduct the heat

How to shoot food.

A composition of dried fruit photographed in an old-fashioned typesetter's tray, for a food spread in Chatelaine magazine. Lighting was achieved with the Broncolor Hazy with the scrim removed to add more luster and sparkle to the fruit. The light was intentionally angled to cast a shadow in the foreground, increasing the dimension of the photograph on the page. Photographed on 8 x 10 with a 300mm Symmar-S lens permitting exposure accuracy to 1/3 f/stop.

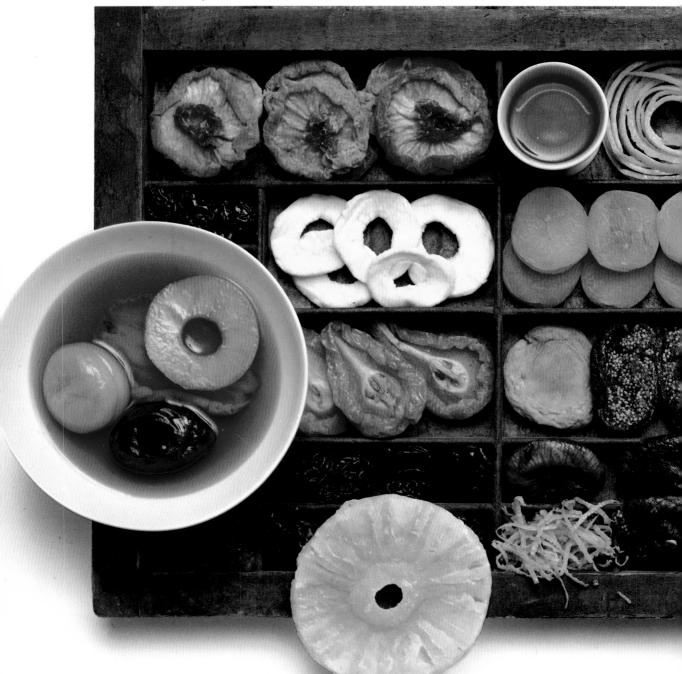

from your hands to the ice cream. To lift the ice cream scoops off the cookie sheet, use a metal spatula with a wooden or plastic handle.

While you are arranging your lighting and composition, work with reject scoops of ice cream. Switch to the final scoops only at the very last moment.

Creams and sauces.

Whipped cream decoration on top of ice cream or desserts quickly turns runny and loses its shape under normal room temperature. To prevent this, add a cream stabilizer such as *Oetker Whip It* while whisking the cream.

The cream can then be spooned into an icing bag fitted with a meringue icing nozzle which will allow you to squeeze out swirls and artistic designs.

To photograph a sauce when it is flowing down an ice cream sundae is a feat indeed. To give you the time that the shot requires, the sauce will need to be thickened so that it will flow more slowly. This is usually achieved by adding an extra tablespoon of cornstarch to the recipe and reducing the amount of liquid. Then chill the sauce for at least two hours in the refrigerator before you use it. This will slow the sauce down considerably.

If the sauce is a commercial brand for use in advertising it is unlikely that you will be permitted to tamper with the ingredients and you will have to rely on chilling alone to increase its consistency.

How to shoot food.

A rush of urgency always surrounds food photography. During photography of this color advertisement for *Carnation Instant Breakfast*, the cornflakes had to be photographed within seconds of pouring the milk as the flakes immediately began to lose their shape. Bubbles in liquids would last only a second, and the rim of the glass or cup had to be wiped clean between each exposure. Also, the syrup had to be photographed at the instant it was poured, before it ran over the plate, and butter pats had to be given a moment's heating under the grill and rushed in front of the camera before they completely melted. In addition, over six cartons of waffles and doughnuts had to be gone through to find contents that were acceptable for photography, and over a dozen slices of bread were toasted until the perfectly golden slice was produced. Styling and photography were completed in a day. Fee for photography: $2,500.

Cheese.

Cheese will begin to dry out within as little as half an hour after being exposed to the air and will quickly assume a crusty appearance.

Always work with two identical slabs of cheese. Keep one slab moist by wrapping it in a damp cloth and storing it in the refrigerator. Exchange the pieces just prior to photography.

If it is not practical to replace the cheese due to the complexity of the composition, cover it with a damp cheese cloth until you are ready to shoot.

When you are photographing a number of cheeses in one shot, you will find that many of them look remarkably similar to each other and that they may be impossible to identify later in the photograph. In this case, you will find it prudent to take a Polaroid and mark the names of each cheese on it before you disassemble the set.

When selecting surfaces to shoot on, choose backgrounds which provide contrast for the creamy-soft nature of cheese. The rough texture of the burlap, the hardness of marble, or the warmth of aged cherry wood are especially suitable. Add cracked walnuts, black grapes, an antique cheese scoop, or a glass of ruby red port. Then show the character and texture of the cheese itself. Slice a wedge out of Gouda, crumble chunks from cheddar, or bury a spoon into a soft English Stilton; these are the elements of good still-life composition.

Let the background fall into darkness to provide contrast for the delicate whites and creams of the cheese. Diffuse your light with sheets of frosted mylar to prevent highlights from bleaching out the cheeses' pale color.

Butter.

One problem with butter is that because of its pastel color and its high reflectance under light, it tends to bleach out in photography. By blending a few drops of yellow food dye in to the butter, you can compensate for this loss in color.

When butter has to be shown as an ingredient in a food shot, instead of showing it in brick form you can shape it into thick butter curls with a butter curl knife, or spread it into tiny butter crocks and then stamp the top with an antique butter stamp.

If butter has to be shown as a block, it can be made more visually appealing by patting it into shape with old-fashioned, ridged butter paddles. The play of light over the fluted ridges adds a wholesome country atmosphere.

Fruit and vegetables.

Cooked food not only loses its shape but its texture, detail and color as well. Therefore, when fruit or vegetables have to be shown cooked, the first rule is that they must be given the absolute minimum cooking time.

Plunge them first into boiling water for a minute or two, drain them, and

How to shoot food.

When presenting food on dishes, fill the plates to
overflowing. With pots of soup or stew, fill them to
the brim and have a ladle scooping up chunks of beef
and pearls of barley or other tempting ingredients.
When using garnishes, be overly generous. When
photographing food, create a visual feast for the eyes.
In practically every cooked food dish, the food must
be undercooked to retain its natural color. In this
table setting of poached salmon for Epicure magazine,
the salmon instantly lost its color when steamed and
therefore a coating of food coloring had to be brushed
on. To further enhance the visual pinkness of the
salmon, a napkin and flower of similar tones were
added to the shot. Fee paid: $600. Even the highest
paid photographers enjoy doing the occasional
editorial spread as most magazines are considered the
showplace for new creative ideas.

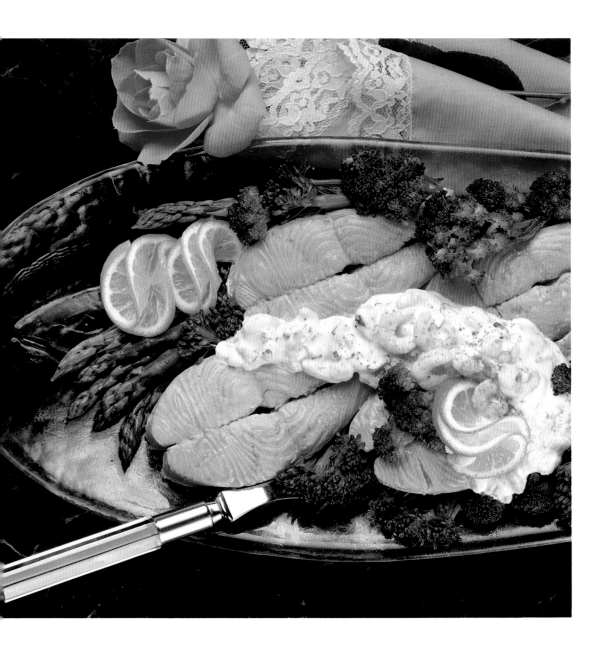

How to shoot food.

For this editorial spread on fried chicken, the chicken skins had to be removed from the meat and then sewn back on for a tighter fit. This prevented the unappetizing appearance of wrinkled chicken skin which would occur during frying. Creating appetite appeal often requires enormous preparation. The extent of the preparation can only be determined by assessing how the food will actually look once it has been cooked.

then immerse them in ice-cold water to halt the cooking action. With most fruit or vegetables, the cold water will also intensify their natural food color. Afterwards, brush them with vegetable oil to add shine.

When fruit or vegetables need to be sliced and shown fresh, remember that many of them are prone to discoloration, especially apples, avocados and mushrooms. To prevent them from turning brown, follow the customary technique of drenching them in lemon juice.

Meat and poultry.

The single greatest problem with meat is its color, especially beef which often turns a gray color when it is cooked.

The food photographer's most precious coloring agent is *Bovril*, a natural beef extract used in making gravy. Brushed over a steak or roasted meat, it adds the deep brown richness you expect with cooked meat.

Keep meat sizzling on a hot plate, right up to the moment of shooting. As soon as the meat begins to cool, it also begins to shrink. The fat marbling in beef and the fatty tissue in poultry begin to congeal and the succulent appearance all but disappears.

Cooking poultry presents a different kind of problem. It is during the last one-third of cooking time that the bird loses its plump shape and the skin begins to shrivel. For a plump, golden brown roast turkey, cook the bird

according to the recipe but for only two-thirds of the recommended cooking time. Then, just prior to photography, brush the partially cooked bird with *Bovril* and cooking oil.

Fish and shellfish.

Fish are among the most photogenic of nature's bounty. A quick brush with glycerine is usually all that is necessary before they are placed in front of the camera's lens.

Lobster, crab and other shellfish look disappointingly dull and artificial when their shells are left dry. To create the atmosphere of freshness from the sea, coat the shells with glycerine then spray over with a fine mist of water.

If the recipe requires the fish to be shown whole, never cook it as the skin and eyes will start to pucker and discolor. For filleted fish recipes, steam the fish until the glutinous look of the flesh disappears. This should take only a few minutes.

When parsley is required as an ingredient in the sauce, it should not be cooked with the sauce but added fresh just before pouring. As with all herbs, parsley loses its distinctive sprig shape when subjected to heat.

othing strikes more terror into the
heart of a photographer than being
asked to shoot a room set. Such large
scale photography is viewed as a mam-
moth undertaking completely devoid of
any creative satisfaction.

But to the contrary, I have found that
shooting a room set can be creatively
challenging and extremely profitable – as
long as you break a few rules.

The first rule to break is in lighting.
Traditionally, room sets are lit with a
vast array of tungsten lights, including
key lights and accent lights, to high-
light every feature but this results in a
photograph which is often unrealistic
and artificial.

Change the rules by shooting with
strobe instead of tungsten and by using
a single source of broad, diffused light
instead of an intricate arrangement of
individual lights. This allows you to
create the atmosphere of a room bathed
in window light – infinitely more natural.

Room sets are commonly shot in this
manner in the leading photo studios in
Germany and Switzerland.

Classically, room sets are always
photographed with normal perspective.
This is the second rule to break. Switch
to a wide-angle lens for its more
dramatic perspective. I recommend the
Schneider 75mm Super-Angulon lens
for the 4x5 format and the Schneider
121mm Super-Angulon lens for the
8x10 format.

How to shoot room sets.

This room set was designed in the studio complete with a custom-made stucco plaster wall. The Broncolor Hazy was used as the main light but with the scrim removed to increase the lighting contrast. Fill lighting around the set was achieved by bouncing light to the ceiling from two additional strobe heads.

The wide angle effect was achieved with a 75 mm Super Angulon lens. Extra stretch was given to the perspective by tilting the lens plane away from the subject. A dozen sheets of film were used before the kitten was caught in the right position.

Equipping your studio.

For shooting room sets, you will need the following:

1. A background wall, at least 4 meters long and 3 meters high. The easiest way to construct this is with three, large sheets of dry wall board, supported at the back by a wooden framework. The seams are fused together with plaster tape. Wall surfaces can be left plain for wallpaper or paint, or given a coat of plaster which can be stippled or swirled into stucco patterns to create a Spanish or colonial wall. If two walls are constructed, they can be placed together to make a corner section of a room.

2. Two window units. One single size and one double size unit, both without glass, to prevent problems due to reflections.

3. Several meters of frosted acetate to cover the back of the windows and to diffuse the light.

4. A length of adjustable drapery track.

5. A selection of tile or parquet flooring to cover an area of 2 x 2 meters. Practically all room sets are shown on broadloom supplied by the client. Where carpets are provided, tile or parquet need only appear around the edges.

6. Ceramic tiles, to cover an area of 2 x 2 meters. These tiles should be a solid color to provide contrast for bathroom rugs, towels and shower drapes.

7. A white toilet and tank unit to use for shooting seat covers, bathroom mats and other accessories.

8. A double-size bed complete with mattress. Headboards are usually provided by the client. A bed is necessary for shooting sheets, pillow cases and comforter sets.

9. Two tables, one rectangular and one round. These tables are used for table linen and tableware settings.

10. A well-equipped tool box containing a pair of heavy duty scissors, utility knife, adjustable crescent wrench, pair of plyers, wire snips (for uncrating), multiple-head screwdriver with interchangeable bits, and a staple gun.

For studio space, you can get by with one large room 6 x 10 meters and a storage room about half that size.

Composition simplified.

In most cases, the client will provide an interior decorator and set stylist who will completely design the room set as well as collect plants, pictures, props and other home furnishing accessories.

In 'White Sale' promotions, where bedding, bath towels and table linen are the advertised feature, room set environments will have to be specially created around these items. When this is the case, the photographer and his assistant may have to shoulder the responsibility for set design.

As a practical matter, I have found it impossible to design a room set first, and then attempt to take a photograph of it afterwards. The space relationships for the camera lens are invariably

wrong. Either the objects have to be brought closer together, or spaced further apart.

As a strategy for composing room sets for the camera, begin by placing the single most important item onto the set. Use this to establish your camera angle and then manipulate the swings and tilts on the camera to set your perspective and depth-of-field. Once this is done, do not tamper with the camera or the controls. While concentrating on the camera's viewing screen, direct an assistant to place the next largest piece of furniture into position, and then to add each piece to the picture, one by one, until you are left with only small gaps which can easily be filled with plants and flowers.

The perfectly designed room by an interior designer may be beautiful to look at, but it is often exceedingly difficult to photograph without making numerous adjustments for camera perspective.

Special problems.

Drapes never hang perfectly; a number of the folds always sag inwards or outwards. To solve this problem, drop lead-weight fishing sinkers into the hem at the bottom of the curtain. This pulls the fabric taut and allows you to easily arrange the folds.

If the folds need more shape and roundness, construct cardboard tubes about 10 centimeters in diameter and pin them into position from behind.

Bedspreads and tablecloths present a similar problem. The folds at the corner appear limp and to be lacking body.

The professional touch is to insert cardboard cones beneath them to give the fabric more shape. Cones can be twisted out of any lightweight card and held together with masking tape to keep them from springing open.

When photographing bed linen, you will probably discover that the pillows look disappointingly small and flat, especially when viewed at the end of a large expanse of bed. The best solution is to use a double set of pillows, and if necessary, prop them up at an angle towards the camera.

Lighting.

The simplest method of lighting a room set is to use one main strobe light. Place this light overhead at an angle of approximately 45-degrees to the set. Direct two or three strobe heads to the ceiling opposite the main light. Position large white reflector cards around the set to bounce light back and keep light loss to a minimum.

For the proper amount of fill lighting, your meter should read one f/stop less than your main exposure. If your main exposure is f/11, the fill light should be adjusted to read f/8.

There is a common belief that only large studios are capable of handling large product photography such as televisions, refrigerators and dishwashers. But I have found that it is remarkably straightforward work for the independent photographer as long as he has adequate storage space, physical help and a trolly for transporting the merchandise from the delivery truck to his studio.

The use of wide-angle perspective can bring a dramatic viewpoint to the simple square and rectangular shapes of televisions and refrigerators. To create this wide-angle perspective with a 4x5 camera, use a 75mm lens. This lens is equivalent to a 50mm lens on a 2-1/4 camera or a 24mm lens on a 35mm camera. With this degree of perspective, distortion increases rapidly as you approach the subject and therefore the camera angle has to be chosen with extreme care.

The following tricks-of-the-trade will solve some of the most common problems you will encounter.

Stereos.

Shooting stereos is often more of a study of shooting lights than of shooting equipment. Dials, panel lights, and meters glow with color and this must be accurately reproduced in photography.

To record these low level lights when shooting with strobe, make your flash exposure first, followed by a time exposure to register the tungsten-type lights from the stereo. To take a meter reading from the panel lights, set your daylight meter on 'reflected' mode and hold it directly against the face of the stereo panel to obtain the maximum reading. Depending on the f/stop, do not be surprised if the time exposure requires from one to two minutes. To balance for daylight film, place a light balancing filter in front of the lens during the time exposure. An 80B blue filter is usually sufficient.

Turntables.

Turntables pose their own unique problem. When a turntable is to be shown with its acrylic cover on top, virtually all detail is lost of the turntable beneath it.

The solution is an ingenious one. It consists of two exposures on the same sheet of film. To do this, remove the turntable cover and take the first exposure of the turntable. Set your lens one f/stop under the required exposure, causing the image to be underexposed by one stop. Then place the cover onto the turntable, and expose the film at exactly the same f/stop. The second exposure will complete the first exposure and the lid will appear transparent as a result of being partially underexposed.

Mime artist Howard Lendé was used in this amusing attention-getter for a tv sale advertisement. Some art directors would consider this a distracting element, but readership studies have shown humor to be an extremely potent force in advertising. Have the support of your art director before you embark on any idea which might be considered a visual frivolity.

How to shoot tv's, stereos and appliances.

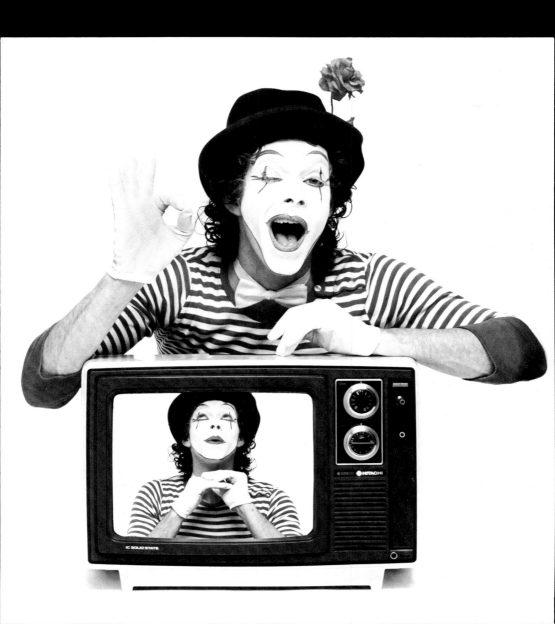

*The art director requested a clean clinical treatment
of the famous Braun line of appliances and the use of
negative space was an integral part of the layout
which had to be complemented in the photograph.
Fee charged: $2,500 including the inset photograph.*

When placing the cover onto the turntable, meticulous care must be taken to prevent any movement of the turntable itself as this will put the second image out of register with the first exposure.

With any technique involving multiple exposures on the same sheet of film, always conduct a Polaroid test beforehand. Depending on the density or opaqueness of the cover, you will have to modify this formula to obtain just the right degree of translucency without the cover disappearing.

The best result is achieved by photographing the turntable against black. On film, black is recorded as the unexposed portion of the emulsion and this allows the second image to register with greater clarity. Also, the darker the tone of the turntable, the more clearly the plastic cover will register on top of it.

Televisions.

With televisions, the photographer usually has the additional responsibility of providing the picture for the screen. This is provided separately as it is always stripped in at the mechanical production stage. But the photographer should size the image and provide the client with a tissue tracing indicating the proposed cropping.

A peculiar problem arises when you are required to provide an image for the inside of the screen when the television has been photographed at an angle.

The first time I had to photograph a television I was completely unable to

resolve this problem. With some embarrassment, I asked the art director if he knew how other photography studios dealt with this difficulty. A grin came over his face, and he leaned across the desk and whispered,"You don't photograph anything at an angle – you simply strip in the picture and the rest is visual deception!" Needless to say, he was right.

Most studios keep a collection of stock photos on hand that are suitable as insets in television screens. Sports scenes are extremely effective and should tie in with the season – skiing scenes for winter, football in the fall, sailing in the summer. Practically any sport or action photo will do.

Photographs of models' faces are also extremely popular as insets for television screens. One caution though: if the model's eyes are looking directly out at the viewer, it can be enormously distracting. Choose images where the model is looking off-camera as this will place the visual emphasis on the television instead of on the model.

Chromed appliances.

Chromed appliances, especially toasters and kettles, reflect everything in the studio including you and the camera. The only completely satisfactory way to photograph any chromed object is to construct a light tent around it. This can easily be done with a large white bed sheet. If a box light is being used, place it in an overhead position and drape the sheet over it. This will make an excellent light tent.

For clean white reflections in the chrome, soft fill lighting will have to be directed through the fabric. Do not aim the lighting directly into the tent from strobe heads as this will cause hot spots to appear in the reflection. Instead, use light bounced from umbrellas, or off white reflector cards. This will create the broadest source of diffused light.

The reflection of the camera in the chrome is unavoidable, but the solution to this problem is to leave a space in the tent above and below the camera so that the gap reflects as a black stripe. This will actually help make the chrome look more like chrome.

To give the kettle or toaster the reflections which are characteristic of chrome, place one or more gray reflector cards close to the side of the appliance so that they reflect tone back into the chromed surface.

Dressing the shot.

In all product photography, it is the propping or 'dressing' of the shot that makes it come to life. For an electric toothbrush set, squeeze a stripe of red jell toothpaste onto one of the brushes. For an electric shaving soap dispenser, create a swirling mountain of lather beneath the spout. Or for curling irons, show the tongs twisting a large golden curl in a model's blonde hair. Make every shot tell a story.

Kitchen appliances should be shown in use whenever possible. With a blender, fill it full of fresh fruit ready to be blended. With a pop corn maker, have it spilling over with freshly made pop corn. With a cake mixer, surround it with baking flour, eggs, sugar and a cup of milk. With all appliances, entice your viewer to use them. This is the secret to good advertising.

Refrigerators, freezers, dishwashers.

In lighting any large appliance, the main light should be placed high above and slightly behind the subject. This will cast a shadow onto the foreground, placing tone on the sides of the appliance and therefore preventing it from merging into the background. This also gives the subject its greatest degree of shape and form. A front fill light may be used as long as it is soft, diffused and leaves no shadows. It must not interfere with the impression of one main light.

My practice is to position large white foam core boards, approximately 1 x 2 meters in size, in front of the subject and reflect the spill from the main light onto the front of the appliance to lighten any dark shadow areas.

For the inside of the refrigerator, allow a time exposure to register the interior lights, or better still, conceal a tiny portable flash unit with a slave attachment so that it fires simultaneously with the main strobe.

With refrigerators and freezers, the photograph must have particular appeal to housewives with families. The refrigerator shelves must be packed full with food to show its capacity.

As few clients will pay for these groceries it is a good idea to build up your prop inventory beforehand with frozen dinner cartons, milk jugs, butter cartons, large pop bottles, and other food containers. It is astounding how much food a large refrigerator holds.

It seems that one request every refrigerator manufacturer makes is to have a large turkey sitting on one of the shelves. Here you will have no choice but to add the turkey to your personal grocery list.

With top loading freezers, the problem of propping is simplified for only the top layer shows. Large cartons and boxes can be used underneath to build up the necessary height.

Dishwashing machines need to be shown with their racks pulled out to demonstrate the enormous amount of china, cutlery, glassware and cooking utensils they hold. But there is an art to filling dishwashers and every manufacturer has their own unique storage system. Rather than risk your interpretation of the instruction manual, the simplest solution is to contact the manufacturer's service department and arrange for a representative to come to the studio and fill the dishwasher in the manner they recommend. I have never been refused this assistance.

66-1 BAYCREST 10 pc. Aluminum Cookware Set. 40 oz. Covered saucepan, 120 oz. Covered Saucepan, 60/80 oz. Covered Double Boiler, 176 oz. Covered Dutch Oven, 10" Open Skillet. Set. **69.98.** Open stock pieces also available. White or Brown.
66-2 Baycrest 12" Buffet Frypan. White or Harvest Gold. **27.99**
66-3 Baycrest 2-Slice Pastry Toaster. White or Harvest Gold. **22.97**
66-4 Baycrest Combination Can Opener & Knife Sharpener. White or Harvest Gold. **15.99**
66-5 Baycrest Deluxe Chrome Kettle. Removable cord. White or Harvest Gold. **17.99**
Housewares, Dept. 636

69-1 CANADIAN GENERAL ELECTRIC Drip Filter Coffeemaker. 2-10 Cups. **39.98.** Or with coffee storage bin with automatic dispenser, as shown. **49.98**
69-2 PHILIPS 12-Cup Drip Filter Coffee Maker. **39.98**
69-3 SUNBEAM 4-10 Cup Coffeemaster Drip Filter Coffee Maker. **42.97**

69-4 Philips 4 Qt. Crock Watcher with Auto Cook Feature. **32.99**
69-5 CORNWALL 4 Qt. Slow Cooker. **24.95**
69-6 RIVAL 3½ Qt. Crock Pot with removable liner. **31.99**
69-7 Sunbeam Multi-Cooker Crockery Frypan. Removeable crockery liner goes to the table for serving or into the oven as casserole dish. **54.98**
69-8 MOULINEX Coffee Grinder. **13.98**
69-9 BRAUN Coffee Grinder. **19.95**
Housewares, Dept 636

Although most photographers consider photographing pots and pans to be creatively demeaning, it is actually a marvellous opportunity to develop technique. For through these and similar projects, every technical and lighting problem will arise. These assignments can also be extremely rewarding financially as well. A standard 72-page catalogue with layouts similar to the above spread will usually command in excess of $50,000 for photography, and with the help of an assistant and stylist, could be completed within six weeks based on a spread a day.

When I first began in photography, I shared the common delusion that a great deal of equipment was needed in order to undertake commercial assignments – and camera shops and lighting suppliers did nothing to change this belief.

With lighting equipment, for instance, I was given the impression that studio photography required an enormous amount of strobe power. Yet in my entire career I have never needed to use more than two, 1400 watt-second power packs and three flash heads at any one time.

Following, I have listed all the equipment that I have ever found necessary in shooting either fashion or product photography.

Lights.

1) Two, 1400 watt-second power packs with three strobe heads, including one wide-angle reflector, one narrow reflector, one pair of barn doors, and a snoot.

2) A strobe softlight, such as the Broncolor Hazy. And one large diffusing scrim made from frosted mylar tacked to a lightweight wooden frame.

3) One silver umbrella and one soft white umbrella, largest size available.

4) Six, white foam-core reflector cards, approximately 1 x 2 meters in size. Numerous small reflector cards in white, black and silver.

5) One high-output portable flash unit such as the Braun F900 Professional.

Finally, how much equipment you really need.

6) Six stands with rubber grip clamps. Especially recommended are the quick locking stands from Balcar and the twist grip clamps from Manfrotto.
Light meters:
For flash: Minolta Flash Meter III.
For ambient light: Gossen Lunasix 3.

Cameras.

For small format:
1) 35 mm Nikon F2AS Photomic camera with motor drive.
2) Nikkor lenses: 24 mm lens f/2.8, 55 mm lens f/3.5 with macro extension tube, 80-200 mm zoom lens f/4.5, 105 mm lens f/2.5, 300 mm lens f/4.5.
3) Action sports finder, grid focusing screens type E and type R.
For medium format:
1) 2-1/4 Hasselblad 500C/M with three, 12-frame film magazines and grid focusing screen.
2) Hasselblad Zeiss lenses: 40 mm lens f/4, 100 mm lens f/3.5, 150 mm lens f/4, 350 mm lens f/5.6, 10 mm extension tube, no. 1 and no. 3 close-up filters.
3) Adjustable lens shade with black focusing screen masks.
4) Hasselblad magazine 100 for Polaroid film.
5) Pistol hand grip, adjustable flash-shoe accessory, bubble level.
For large format:
1) Sinar Professional model with interchangeable rear standards to convert from 4x5 to 8x10.
2) Lenses for 4x5: Schneider Super-Angulon 75 mm f/5.6, Schneider

Symmar-S 150 mm f/5.6.
3) Lenses for 8x10: Schneider Super-Angulon 121 mm f/8, Schneider Symmar-S 300 mm f/5.6.
4) Accessories: bag bellows for wide angle lenses, extension rail for the 8x10 standard, grid focusing screen, fresnel viewing lens, filter holder, adjustable lens shade.
5) Polaroid 4x5 Land Film Holder #545.
6) Cambo professional studio stand.

Inside a shooter's bag.
Thirty tools of the trade.

1. Anti-static cloth.
For cleaning mylar, vinyl and other acrylic surfaces. Helps to prevent dust from settling.
2. Artificial snow.
(Heaven forbid!) If you must have it, it is available from any Christmas decoration supplier. Comes in a spray can.
3. Artist's brushes.
For brushing or dabbing on small amounts of glycerine or coloring to food.
4. Artist's putty.
For preventing objects from slipping when placed on glass or acrylic surfaces. For supporting small objects, especially for keeping rings and earrings sitting upright.
5. Artist's white paper tape.
For holding paper, art cards and small reflectors in position. Removes easily

without tearing the paper beneath it. Especially useful when working with delicate foil surfaces.

6. Perfume atomizer.
For spraying a glycerine and water solution onto glasses to give an icy-cold, wet appearance.

7. Bamboo tongs.
For moving food or other objects into position on the set. Especially recommended for handling cold foods, ice-creams and real ice cubes since wood does not transmit heat.

8. Basting syringe.
A jumbo eye-dropper for putting just the right amount of soup into a bowl or coffee into a cup. Eliminates splashing or rim marks caused by pouring.

9. Blower brush.
For removing dust without disturbing objects on the set. Recommend one type with jet nozzle for hard to reach areas, and one with brush tip for delicate work.

10. 'Bovril'.
A natural beef extract colored with caramel. Especially useful for browning freshly cooked meat and poultry. Available at practically any grocery store.

11. 'Bromo Seltzer'.
For restoring the sparkling fizz to champagne and soft drinks. Can be used to make any liquid appear effervescent.

12. Cotton balls.
Particularly valuable in beauty photography for dabbing on make-up, wiping off perspiration or removing the shine from a model's nose.

13. Double-sided 'Scotch' tape.
Transparent and easily concealed. Extremely useful for keeping glassware in position, especially on slippery surfaces such as marble or glass.

14. Duster brush.
For cleaning off table-top surfaces. Especially recommended are any of the large, soft-bristled brushes used by carpenters, painters or artists.

15. Food dyes.
For coloring food and beverages. Standard kit contains red, yellow, green and blue concentrated food dye. May be mixed to form any color or hue.

16. Glycerine.
For creating a wet, moist look whenever needed. Unlike water, glycerine does not evaporate and maintains shape of beaded droplets when sprayed onto glass or bottles.

17. Hypodermic needle.
For adding critical amounts of liquid to a glass. For strategically placing tiny drops of glycerine onto fruit, vegetables or flower petals. Also for squeezing tiny air bubbles into a glass of wine or a cup of coffee to give that fresh poured look.

18. Invisible thread.
For supporting lids and container tops when they must appear partially open.

19. Lens tissue.
For cleaning jewelry, glass, chrome, as well as camera filters and lenses. Unlike facial tissue, does not leave small fibers on surface.

20. 'Letraset' burnisher.
A perfect tool for moving tiny objects into place when they are sitting on a surface, especially when creating compositions with jewelry. Its round tip makes it perfect for smoothing out links in jewelry chains.

21. Linen thread.
Strong, heavy-duty thread for supporting objects that are placed at an extreme angle. Particularly useful when luggage needs to be shown partially open. Easily removed with retouching.

22. Petroleum jelly.
For applying to a lens filter to diffuse an image. When smeared in straight lines across the filter it causes window light to break up into shafts of light.

23. Plastic straws.
For creating the soap bubbles which are often used in photographing toiletries. Bubbles of practically any size, or amount, can be produced by blowing air into a concentrated solution of standard dish washing liquid.

24. Q-Tips.
A hundred-in-one uses. For applying small quantities of rubber cement, food dye or make-up. For cleaning grooves in calculators, watches, and tv's.

25. Rubber cement.
A transparent glue used by assembly artists. For sticking anything together temporarily. Easily removable from any surface including paper.

26. Spot remover.
For removing make-up stains from model garments after photography. Wax stick form recommended.

27. Spray cobwebs.
For creating the dusty, years-in-the-cellar look. Especially effective in still life photographs containing vintage wine bottles, old books, antiques or mementos. Available from a theatrical supply house.

28. Spray dull.
For reducing the glare on chrome. Gives polished surfaces a dull, semi-reflective sheen.

29. Tweezers, large size.
For placing into a food shot small ingredients such as peppercorns, cloves and bits of spice. Perfect for making small adjustments to the composition. Available from any dental supply house.

30. White darkroom gloves.
For handling glassware, bottles and any other object which may show finger marks. A must for handling valuable new product 'dummy' packages supplied by advertising agencies for photography.

A few personal observations.

I have always found it extremely difficult to produce perfectly straight pictures. This is undoubtedly because I wear glasses and cannot bring my eye close enough to the focusing screen. For this reason, I use the focusing screen that is designed primarily for architectural photography. It has a square grid pattern with horizontal and vertical lines etched into the glass. Besides making it easier to keep a hand-held shot level, it helps in composition.

Another problem, experienced by every photographer, has to do with the long, flash sync cord which extends from the camera to the strobe power pack usually several feet away. In the low-level light of a working studio, this black cord disappears into the background and invariably someone steps on it or trips over it. In the back of your mind there is always the fear that this could bring the camera equipment down. I tripped on the sync cord once and pulled a flash head over. The flash tube exploded and cost $240 to replace. The most frequent problem is that the cord is very easily ruptured and the terminal ends become distorted from use. It can be extremely embarrassing and unnerving when you are in the middle of a fashion shoot and your flash only fires one out of three times because of a damaged sync cord.

From these experiences I recommend the Broncolor IRS infrared system which triggers the flash with its invisible signal.

The IRS system consists of a transmitter which is a small cube-shaped device that slides into the accessory shoe on the camera, plus a receiver, which is equally small in size and connects to the strobe power pack. Each component is self-powered by internal batteries. The transmitter operates by sending out an infrared signal to the receiver, which in turn triggers the strobe to fire. The entire process occurs instantaneously.

Another matter of concern is what make of camera equipment to buy. In professional photography, Nikon and Hasselblad have attained the status of being among the most acknowledged names. When an art director asks you what equipment you use, as they will often do, few other names implant the same degree of confidence. When art directors are paying a lot of money for a photograph they seem comforted in knowing that you have 'Rolls-Royce' equipment, as well as a creative eye.

A motor drive for a 35mm camera is undeniably valuable for shooting fashion. Even though you cannot shoot faster than the recycle time of flash, the automatic operation of a motor drive frees you from the mechanical interruption of winding the film and the unavoidable jerking of the camera which accompanies the process. However, with Hasselblad equipment, the motor drive accessory is disturbingly noisy and painfully slow for fashion photography. But in this instance, it is no great loss, for the quick action, short-travel hand

Working from an art director's layout for Sealtest ice cream, the guiding direction was to create a terrestrial landscape of fruit into which the package would later be stripped into position, intentionally out of scale. Fee for photography: $2,250.

crank on the camera body is such a delight to use that one may gladly be spared the expense of a motor drive.

Under heavy use, all camera equipment needs servicing and even Hasselblad is no exception. In particular, with their magazine backs, the advance and film transport mechanism may go out of sync, often causing a slight overlap on the first few frames of the film. A Hasselblad service technician confirmed this problem by advising me that it is common practice amongst most professionals to have their magazine backs readjusted every year.

It is all part of the business.

Note: Nikon's photomic, through-the-lens metering system is remarkably precise. In fact, I have rarely been able to achieve more accurate exposures with a hand-held meter. But you must be aware that Nikon's metering system is center-weighted. Twin light-sensors read the whole viewing screen, but concentrate 60% of their sensitivity in the 12 mm diameter circle in the center. Therefore, the best exposure is obtained by taking a close-up reading of the subject and then composing your photograph. Or, when a close-up reading is not possible, a perfect exposure can be obtained by pointing your meter towards another area in your picture which approximates the mid-tone gray. When a bright sky is in the background, the best exposure for any subject is usually attained by first pointing your camera downwards to obtain the reading and then raising your camera to take the photograph.

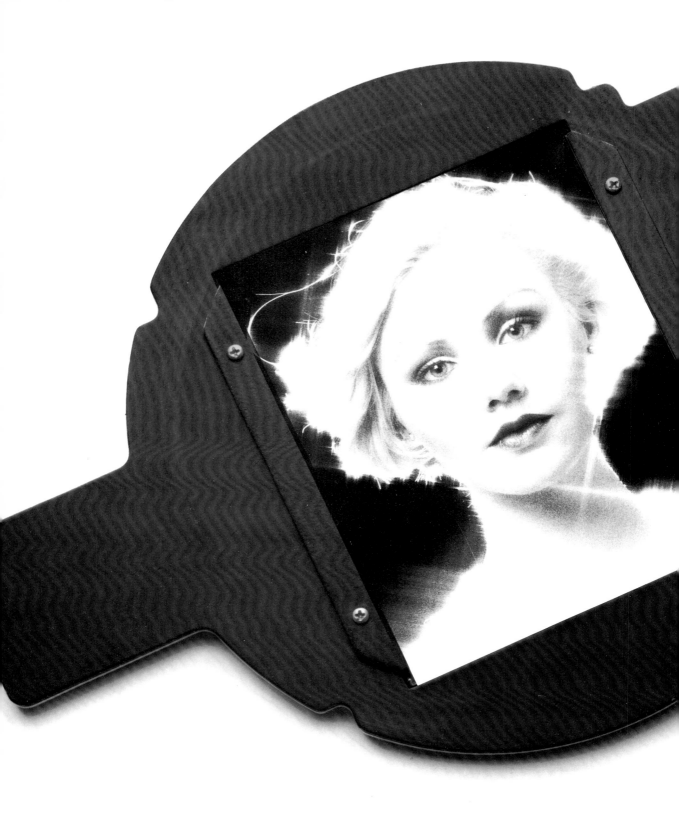

At first, photographing models can be an awesome experience. This is possibly because there are too many preconceived ideas of how the photographer and model should behave with one another.

The stunning appearance of the model as seen on her comp may add to the intimidation. Her photographs may present her as strikingly beautiful, sensuous, and remote. But in real life, these models often arrive at the studios wearing jeans, their hair in ponytails, a satchel full of model junk slung over their shoulder, and an impish curiosity about the whole business; little resemblance to their often voluptuous image.

The visual love affair.

Is it the photographer who makes the picture, or is it the model? What is the magic behind every beautiful shot?

In photography, as in any visual art, the secret likes in the artist's perception of the subject. It is how the photographer perceives the model to be, rather than how she really is. This is the key. The literal duplication of what is there holds little fascination. The excitement lies in making a revelation; in discovering a hidden truth. The great satisfaction comes from his ability to extract what is unknown and to reveal what is unseen. Creating the "visual statement" is the fuel that fires every good photographer.

Judging comps and portfolios. Pitfalls to avoid.

For the car photographer, every snap of the shutter is an expression of his love of machines. The sweep of a spoiler, the flow of a sculptured body, or the glitter of chrome – these are what capture his imagination and feed his inspiration.

For the food photographer, it may be glistening black caviar, sparkling iced champagne, or a plump strawberry dipped in sugar. For him, such images are almost sensuous in appeal.

And so, for the fashion photographer, it is the model, and the pursuit is the same: to perceive a glimpse of what no one else may perceive, and to capture it.

During the shoot, the photographer constantly coaxes different moods and expressions from his model, for every response reveals a little more, and the camera clicks with every insight. An experienced model comes to understand this pursuit. And she strives to remove all inhibition. There must be no barrier between her and the photographer. Even to question the photographer's direction can shatter the mood and illusion of the shoot.

So far, I have only once found a model with whom I am so completely inspired that every shoot becomes an electrifying experience. When she steps in front of my camera, I sense she can see herself through the lens, correcting every movement until it is aesthetically perfect – all without my giving direction, and having to guide her only with encouragement. She knows how to com-municate feelings and emotion and every change in attitude springs life into the fashion; I have only to capture these moments. Such inspired relationships are rare indeed.

The single greatest error aspiring photographers make is when choosing a model for an assignment. They see a great looking portfolio, and attribute to the model a more significant contribution than she may, in fact, have made. It is easy to be deceived by exotic locations, beautiful clothes and clever lighting techniques. Do not be misled by impressive portfolios.

A model's composite may be equally deceptive. Does it contain shots from actual assignments – or mainly from testings? Who are the photographers whose names are credited on the composite? Are they well known?

If most of the photographs on the composite are the result of testing and experimenting, which means that the model and photographer were not limited by time, bear in mind that given these conditions even an inexperienced photographer can raise an aspiring model to visual professional status. Yet these ideal conditions rarely exist in actual commercial photography, and it may prove financially expensive for you if you have to start teaching the model on the set.

Test shooting with models serves the valuable purpose of making you aware of the model's personality and behavior. It also provides the opportunity of experimenting with new visual ideas, enhancing your portfolio with more imaginative fashion ideas than your current clients may let you do. And of course, it gives you an opportunity to test equipment and technique.

But a word of advice. When you do test, test only the best models you can find. If your shots are to look professional, this will only come from photographing models who spent a lot of time in front of a camera. Some photographers pride themselves on having tested virtually every new model who comes into the business. This is rather foolish. Working with the fewest number of good models will allow you to become more familiar with each model's peculiarities: how she moves, the moods she can project and how she takes direction.

Student models are for student photographers. Once you find good models with whom you can produce superlative photography, work with them as often as possible. Make them your 'stars'. This is also good insurance as the outcome of your photographs will be practically guaranteed.

One small point. Remember, that when you undertake a test shooting of a model, the model will expect to receive prints or transparencies from the testing. This is the exchange.

If you are fortunate enough to be entrusted by your client to choose your own models, you will want to bear the following in mind:

1. Establish your client's idea of age appeal. More than once I have had to re-shoot because I had used models who looked too young, even though they were the correct age.

2. Determine the image appeal of the garment: soft and feminine, sophisticated and cool, or tailored and businesslike. Not all models can convey all images. Assess this carefully.

3. Be aware of how the model looks when she is smiling or laughing. This is vitally important. Some of the most beautiful women reveal an inordinate amount of gum when they laugh. It may be very real, and natural, but it simply is not flattering. Determining this before you shoot, you will then be able to direct your model accordingly.

4. Is a fitting necessary? For an official fitting, where garments are tailored and fitted to the model, a fitting fee of one-half the model's hourly rate is standard. Some models, especially beginners, confuse the difference between an 'official fitting' and just trying on a garment. On one occasion, after asking a model to try on a garment to see if it suited her, I received an invoice from her agency for a fitting! Needless to say, to refute such charges can cause one a good deal of time and annoyance.

5. At all costs, avoid booking models who do not work through an agency.

Model testing.
What it's really for.

Agencies set down very disciplined rules for behavior, as well as attending to all the financial and legal matters. Model releases, extra rates for poster exposure and a number of other factors, are the responsibility of the agency. You will also be saved from the distracting presence of boyfriends and husbands, as well as from children for whom the model "simply could not find a babysitter."

A good model release.

In the event that a model may not bring a release form to the shoot, or that you use someone who is not with a model agency, you should always have a number of standby releases in your file. Here is a good model release form which you can have photocopied.

Date _____

Studio _____

Address _____

Client _____

Model _____

Model's agency _____

Hours worked _____

Hourly rate _____

Total fee _____

In consideration of my employment as a model by the above for the terms and fee stated, I hereby sell, assign and grant to the photographer, or those for whom the photographer is acting as indicated above, the right and permission to copyright and/or use and/or publish, and republish, photographic pictures and portraits of me in which I may be included in whole or in part, in color or black and white, made through any media by the photographer at his studio or elsewhere, including the use of any printed matter in conjunction with such photographs.

I hereby waive my right to inspect and/or approve the finished photograph or advertising copy or printed matter that may be used in conjunction with such photographs, or to the eventual use that it might be applied.

I hereby release and discharge the above, its assigns, and all persons acting under its permission or authority or those for whom it is acting, from and against any liability as a result of any distortion, blurring, alteration, or optical illusion that may occur in the taking of the picture, or processing or reproduction of the finished product.

I hereby warrant that I am of full age and competent to contract in my own name in so far as the above is concerned. I have read the foregoing release and warrant that I fully understand the contents thereof.

This release does not apply to the use of the photographs for billboards, posters, packaging or television.

Model's signature

Model rates vary enormously between beginner and established professional and also from one country to the other. Models in the United States charge from $75 to $225 an hour, and from $600 to $1,800 a day. Models in Canada charge from $40 to $70 an hour and from $240 to $420 a day.

Minimum bookings.

In the United States, the minimum booking is two hours, and in Canada the minimum is one hour. Bookings in excess of the minimum time are calculated by the additional half hour or hour. If you book a model for two hours, for example, but the session lasts for two hours and ten minutes, you are expected to pay for two and a half hours.

Day bookings are limited to eight hours. Bookings before 9 am and after 5:30 pm are billed at time-and-a-half.

In major European cities, rules and rates for hiring models tend to be similar to those of the United States with the exception that minimum bookings are usually by the half day.

'Super-star' models charge considerably higher than the rates mentioned here and have their own set of rules concerning minimum bookings and travel time.

Travel time.

In the United States, if the model has to travel to a booking which is outside of the city, the travel charge is for the full hourly rate. In Canada, it is half the hourly rate. For out of country and long-distance traveling, a lower travel fee is usually negotiated. However, all expenses for air fare, hotels and food must be covered by the client.

Cancellations.

The booking must be canceled at least 24 hours prior to the session, otherwise, the full fee will be charged. If the booking is merely postponed, agencies will rarely enforce a cancellation fee. In the United States, it is common practice for model agencies to charge half the fee for any cancellation up to 24 hours prior to the booking.

Weather permit.

In Canada, for outdoor photography, the usual caution is to book the models on a weather permit basis. This way, there is no charge for the first cancellation; however, there is a half fee charge for the second cancellation, and a full fee charge for the third cancellation.

Most agencies in the United States are less lenient than those in Canada, and do not acknowledge a weather permit booking, therefore a cancellation requires payment of the fee in full.

Conflict of interest.

Before booking a model to be used in association with a specific brand name, check with the agency for any possible conflict of interest. Understandably, no manufacturer wants to see his product

Hiring models.
Where you stand with agencies.

advertised by the same model who is associated with his competitor's brand. With cosmetics, this is of special concern, for the image of the model is often the product's most important identification.

A client may want the model to be associated exclusively with his product. Because such product-related photography limits a model from working for competitors for at least one year, an extra fee is charged for this exclusive right. This fee is determined by the model's agency. Depending on the caliber of the model and the intended use of the photograph, this release fee can run from $500 to several thousand dollars. Similar release fees are charged when the model appears on billboards, posters and point-of-purchase displays.

Usually, the signed release for the use of the model's photograph in advertising does not extend beyond twelve months, after which time additional fees may be required.

Service fee.

All model agencies charge a 10% service fee. Be certain to allow for this when discussing model fees with your client. This may affect the budget.

Bras, girdles and panty hose.

In the United States, the standard rate for bras, girdles and panty hose is $250 an hour. In Canada, the fee is double the regular hourly rate unless the garment is a 'see-through', in which case, it is triple the hourly rate.

Slips, nightgowns and panties.

In the United States, the standard rate for slips, nightgowns and panties is $150 an hour. In Canada, the usual fee is the regular hourly rate plus $10 an hour, provided that the model's face does not show. When it is shown, the fee is double the hourly rate.

Swimwear.

Swimwear is billed at the regular hourly rate.

Nude photography.

In the United States, the standard rate paid to models for nude photography is $500 an hour or $2,500 a day. In Canada, it is triple the regular hour rate and often subject to a minimum two hour booking.

Preparation time.

Time for hairstyling and makeup is charged at the full hourly rate in the United States, and at half the hourly rate in Canada.

Fitting fee.

In the United States, the full hourly rate is charged for fittings, although you can book a minimum of half an hour. In Canada, the fitting fee is half the hourly rate and subject to a minimum one hour booking.

VIII
A photographer's credo. Guidelines for creative success, tactics for survival.

Over the years, every professional photographer develops his own working philosophy. Originally, his thoughts on how he approaches a problem, how he runs his studio, and how he handles his clients; these all are shaped by his personal attitudes. But gradually, this philosophy grows and becomes more defined through the hard lessons of experience.

The following is the essence of my philosophy, a formula for success gleaned from years of experience. It has helped me produce better work, win greater respect from clients, and most of all, it has helped me to preserve my sanity.

Part I
On achieving creative excellence.

1. Every photograph should demonstrate visual courage. Don't be timid.

Whenever I begin a shoot, I start with the simplest and safest approach. In this way, I make certain I have good, competent shots. Once this is achieved, I have the courage to become daring. Practically all of my better photographs are spawned from the latter frame of mind. My clients never know this.

Part I.
On achieving creative excellence.

2. Visualize every idea. Only when you can sketch an idea are you ready to shoot it.

When I began my career in photography, I couldn't draw or sketch even the simplest idea. But as I learned to visualize with more clarity, it became easier to draw line, shape and dimension. The more time I spent visualizing the idea with rough sketches, the more effective the photograph became, and the more easily it was executed.

Sketching also impresses clients. It shows you are thinking about solutions to problems, not just taking pictures. Do not underestimate the importance of developing this ability. It is a tool of your profession.

3. Inspiration thrives in silence. Preserve your solitude at all cost.

Creative thought flourishes in solitude. If you are to achieve creative excellence, the one essential ingredient you need is inspiration. But inspiration is elusive and can vanish with interruption. This is one of the reasons that you must work alone as much as possible.

Whenever I am working on the creative problems of a shot, I send my assistant out of the studio. All clients are forbidden in my studio during this process. Protect your inner sanctum.

4. Premature judgment destroys inspiration. Prevent interference.

Conceal ideas when they are in their embryonic stage. Protect yourself from having to explain or to rationalize them.

Such tampering is harmful in bringing ideas to fruition.

5. You cannot please your client if you do not please yourself first. Have the courage of your convictions.

Most clients view photographers as unbridled artists. As a result, they will often issue formidable instructions to prevent you from taking free reign. If you adhere to clients' dictums, you will produce unimaginative photography. Present your client with imaginative solutions to problems, whatever the risk. Be your own master.

6. Compromises destroy creative excellence. Prepare to battle.

Good ideas are preciously rare. When you are fortunate enough to conceive one, defend it to the hilt. Compromises open the flood gates to destruction.

7. Every photograph should be distilled to its simplest form.

Whenever I begin work on a photograph which contains a number of components, such as a food shot, I find it difficult to resist the temptation of putting everything into the picture. However, in between taking Polaroids, I continuously remove items until the photograph is distilled to its simplest form. Most other professionals I know work the same way.

8. Every photograph should be held together by strong lines. The strength of these lines alone often creates a successful photograph.

When people inquire how it is possible for me to shoot so much so quickly I rarely confide in them. The secret, if there is one, lies primarily in being able to visualize graphically. This means you must detach yourself from seeing emotionally and concentrate on seeing objectively.

When you look through the camera, reduce the image to lines. Then organize these lines until they present the strongest picture. With this method, good design comes more easily.

9. Cling to one idea. This is more effective than developing a number of different ideas, none of which are executed well.

Some clients will ask you to shoot an idea a number of different ways. This is either because they don't have the confidence that you can shoot it one way correctly, or they don't really know what they want. Because they are uncertain about the visual approach, they assume you are too.

To overcome this, infuse your clients with your understanding of the particular problem at hand. Advise him that your creative strategy is to execute one idea well. If this doesn't serve to persuade him, offer a guarantee: if he is not pleased with the final shot, you will undertake to re-shoot at your expense.

This will always suffice. Now you can put the full weight of your mind into making one idea work.

10. Pursue a theme in any project which requires a series of photographs. A good theme proliferates ideas. It solves a thousand problems.

Whenever I am asked to shoot work for use in a catalogue or brochure, the most important thing on my mind is to find a theme. A good theme gives common purpose to all photographs.

On one 24-page fashion shoot, I established the theme of an 'English Car Rally', complete with antique cars as a prop. Ideas for individual spreads came easily out of this theme: from models flagging the start of the race on the first page, followed by a stop for a champagne picnic, to models in nightwear being taken away in an antique police paddy wagon. A good theme allows for visual entertainment.

11. In a series of photographs, maintain the same form of lighting and perspective. A change in direction breeds visual confusion.

On my first catalogue assignment, I decided that in order to demonstrate my creative ability, I would use a different technique in each photograph. I was anxious to impress my client with my imagination.

Individually, every picture was acceptable, but when they were all assembled together on the paste-up board, the presentation appeared con-

fused and amateurish. I knew it and my client knew it, and the only solution was to re-shoot; every photograph had to be re-taken, applying the same lighting, perspective and background. An expensive lesson, indeed.

12. Plan fashion shots carefully. Good photographs rarely 'just happen'.

One fashion photographer I know actually does succeed on the hit or miss method. Very little planning goes into his shots. The models rule the shoot and clients who observe this procedure are filled with apprehension. This method does not inspire confidence. For such photographers, repeat business is a long time coming.

13. Avoid gimmicky backgrounds. They are the trademark of the amateur.

Gimmicky ripples, crumpled foils and busy patterns do not contribute to good product photography. They are distracting and visually jarring and they change the visual emphasis from the product to the background. They rarely, if ever work. Choose surfaces which are harmonious, or which contribute to the story.

14. In color photography, choose backgrounds with an absence of color.

To provide contrast when photographing products, few backgrounds are more powerful than black. It lets colors speak loudly. Gray is the most versatile color for backgrounds as it is always harmonious.

White is the purest, but has one difficulty that must be overcome. It reproduces bluish-gray during printing unless the 'dot' or screen is cut back during the making of color separation.

15. With outdoor lighting, avoid harsh shadows. They are mercilessly destructive.

Never shoot in direct sunlight without relieving the shadows. This is especially important for fashion photography. Harsh shadows destroy detail. Tolerate the inconvenience of carrying large white reflector cards, but refrain from using fill-in flash for it never looks natural.

With color film, pursue low contrast lighting. This ensures color saturation. Favor hazy, overcast days and late afternoon light. When circumstances force you to shoot on a bright day, select locations which are in the shade.

16. Test everything. Leave nothing to chance.

Test the lighting. Test the film. Test the equipment. Test the model. Do not proceed to final photography without a count-down. Photography is a risky business. If anything can go wrong, it will.

17. If your client is a good art director, listen to him carefully. If he is a poor art director, turn a deaf ear.

I have worked with good art directors and have won numerous awards. I've worked with poor art directors, and have never wanted to see the finished material. Good art directors are found mostly in advertising agencies. Seldom are they found in retail department stores. They sometimes pop up in the editorial department of magazines.

Good art directors are easy to recognize: they know how to crop photographs, how to create visual impact, and are prepared to change layouts if a better idea presents itself. They are an inspiration to work with. Poor art directors do not know how to crop photographs, they lack visual courage, and they are afraid to change their original layout. They are a frustration to work with.

In poor hands, even good work can appear second rate. But in good hands, your work will always have a first class ticket.

18. If your client is not an art director, the burden for the shot remains entirely with you. Allow your conscience to rule.

Whenever I have taken a picture exactly the way a client wanted it done, or exactly the way it was laid out, I have always ended up with an uninspired photograph.

Most layouts are frightfully inaccurate. The drawing of the subject is usually

Part II.
On dealing with clients.

compressed or extended to fit the space. It often bares no resemblance to reality. And it defies photography. What works in a drawing hardly ever works in a photograph. Therefore, when you foresee difficulty in duplicating the illustration, equip yourself with creative alternatives, and present them to your client. (Do not tamper with layouts; this is treacherous ground.)

19. If your client suggests ideas which you think are ludicrous, don't tell him what you think. Rather, inform him you don't feel you can execute his suggestion satisfactorily. Success is based on diplomacy.

One of my clients had devised an idea for a fashion advertisement which centered around a riding stable. In the distance and behind the models, my client wanted a horse and rider to execute an 'equestrian' leap over the bushes – at the exact moment when the models were to be photographed running face-on towards the camera. I actually told the client he was crazy. Understandably, I lost the assignment, and he has never hired me since. The above rule saves me from losing clients when diplomacy can save the day.

20. When a client suggests a number of ideas, none of which captures your imagination, remain silent. To attack a client's ideas is folly.

When dealing with clients in large companies, prepare to endure their passion for meetings. Here, staff opinion is elicited and ideas run rampant. Beware. These are dangerous waters. If you agree with one person, you'll certainly be disagreeing with someone else. And inevitably, it is that person who will vote against your work when the time comes. Photographers come and go on such whims. That's politics. Therefore, whenever you are in a meeting, do everything possible to say nothing. To remain silent and deep in thought conveys understanding.

21. Never let a client look through your camera. It solicits premature judgment.

It appears to be human nature that when someone is permitted to look through your camera when you are working on an idea they feel compelled to pass judgment. This can be unintentionally destructive. For when a creative person is subjected to criticism while an idea is still in its formative stage, this can only serve to destroy the delicate process of inspiration.

When I am working on a shot, my policy is to have the client wait in another room. I provide him with a pot of coffee, and I bring him Polaroids as the shoot progresses. If there is a problem, I immediately stop the shoot and resolve it. Then I go back into the studio, make the corrections, and return

with another Polaroid. I get what I want, the client gets what he wants.

Art directors are impressed with this orderly and painless process. It never fails to make up for their annoyance at not being on the set and looking through the camera.

22. Never discuss the execution of a photograph, only the general concept. Give yourself room, and give yourself time.

When a client wants to know exactly what I am going to do, I pacify his request by discussing the 'general idea' and the objectives of the advertisement. I detour demands to be specific. The more questions a client asks me, the more I ask him.

Once, a client managed to extract from me every single detail on how I would take the photograph: lighting, background, composition and props. After I had begun work on the shot, a number of improvements occurred to me. But how could I change the idea in any way without having to go into lengthy explanations – and approvals. Frustration set in, and any possibility of inspiration had been extinguished. Unknowingly, I had sentenced myself to a mediocre shot.

23. Never show a client your rejects, only your final choices.

This is one of the hardest principles to maintain in photography. When a client sees your rejects, he sees your struggle, he sees the imperfections and he sees

your mistakes. He may not take into account that they were instrumental in arriving at the final creative solution. Seeing these rejects has given the client ammunition to criticize your final choices. Almost always, this deteriorates professional respect.

Many fashion magazines stipulate that they are to be provided with all the film at the end of a shoot. And then invariably, they'll choose the final from among the rejects, ignoring the photographer's recommended choices. I do not know of one photographer who is not humiliated by this approach.

Rejects are any photographs that you would not want to see published, for whatever reason. If, at the end of a shoot, you have twenty final choices, any one of which would be acceptable to you for publication, then by all means give them all to your client. But if you have only one shot you are satisfied with, present only one, and stick by your guns. Remember: once rejects are revealed, respect is removed.

24. If you encounter difficulty in pursuing new clients, raise your sights. Talk to the top.

Bypass juniors who have no power. When someone needs to show your work to someone higher up, you have approached the wrong person. It is more effective to win approval of your work at the top, and then descend to the lower ranks. The blessing from above will open doors and guarantee you votes. Working your way down is always more effective than working your way up.

25. Pursue art directors, designers and creative directors who have established a reputation.

With creative departments, search out the 'stars'. Locate the creative 'brains'. If your work shows talent, these are the people who will recognize it.

Be wary of untalented people who hold high positions in these departments. They are generally insecure, and gravitate toward mediocrity; thus they tend to shun new talent. Their creative counterparts by nature are more courageous and in constant pursuit of excellence. Hence they embrace new talent. Learn to judge people by what they can produce, not by what they are promoted to be.

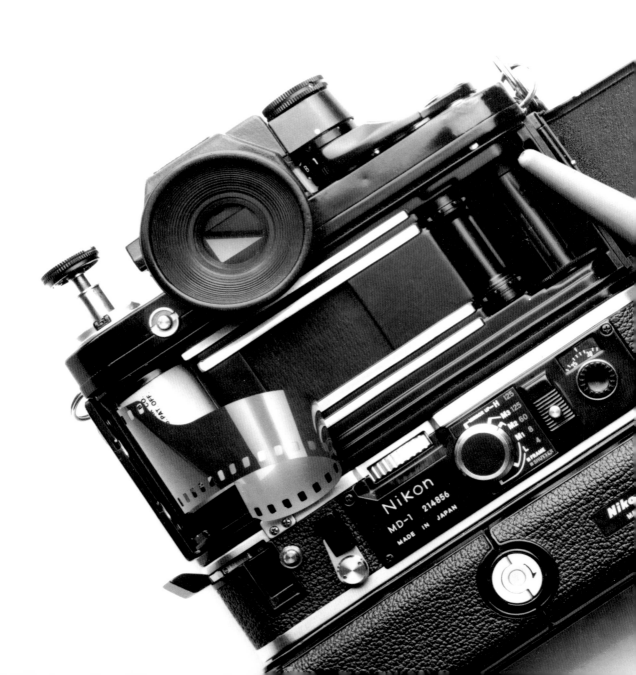

IX
Conclusion.

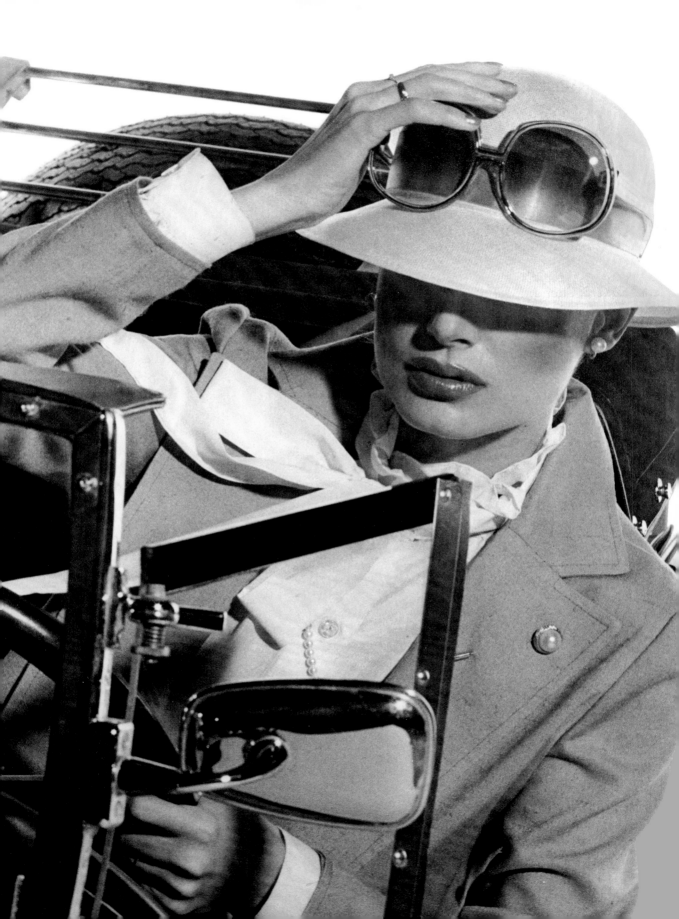

A question of passion.

Many students of photography pride themselves on their technical knowledge. They immerse themselves in studying the specifications of every new lens, camera, filter and gadget that comes onto the market.

There seems to be great comfort and security in attaining such technical knowledge. But all too often, this is used as a blanket to conceal a lack of creative ability. Great art grows from the mind. The camera is only the tool, as are the painter's brushes and the sculptor's chisels. They are the partial means, but not the way.

For creative ability to flourish, time must be spent in the art of creation. To become prolific in your work you must exercise your imagination. Thus, the axiom: great pictures are not taken, they are made.

If you secure a position with a large studio, and you have high ambition for yourself, keep your tenure brief. Too many years in a photographic 'factory' will dampen the formation of your style. Three years should be considered sufficient apprenticeship; after this, the repetitive methods begin to take their toll, until eventually all imagination is vanquished. If you are to develop yourself creatively, you must become your own master.

Those who succeed in any endeavor, realize that it is not luck but the total mental commitment to succeed that governs their outcome. When a person is seized with such a passion, it cannot be hidden. You can see it in his eyes, you can hear it in his voice, and you can feel it in his manner. There is an enthusiasm which surpasses the most carefully rehearsed state of optimism. When such a passion is set in motion, all difficulties can be overcome. For the photographer who is passionately committed to his art, nothing will stand in his way of achieving creative and technical excellence.

Strive to create visual triumphs, avoid the safe approach, and attack competition with courage. In all things, fortune favors the brave.

Photographed in a studio with light bouncing into a white wall background and direct flash in front to cast the appearance of a strong sunlight shadow beneath the brim of the model's hat. To capture the sense of motion, a fan was set up to flutter the ribbon on the model's blouse and the camera was angled at a 45-degree angle to help in composition.

As a photographer, you will need to pursue the same two paths every artist must follow. One path will be the development of your artistic perception. The other will be the control of your tools. To learn technique in any artistic field, the natural way to begin is to study the work of its masters. By striving to create the same work, you gradually gain control of the mechanical processes. And, at the same time, you gain an increased insight into the elements of visual communication. In selecting the right books, you select the right teachers.

Invest in the photographic annuals. Immerse yourself in the business of commercial photography. Be aware of those who achieve creative recognition, and study their work critically. From their ideas, let your imagination develop other ideas. In the process of emulating the work of those whom you admire, you will find a direction for youself, and out of this practice, a style of your own will grow.

To create beautiful photographs with the ease of an artist is a lifelong endeavor. In this pursuit, you will find the following publications invaluable.

Annuals.

The Annual of Advertising, Editorial, Art & Design.

This book is an awards annual of the most oustanding creative work in the USA. It is organized by The Art Directors Club and The Copy Club of New York. The emphasis is on advertising with award categories in graphic design, art and photography.

Appears in bookstores in November. Published by Watson-Guptill Publications, One Astor Plaza, New York, N.Y. 10036.

Art Director's Index to Photographers.

This is one of the most superlatively printed and produced photographic annuals of its kind, on a par with PhotoGraphis. It contains the work of up to 500 professional photographers from over 20 different countries.

This is not an awards annual and the space may be purchased by any professional photographer. As each photographer chooses his own material, it gives you a glimpse of the best work from his portfolio.

Appears in bookstores towards the end of the year. Published by RotoVision S.A., Case postale, 10, rue de l'Arquebuse, 1211 Geneve 11, Switzerland.

The Creative Black Book.

This valuable little book is coveted by every art director in the business. It lists practically every major photographer, illustrator and designer in North America, as well as hundreds of speciality suppliers from retouchers to jumbo print makers, together with unlimited sources for stylists, props, sets and locations.

In promoting themselves, many top

Your own library.
A source of inspiration.

commercial photographers buy ad space in it to show their most outstanding work.

Available directly from the publishers: Friendly Publications, Inc. 80 Irving Place, New York, N.Y. 10003.

PhotoGraphis.

If you can invest in only one big book a year, this is the one. PhotoGraphis is the international annual of advertising, editorial and television photography. It represents the standard of excellence in commercial photography.

PhotoGraphis contains the most outstanding examples of photography in the following 12 categories: (1) advertisements, (2) annual reports, (3) book jackets, (4) booklets, (5) calendars, (6) editorial photography, (7) film advertising, (8) in-house publications, (9) magazine covers, (10) packaging, (11) record covers, (12) television.

PhotoGraphis is available in the bookstores in the Fall and is published by Walter Herdeg, the Graphis Press, 45 Nuschelerstrasse, CH-8001 Zurich, Switzerland.

Creative reference.

A Source Book for Creative Thinking edited by Sidney J. Parnes and Harold F. Harding.

A compilation of fascinating studies on creativity including how the brain creates ideas, measurement and development of creativity and the psychology of

imagination. Published by Charles Scribner's Sons, 597 5th Avenue, New York, N.Y. 10017.

Seeing With The Mind's Eye by Mike Samuels, M.D. and Nancy Samuels.

The history, techniques and uses of visualization. A richly illustrated book on how memories, fantasies, dreams and visions supply the creative force in art, psychology and daily life. Presents a wide range of exercises for visualizing.

Distributed by Random House, 201 East 50th Street, New York, N.Y. 10022.

Technical reference.

Advanced Photography by M.J. Langford.

This textbook is for students of photography attending second and third year college courses, and for graphic designers. Presents sophisticated technical knowledge illustrated with original diagrams and photographs.

Published by Focal Press Limited. Distributed by Hastings House Publishers, Inc., 10 E. 40th Street, New York, N.Y. 10016.

Photo Know-How by Carl Koch.

An extraordinary self-study course of sophisticated view camera technique. Includes self-teaching aids and lessons on perspective, lens control, camera

movements and exposure. Teaches all the fundamental principles involved in large format photography.

Available through camera shops carrying the Sinar view camera system. Published by Photo-Know-How Publishing Company, CH-8200 Schaffhausen, Albulastrasse 10, Switzerland.

The Color Photo Book
by Andreas Feininger.

A thorough coverage of every technical aspect of photography in easy-to-understand language. Particularly valuable advice on how to use an exposure meter correctly and how to see reality in photographic terms. Provides an intensive study in lighting.

Published by Prentice-Hall Inc., 301 Sylvan Avenue, Englewood Cliffs, N.J. 07632, USA.

The Gum Bichromate Book
by David Scopick.

Describes the entire process of making gum bichromate prints as researched by the author. A step-by-step procedure allows you to duplicate this beautifully subtle form of image making.

Published by Light Impressions Corp, Box 3012, Rochester, N.Y. 14614.

Basic Photography
by M.J. Langford.

An outstanding textbook adopted by most schools of photography and used by universities and colleges throughout the world. The book constitutes a theory course for the first year students of photography. Do not be misled by the title 'basic'. This book is highly technical and informative.

Published by Focal Press Limited. Distributed by Hastings House Publishers, Inc., 10 E. 40th Street, New York, N.Y. 10016.

Handbook for Contemporary Photography
by Arnold Gassan.

An extremely informative book on methods of darkroom printing. A complex subject presented in a clear, easy to understand manner. Explains how to use developer-density curves and has an excellent section on non-silver printing processes. Spiral bound for easy use in the darkroom.

Published by Handbook Company. Distributed by Light Impressions, P.O. Box 3012, Rochester, N.Y. 14614.

Kodak Black-and-White Darkroom Dataguide, Publication No. R-20.

Contains examples of grain structure in different films plus data on push-processing. Includes a developing dial, enlarging dial, and numerous visual comparisons of prints made on selective contrast papers and graded contrast papers. An invaluable visual reference for darkroom work.

Published by Eastman Kodak Company, Rochester, N.Y.

Recommended reading.

Confessions of an Advertising Man
by David Ogilvy.

A remarkable insight into the advertising business by the creator of one of the most successful advertising agencies on Madison Avenue.

Published by Dell Publishing Co. Inc., 245 E. 47th Street, New York, N.Y. 10017.

The Science of Photography
by H. Baines.

For the technical buff, this book is a masterpiece of scientific knowledge. Includes the behavior of light, the chemistry of photography, sensitometry, color sensitivity and filters, the granular structure and the image.

Published by Fountain Press Limited, 46-47 Chancery Lane, London, England. WC2A 1JU.

Zone System Manual
by Minor White.

Presents the famous Ansel Adams Zone System as a technique for allowing the ultimate quality in printing to be achieved. Describes how the Zone System affects exposure and development and gives instruction on how to manipulate a meter dial to control the tonal quality of your image. Includes fascinating techniques for previsualizing.

Published by Morgan & Morgan, Inc., 145 Palisades Street, Dobbs Ferry, N.Y. 10522, USA.

Kodak Professional Black-and-White Films, Publication No. F-5.

Includes all the film data sheets for black-and-white film processing along with superb articles on judging negative quality, controlling contrast, and assessing emulsion characteristics.

Published by Eastman Kodak Company, Rochester, New York.

Kodak Professional Photoguide, Publication No. R-28.

A summary of all the information a professional photographer needs to have about films, exposure, flash, filters, depth-of-field, close-up exposure corrections, and perspective control. An instant reference book which can be tucked into the camera case. Contains the gray scale, color patches and eight valuable reference dials.

Published by Eastman Kodak Company, Rochester, N. Y.

Lootens on Photographic Enlarging and Print Quality
by J. Ghislain Lootens.

A classic in darkroom printing. Includes information on the test strip and how to use it, how to determine the paper contrast grade, dodging and printing-in, flashing for tone control, chemical reduction, print intensification, retouching, toning, and mounting. Complete with chemical formulas.

Published by Amphoto, 750 Zeckendorf Blvd., Garden City, N.Y. 11530.

Air-brushing

A technique for retouching photographs or artwork using a fine high-pressure spray instead of a brush. Used to emphasize detail or to create tones and highlights.

Art director

The designer responsible for layouts and graphic presentation of visual material. The person also responsible for hiring photographers and illustrators.

Artwork

The assembled components of a layout including type, stats and prints, mounted on an art board and ready for photomechanical reproduction.

Assembly artist

The artist responsible for preparing the art boards. This includes pasting-up type, drawing-in key lines, positioning stats and cutting masks for artwork.

Barn doors

Folding panels which clip onto the front of a light head. Designed to prevent light spill by controlling the direction and width of the light beam.

Bellows

Found on any large-format camera. This is the lightproof, folding sleeve positioned between the lens and the image plane. The accordian-type bellows produces a wide range of lens-to-image distances. The bag-type bellows is used with wide-angle lenses when the accordian-type bellows will not compress sufficiently for the very short lens-to-image distances. Bellows are also available for most 35mm and 2-1/4 cameras for extreme close-up photography.

Bleaching

A process which chemically converts black, exposed silver halide crystals into a colorless form. Used to reduce the tone or density in a black-and-white print or negative. See 'Farmer's Reducer'.

Bleed

Term used when one or more sides of a photograph are printed off the very edge of the page for graphic effect. To achieve a bleed, an excess of 3 to 6mm of the image must be left to extend past the trim marks indicated on the art board.

Bounced light

Term used to describe the softening of light by reflecting it off a surface. The degree of softness depends on the reflectance of the material.

Box light

An enclosed device containing one or more flash heads and with a diffusion screen to soften the light. Ranges in shape from a simple box to a parabolic; the latter bounces light within the interior of the shell in the most efficient manner. The box light provides the ultimate in soft lighting for commercial product photography. Also known as a 'softlight'.

Bracketing

The practice of overexposing and underexposing. Standard bracketing is in three's: one exposure at the estimated correct reading, one exposure at a half-stop over, and one exposure at a half-stop under. A common safety procedure for assuring accurate exposure and maximum color saturation.

Brightness range

The range of tones detected by the human eye. This far exceeds the sensitivity of photographic emulsions. It is important to know that this range of tones is compressed on photographic emulsions and further compressed during various stages of photomechanical reproduction.

Burning-in

A procedure for adding more exposure time to selected areas of a print. Control is achieved by interrupting the light beam with a large card having a small hole cut in the center. This allows extra exposure to be directed where needed.

Characteristic curve

A line on a graph that shows how an emulsion responds to exposure and development. The 'toe' or base of the curve represents the region of exposure in which the film gives no response, the straight line represents the portion in which the tonal scale is compressed evenly, and the 'shoulder' represents the limit of the film, where tone separation is lost and highlights are 'blocked'.

Cibachrome

A process for producing color prints directly from a transparency without an internegative. Based on the dye-destruction process. Cibachrome is noted for achieving exceptional sharpness with high brilliance and color saturation.

Clip test

A term used when processing only a few inches of film clipped from the end of a roll. This precaution is usually taken when the exposure is suspected to be incorrect, such as from accidentally setting the wrong ASA on the meter. This allows an opportunity to correct the error by adjusting the processing time.

Close-cut
Refers to a photograph in which part or all of the background has been removed. With color transparencies this is achieved by masking out the background. With black-and-white prints the background is blocked out with artist's white opaque, or screened out with a rubylith.

Color balance
When all colors are in correct visual harmony – a subjective interpretation. To a color technician, color balance is achieved when the color emulsion can accurately record a neutral gray. If the color balance is 'off', a color cast will be recorded on the neutral gray.

Color cast
The overall distortion of colors in a transparency or print. A bias or shift towards one particular color.

Color-compensation filters
Commonly known as Kodak CC filters, these are clear plastic filters, gelatin-dyed, in six primary colors: red, green, blue, yellow, cyan and magenta. They range in density from 025 to 50. CC filter correction is specified in the film data supplied with professional color film. Correction is given to compensate for any batch-to-batch emulsion variation or to adjust for any shift in color balance which may arise from reciprocity due to time exposures. CC filters allow the highest critical standard of color balance to be achieved.

Color control patches
A card showing a range of color swatches which have been selected as being representative of those inks commonly used in printing.

When incorporated into a set of color separations, they serve as a convenient check on color balance. Also used for comparing color values between the original and the reproduction.

Color matt
A facsimile of the final image produced from a set of color separations. Consists of four separate acetate layers of the image: cyan, magenta, yellow and black. These are sandwiched together and viewed by placing on a white card. The density of the acetate material must be visually subtracted when judging color quality. Considered as only a preliminary stage in proofing but often used as a substitute for the expense of final press proofing.

Color separations
The set of film which combines to produce a full-color image for photomechanical reproduction. Consists of cyan, magenta, yellow and black. Produced by placing a transparency of the image in a scanner and then screening out each color onto a separate sheet of film. The scanner operates on either a darkroom-type process or by laser light. Basic adjustments to color density may be dialed in. Additional color correcitons must be done afterwards by hand.

Color temperature
The color of light as measured in Kelvin degrees and on a temperature scale from warm to cool. It governs the choice of film and any necessary filtering. Daylight film is rated at 5500°K, the color temperature of mean noon sunlight. Filter corrections must therefore be made

for an overcast sky, or other times of the day if color accuracy is required. Tungsten type film is rated at 3200°K, a temperature balanced for quartz halogen lighting. A color temperature balance dial may be found in the Kodak Professional Photoguide manual No. R. 28.

Common focus
This refers to the grouping together of a number of transparencies which are in proportion to each other. In this way, all the transparencies may be scanned at the same time during the process of making color separations. This procedure allows the maximum amount of color transparency film to be placed on the scanning drum, which is more economical than if each transparency were scanned singly. In catalogue production, where a large number of transparencies are involved, this results in substantial savings. Common focus may be achieved during photography by shooting every image to fit the exact size indicated in the layout, a procedure which often requires the layout to be scaled down.

Complementary colors
The perfect opposite of a color. Used to provide maximum color contrast. Examples: red/green, orange/blue, yellow/violet. Complementary colors may be determined by referring to an artist's color harmony wheel.

Composite
A selection of photographs of a model printed on a single sheet or folder and sent out to studios by the model or agency for reference

purposes. Known in the business as a 'comp'.

Compression
The visual flattening of an image due to distance. The effect of a telephoto lens.

Condenser
A simple lens system for concentrating the light rays from an enlarger bulb into a beam. Compared to a diffusion enlarger, a condenser head provides higher contrast and greater potential sharpness.

Cone
For creating full, round folds at the corner of a bedspread or a tablecloth. Achieved by twisting a card to a point at one end in the shape of a cone, and placing it beneath the fabric.

Continuous tone
A term used to describe black-and-white photographs which contain a range of tones and therefore must be mechanically screened for reproduction.

Contrast index
The slope of a straight line drawn between two points on the characteristic curve of a film graph. These points represent the highest and lowest usable densitites in a normal negative. Use of a contrast index graph permits the changing of development contrast in a controlled manner.

Contrast ratio
The degree of contrast in an image as measured from the lightest to the darkest areas, and expressed either as density difference or f-stop difference. The contrast ratio determines the limits of reproduction; for example, color transparencies should be within a contrast ratio of

1:4 which is a difference of two f-stops.

Copyright
Establishes ownership of a photograph or piece of work. Generally, the photographer retains copyright over the negative or transparency after the sale of the photograph, and this copyright does not pass on to the person who purchases the print or who commissions the work unless it is so specified.

Crop
The actual area of the photograph to be used. To determine the final crop, photographers often use a pair of crop arms, which are two L-shaped pieces of black card. By placing the crop arms over the print or transparency, different crops can be easily visualized.

Cut-and-butt
A method of stripping one transparency into another. Mechanically achieved by cutting into one piece of film and fitting the other transparency into its space. Results in a hard-edged line around the inset transparency and therefore is second in preference to emulsion-stripping.

Dark slide
The removable metal or plastic slide which makes magazine backs and film holders light-tight. Permits film backs to be interchanged. With sheet film holders, the plastic dark slide is coded silver on one side, and black on the other to remind the photographer if the film has been exposed.

Densitometer
An instrument for measuring the density of the film emulsion. Used by lab technicians and color

separators to maintain the critical standards involved in photo-mechanical reproduction.

Density
This refers to the amount of silver deposit produced in the emulsion after exposure and development have taken place. When measuring from the lightest to darkest areas of an image, every 0.10 units of density are equal to 1/3 of an f-stop, or 0.30 units for every whole f-stop. The higher the density in an image, the higher the potential contrast. The technique of pushing film increases density and therefore increases contrast.

Diffusing
The softening of light by scattering light rays through any translucent material such as tracing paper or frosted acetate. Diffusing light is an extremely important practice in color photography in order to lower lighting contrast and therefore increase color saturation.

Diffusion enlarger
An enlarger which transmits light through flashed or opal glass in order to soften the light and reduce sharpness and contrast. Primarily used in portraiture printing.

Dry mount
A method for mounting prints using a wax sheet as a sealant instead of artist's rubber cement. Requires the heat and pressure from a hand mounting press to seal the print to the board.

Dupe
A duplicate copy of a transparency. The process of duplicating is accompanied by a natural increase in contrast which may be compensated for by using a contrast

reducing mask. Small transparencies are often duped-up in size for retouching or to be in common focus with a number of other transparencies.

Dye transfer
A method for making exceptional color prints from color transparencies or color negative film. Involves the use of separation negatives and print from color dye matrixes. Requires a considerable amount of hand work and is therefore considered an expensive process.

Emulsion stripping
A technique for stripping color transparencies together during photomechanical production. Actually involves the removal of the emulsion from the backing so that images can be stripped together without having to cut into the film. A superior stripping method to cutt-and-butt, although more expensive.

Exposure latitude
The degree to which film can be over or underexposed and still produce an acceptable result. Normally, the higher the speed of the film, the greater their latitude, but the lower the tonal quality.

Exposure range
The difference in brightness from the lightest to the darkest part of the subject, measured in terms of f-stops. Essential for determining the contrast ratio of the image and therefore controlling tonal quality.

Extension tube
An accessory for close-up photography which fits between the lens and camera body. Extends the film-to-lens distance and thereby provides greater magnification.

Farmer's reducer
A bleaching chemical for reducing density in either black-and-white prints or negatives. Not suitable for color work. Available from Kodak.

Final film
The black-and-white negative film which contains the image of the final artwork and color separations. Used in the photomechanical production of positive printing plates.

Flare
The dispersion of non-image forming light through the lens. This reduces contrast and softens the image. In color photography, flare reduces color saturation.

Focal length
The distance between the lens and the image plane when the camera is focused on a subject at infinity.

Fogging
The overall gray or washed out appearance of film or prints due to accidental exposure to light. Usually caused during loading or unloading film.

Generation
Every time a transparency is duplicated during photomechanical reproduction, the image is one step or generation further from the original. Each step results in a small loss in quality, known as a generation loss. In achieving the ultimate quality when working with film material, the sequence which involves the fewest generations should always be chosen.

Gobo
A reflector card set up to prevent light spill. Also used to shield camera and photographer from lights on the set.

Grain
The clustering together of the silver grains of the emulsion during development. Grain is most apparent in gray tone areas, and increases with both overexposing and over-processing. The slower the speed of the film, the finer the granularity of the light sensitive crystals; the higher the speed of the film, the coarser the granularity.

Gray card
For use in determining the correct exposure. Provides a reflectance of 18% which is equivalent to the mid-tone gray in the scale. An extremely valuable aid for taking spot readings when a range of lighting affects the picture.

Gray scale
A card with different densities of gray in the form of a scale or step wedge. When incorporated into the image, allows tone values or densities to be compared between the original and the reproduction.

Gum bichromate
An early method of darkroom printing involving the making of your own photographic paper. The paper is coated with a light sensitive emulsion of gum bichromate, then exposed by ultraviolet light and developed in water.

Gutter
The fold of any printed material. When designing layouts or photographs, faces or critical detail should be kept free of this area.

Half-tone
The small dot pattern which all continuous tone images must be converted to in order to permit tonal reproduction in the printing process.

Half-tone screen
The actual size of the dot pattern or screen used in making half-tones. Choice of screen depends on the method of printing, speed of press and quality of paper. The higher the quality of printing, the finer the screen which may be used, with a result that a greater range of tones and details may be reproduced. Screens are measured by the number of lines to the inch in order to determine fineness. Average line screen for newspaper, for example, is 85; for magazines printed by high-speed web offset, 133-150; for general books, 150-200; for high quality art book reproduction, 250-300.

Headsheet
A model agency's current listing of models, complete with photographs and information on each model.

High key
A photograph consisting of light tones with very few mid-tones or shadows. This is achieved with shadowless lighting and a subject which is low in contrast. In color photography, high key refers to an image which is light and delicate in color. Exposure is usually increased by one or two full stops to reduce color saturation.

Highlight
The overexposed area of a print or transparency which contains little or no detail. Highlights such as the reflection of light in the eye, the glint on chrome, or the sparkle on the rim of a glass, all add a three dimensional quality to the final photograph.

Hypo
A common term used for a fixing solution. Even though this is a chemically incorrect abbreviation, it refers to sodium thiosulfate.

Image plane
This is the visual plane where the image of the subject is formed. When focusing, the closer the subject is to the camera, the greater the distance from the lens to the image plane.

Incident light
The light falling onto a subject. Measurement of this light does not take into account the brightness range of the subject or its reflectance.

Incident light reading
To measure incident light, the meter is placed directly next to the subject with the meter aimed towards the camera so that it receives the same amount of light falling onto it as does the subject. When the same amount of light is falling onto the area occupied by the photographer, the meter reading can be taken at the camera position.With outdoor photography, this method saves a great deal of time and allows the photographer to make more frequent exposure checks, especially when the lens-to-subject distance is considerable.

Intensifying
A chemical treatment process for strengthening the density and contrast of thin, underdeveloped or underexposed black-and-white negatives. Intensifying can be done in room light using Kodak Chromium Intensifier.

Internegative
An intermediate stage necessary when converting film from either positive to negative or negative to positive. To make a color or black-and-white print from a transparency, an interneg is required as the transparency is in positive form. The exception to this is a color print made from Cibachrome.

Kelvin scale
The color temperature of light measured in degrees. The Kelvin scale provides a basis for determining color correction with filters when the temperature of light is out of balance with the color temperature of film.

Light box
For viewing transparencies. When transparencies are being judged for photomechanical reproduction, the color temperature of the light must be 5500°K.

Lighting contrast ratio
The difference in brightness measured between the lightest and darkest parts of the subject. Determined by taking a meter reading of the lightest area (not white) which records detail, and of the shadow area. The difference should not exceed two f-stops if the color transparency is to be used for reproduction.

Light table
An acrylic table top with a slope rise at one end to create a gradual fall off of light. Used for photographing products when bottom light is required.

Light tent
Constructed by totally enclosing the set with a translucent material such as frosted acetate or mylar,

and then directing light through the material from behind and above. This produces soft, shadowless illumination and eliminates unwanted reflections. Especially recommended for photographing silverware, chrome and jewelry.

Low key
A photograph consisting mainly of dark tones and deep, rich shadows. An image which is intentionally underexposed or devoid of fill lighting.

Macrophotography
Extreme close-up photography using bellows extensions, close-up filters, or large extension tubes. Commonly refers to taking photographs in which the image is magnified one to 10x larger than life size.

Mask
Primarily used to control the exposure in the shadow and highlight areas of a photograph. This type of mask consists of a sheet of film which has a softened image of the actual photograph. Sandwiched with the negative, this allows the highlights and shadows to fall into the same printing range, so that the entire image prints correctly without the necessity of dodging or printing-in.

A contrast reduction mask can be used to reduce density in shadow areas to allow detail to show through. This mask is a thin positive of the image, made from the negative through contact printing.

Mass
The term to describe the amount of image concentrated into the layout space. Art directors will

often require you to "increase the mass". This may be achieved not only by designing the shot so that the subject fills the given area, but by making maximum use of lens compression.

Mechanical
All the artwork, overlays, masks and screens used in preparing the photograph or other visual material ready for reproduction.

Mezzotint
A 75-line mechanical screen for converting photographs into a random dot pattern which creates the appearance of a grainy image. The best effect is produced from photographs which are flat in tone and predominantly gray.

Microphotography
Photography with the use of a microscopic attachment to achieve magnification greater than 10x.

Moiré
The confusing pattern created through double mechanical screening. This effect prevents quality reproduction from material that has already been printed.

Montage
A photograph created from a number of separate photographic images which have been stripped together or overlaid to produce one image.

Newton's rings
Rings of rainbow colored light formed when two transparent surfaces are sandwiched together and part of one surface becomes slightly out of contact with the other. This often occurs when transparencies or negatives are pressed together in a glass mount or in a glass enlarger carrier. These rings can be elimi-

nated by spraying the film with a fine talc available from graphic arts suppliers.

Pencil light
This normally refers to a portable flash tube which is mounted in a small base together with a modeling lamp. Particularly useful wherever a small light is needed that must be concealed, such as in a refrigerator or in a car interior.

Perspective
The dimension created within a photograph. All perspective is controlled by viewpoint and can be exaggerated with wide-angle lenses or diminished with telephoto lenses. Linear perspective refers to the impression of depth produced when lines converge to a vanishing point.

Photomechanical
Photomechanical production defines the process of preparing transparencies, artwork and type for final film and printing plates.

Pictafilm
A television commercial shot from photographs instead of live action. Movement from one image to another is softened with dissolves and other optical effects. Due to its relatively low cost, many advertising agencies often produce a pictafilm test commercial before proceeding to final production.

Polycontrast
A term to describe variable contrast printing paper. With the use of polycontrast filters placed in the enlarger's condenser head or in front of the lens, contrast can be determined at the exposure stage.

Primaries
The three primary colors of the

spectrum are blue, green and red. These make up all colors, including black and white. With painter's pigments, the primary colors for mixing are blue, yellow and red.

Progressive proofs
A set of press proofs produced by using the same inks and paper that will be used for the final printing. This determines exactly how color will appear, and what corrections may be required. Built in 'color patches' and density checks permit the printer to exactly match the approved color proofs.

Pushing
The practice of underexposing film and then over-processing it to compensate. A technique for boosting the ASA rating of the film, giving it an apparent higher speed. Valuable in low level light or when increasing grain or contrast.

Registration
The alignment of final film or press plates in order to produce a sharp image during printing. Of special concern when sandwiching images or working with color separations.

Resolution
The fineness of detail recorded by the eye, lens or film. Resolving power is specified as number of lines per mm and stated for each film in Kodak's professional films booklet, No. F-5.

Retriculation
The cracked patterns produced in the emulsion layer of a film when it is subjected to sudden and extreme changes in temperature.

Ring light
A circular light placed around the camera lens. Originally designed for extreme close-up photography,

now often used for fashion photography. Provides flat, shadowless lighting.

Rotogravure
A high-speed method of printing which provides the most economic efficiency in press runs approaching one million copies. Utilizes copper cylinders which do not need replacement, as opposed to the plates used in offset printing which eventually wear out and must be replaced. 'Roto' provides greater ink control and sharper reproduction than webb offset. Considered a high quality method of printing.

Rubylith
A red, transparent mask placed over the areas of the photographic image to be reproduced. Used in screening for reproduction.

Sandwiching
The combining of transparencies or negatives to produce a single image. Color transparencies are often effectively sandwiched with transparencies of black-and-white images.

Scrim
A framework with an overlay of frosted acetate or other diffusion material to soften the light passing through it.

Sensitometry
The study of how light affects photographic emulsions.

Sheet fed
A low-speed method of printing, providing the most economic efficiency in press runs of less than 100,000 copies. A small press designed for printing in single sheets. Ideal for art book quality.

Silk screen
A method of printing in which the image is actually transferred onto a

silk screen and printing is done by forcing inks through the screen with a rubber squeege. Allows unlimited use of special colors and is especially effective for creating poster graphics.

Silver halide
The light sensitive crystal which makes up photographic emulsions in film and paper. Exposed and developed, the silver halides form grains of black metallic silver.

Snoot
A cylindrical or funnel shaped tube which is fitted over a studio light to produce a narrow spot of light. Commonly used in portraiture to direct highlights onto the hair.

Stat
A positive paper image, usually of low quality, used in preparation of layouts to show the size and position of photographic or art illustrations. High quality stats for reproduction are known as photo-prints.

Stopping down
Term used when the size of the aperture is reduced.

Storyboard
Presentation of an idea for a television commercial, prepared on a sheet which includes blank tv frames for indicating the sequence of visuals.

Strobe
Often used to describe heavy duty, professional electronic flash equipment. In professional context, does not refer to the rapid pulsating effect of stroboscopic light.

Superimpose
The placing of one image directly on top of another. In television commercials this refers to the words which appear over the image

on the screen; in photography this term may also mean directing an image from a slide viewer onto a subject and photographing the final effect.

Test strip
A number of different exposures made on a single strip of printing paper in order to determine the correct exposure needed for the final print.

Thumbnail
A rough sketch used to convey an idea. Also known as a 'doodle'.

Tone separation
The degree of separation from one tone to another. The higher the contrast the less the tone separation.

'T' setting
The setting on the camera for 'time' exposure. After the release is pressed the shutter remains open until the release is pressed again.

Turtle
Portable metal bracket with clamp. This can be attached to any structure and used to support a flash head or reflector.

Van dyke
The assembled proof sheets of a magazine, book or any printed project involving a number of pages. Serves as a check that the page sequence and all the mechanical stages have been correctly completed.

Velox
A screened, positive image paper print used for reproduction.

Watt-second
A unit of measurement applied to the output of an electronic flash. Equivalent to a joule or to 40 lumen-seconds. The higher the number of watt-seconds, the greater the light output.

Webb offset
A high-speed method of printing which provides the most economic efficiency in press runs of 100,000 to 500,000 copies.

Zebra
An umbrella with wedges or stripes of reflective silver attached to its inside surface. Designed to provide contrast that is midway between a translucent white umbrella and a completely silvered umbrella. Adds the right amount of snap and crispness to color photography. Available from Balcar.

Zone system
A method for controlling the tonal gray scale during exposure. The choice of exposure regardless of the meter reading provides control over the contrast and brightness range of the subject.

Acknowledgments and credits.

Conceptual development:
John Stewart.
Design consultants:
Robert Torrans.
Michael Winston.
Text editing:
Elizabeth Kimball.
Wayne Herrington.
Technical consultants:
Arthur Parkinson, Rutherford
Photographic, Toronto.
Ron Silverstein and Hank Forrest,
Vistek, Toronto.
Peter O'Connell, Qualicolor, Toronto.
Food photography consultants:
Dale and Colnett, Toronto.
Model agency consultant:
Sherrida Rawlings, Sherrida Personal
Management Inc., Toronto.
Photo-art consultant:
Marcia Reid, Déjà Vue Gallery of
Photographic Art, Toronto.
Typesetting:
Ed Frattaroli, CompArt, Toronto.
Assembly:
Beverley Bradley.
Color separations and printing:
Herzig Somerville, Toronto. Color
technicians: Arne Roosman, Otto
Theoner. Film technician:
Kerry O'Connor.
Marketing consultant:
John Duff.

Models and their agencies:
Denise McCloud, pages 3, 36. Janice
Youngren, page 163. From International
Management, Toronto.
Suzanne Cyr, pages 59, 100. Hayley
Mortison, pages 97, 160. Sue Pace,
pages 171, 177. Carolyn Patterson,
pages 86, 87. From Jo Penney Model
Agency, Toronto.
Sam Turkis, pages 22, 135. From Judy
Welch Model Agency, Toronto.
Lucy, page 180. Philip Matthews, page 92.
Yanka VanderKolk, pages 7, 8, 56, 73, 82.
From Models One, Toronto.
Colin Armstrong, page 26. Mary
Eastwood, page 92. From Nexus Personal
Management, Toronto.
Kerry Jewitt, cover, pages 9, 10, 30, 36,
51, 90, 92, 159, 163 (right), 238. From
Sherrida Personal Management, Toronto.

The art of creating still life photographs lies as much in the choosing of authentic props as it does in the lighting and composition. For this cover photograph for a wine and spirits magazine, two days were spent rummaging through antique shops to turn up the following: a Georgian crystal sweet dish for the grapes, a pair of Victorian silver grape shears, a classic long necked wine bottle, an old French wine goblet, Victorian playing cards, an old-fashioned corkscrew, and a coarse weave napkin. Standard rental rates charged by most shops is 15% – 20% of retail value per week.

The index.

Last words.

On the photographer's judgment of his own work and that of others:

When one's work is equal to one's judgment, that is a bad sign for one's judgment; and when one's work surpasses one's judgment, that is worse, as happens when a photographer is amazed at having done so well; and when judgment exceeds the work, that is a very good omen and a person so endowed will without doubt produce excellent work. He will compose few works but they will be of the kind to make others stop and contemplate such perfection with admiration.

—adapted from the writings of Leonardo da Vinci.